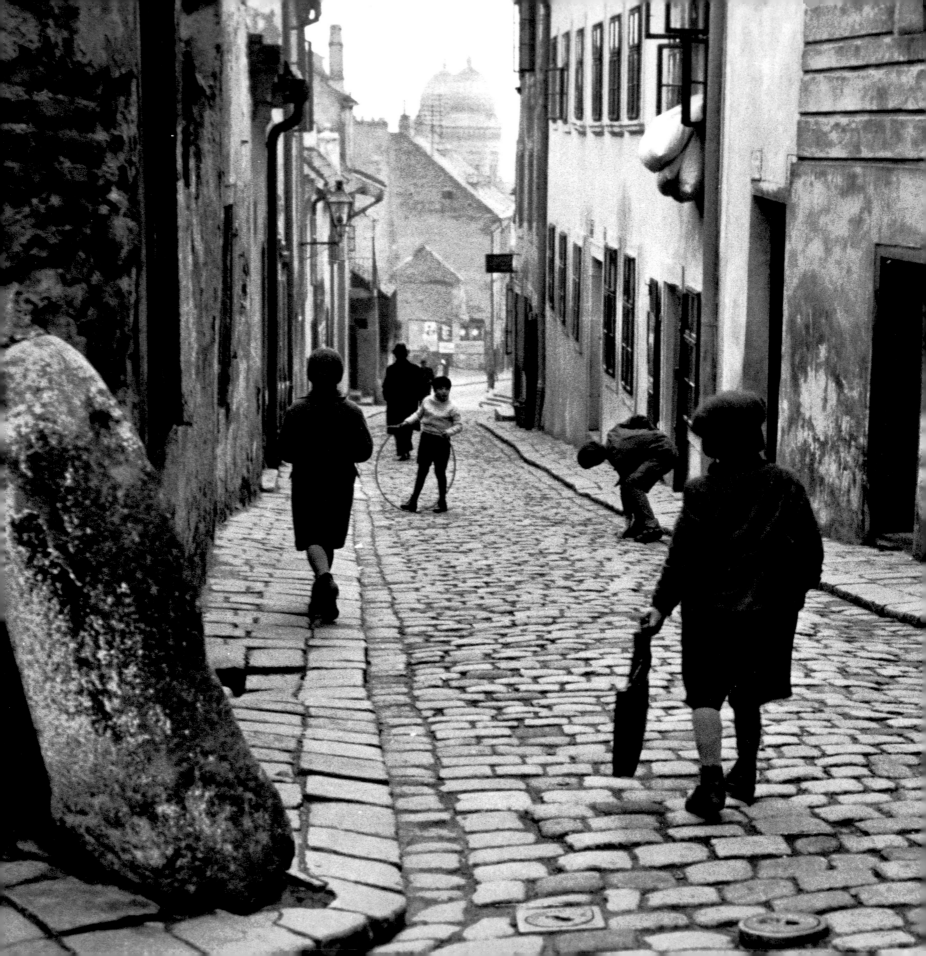

TO
GIVE THEM
LIGHT

THE LEGACY OF
ROMAN
VISHNIAC

edited by
MARION WIESEL

SIMON & SCHUSTER

New York London Toronto Sydney
Tokyo Singapore

Children at play. Bratislava

SIMON & SCHUSTER
Simon & Schuster Building
Rockefeller Center
1230 Avenue of the Americas
New York, New York 10020

Designed by Laurie Jewell

Production directed by Joanne Barracca

300 Line Screen Scanned Duotones and Printing by Phoenix Color

Bound by Horowitz/Rae

Manufactured in the United States of America

1 3 5 7 9 10 8 6 4 2

Library of Congress Cataloging in Publication Data

Vishniac, Roman, 1887–1990
To give them light : the legacy of Roman Vishniac / edited by
Marion Wiesel.
p. cm.
1. Jews—Europe, Eastern—Pictorial works. 2. Europe, Eastern—
Pictorial works. I. Wiesel, Marion. II. Title.
DS135.E85V57 1993
305.892′4047′09047—dc20 92-32288
CIP
ISBN: 0-671-63872-6

Photo researcher and archivist: Barbara Koppelman

This book is dedicated to all the men, women, and children whose lives Roman Vishniac illuminated.

It is also dedicated to my grandparents, who lived and perished in Poland with all the others....

—M.W.

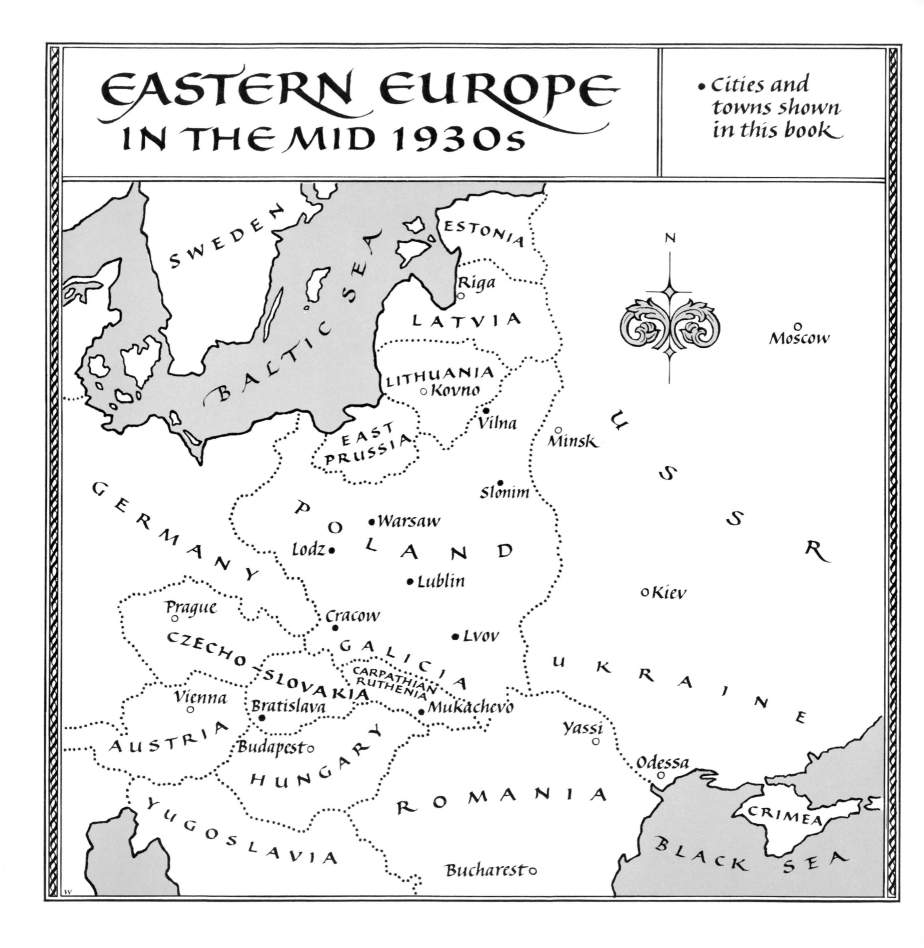

EASTERN EUROPE
IN THE MID 1930s

• Cities and towns shown in this book

SWEDEN

BALTIC SEA

ESTONIA

Riga ○

LATVIA

N

Moscow ○

LITHUANIA
○ Kovno

• Vilna

○ Minsk

U

EAST
PRUSSIA

GERMANY

P O L A N D

Slonim •

S

• Warsaw

Lodz •

○ Kiev

S

• Lublin

Prague ○

• Cracow

CZECHO-SLOVAKIA

GALICIA

• Lvov

R

CARPATHIAN
RUTHENIA

U K R A I N E

Vienna ○

Bratislava •

• Mukachevo

AUSTRIA

Budapest ○

HUNGARY

Yassi ○

Odessa ○

R O M A N I A

YUGOSLAVIA

CRIMEA

Bucharest ○

BLACK SEA

CONTENTS

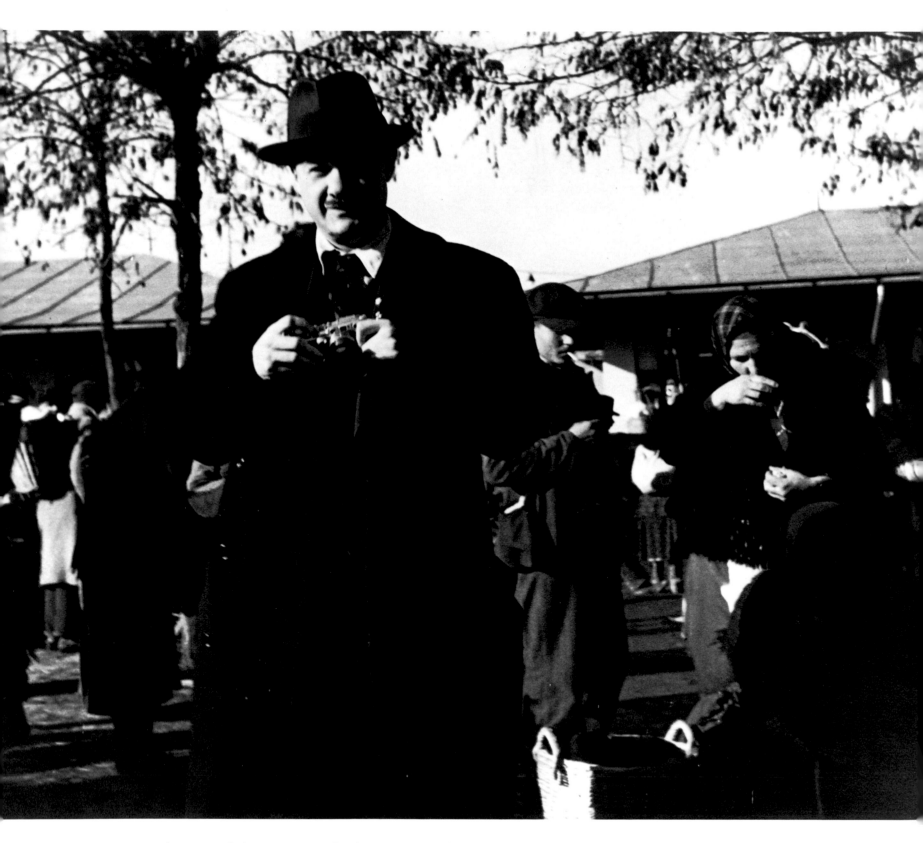

*Roman Vishniac with his Leica. Mukachevo, 1937. Photo by
Henryk Schwartz (see pages 52 and 65).*

APPRECIATION

IN 1971, I was privileged to mount the first major exhibition of Roman Vishniac's work in the United States. A comprehensive exhibit, it included Vishniac's scientific photographs as well as his pictures of Jewish communities of Eastern Europe in the late 1930s. Surely, the latter will stand as his greatest achievement, the most enduring part of his legacy.

To Give Them Light is such an appropriate title for this volume. I remember my surprise and delight the day I first saw the photographs laid out. All the riches of Vishniac's Eastern European work were there. My own love affair with Roman's spirit and images is a lasting one. His concern and respect for life are gifts to cherish.

Roman Vishniac, like Elie Wiesel, who contributed the preface, was passionate about remembering Jewish life before the Holocaust. Each has been a witness; each has given us his memory of a world that has vanished, a world you are holding in your hands.

December 1992
 Cornell Capa, Director,
 International Center for Photography

ACKNOWLEDGMENTS

FIRST AND FOREMOST, I wish to thank my friend and long-time editor, Ileene Smith, whose collaboration was essential. She used her enormous creative talent to help shape a wide-ranging collection of photographs into a cohesive book. Her commitment to this project was total.

I am also grateful to the following for their invaluable assistance: Miles Barth, Cornell Capa, Lucjan Dobroszycki, Florence Falkow, Laurie Jewell, Mara Vishniac Kohn, Barbara Koppelman, Paul Magocsi, Sybil Milton, Roberta Newman, and, of course, my husband, Elie Wiesel.

M. W.

EDITOR'S NOTE

ROMAN VISHNIAC was already ill when he showed me these photographs from his travels through Eastern Europe in the ominous years 1935 to 1939. Together with his beloved wife, Edith, I looked at the pain and beauty they contained, and listened rapt as he stepped back into the past to tell his wondrous, poignant and, at times, funny tales. Surely it was his passion for historic justice that had driven him to record what turned out to be the last years, the last months, of Jewish life in Eastern Europe. On that day in New York City, thousands of miles away and some forty years later, he spoke about the people in his pictures as if he still shared their lives.

I promised to help him sift through the thousands of photographs stored helter-skelter in his apartment on New York's West Side, a place crammed with rare books and Far Eastern art. I promised to help him ready the photographs for publication. But, in the end, he became too ill to continue to work on this project that we both knew would be his last.

Then one day he was gone. And the promise had to be kept.

December 1992 Marion Wiesel

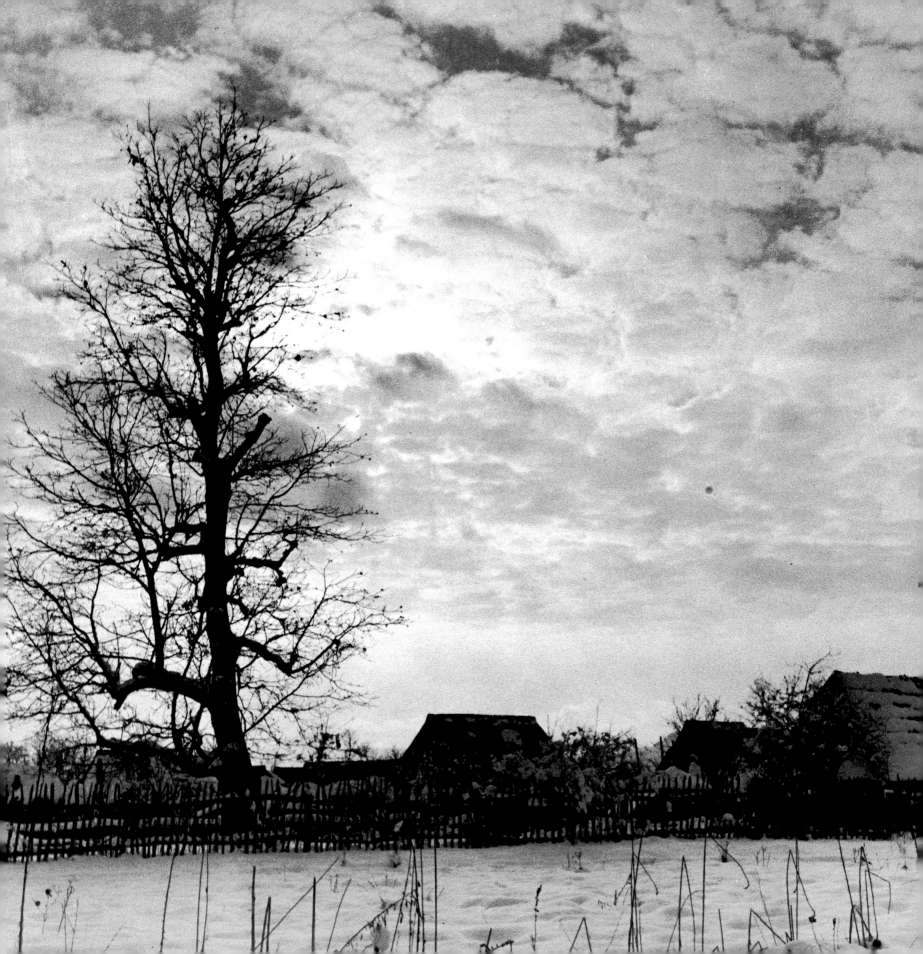

PREFACE

FOR THOSE OF US who knew him, it is difficult to speak of Roman Vishniac in the past tense. Like his photographs, his presence transcends time. Thanks to him we now know that a world that has been shattered can survive its own death.

Look at the photographs in this volume, and you will understand the importance of memory; sever a man from his past or that of his family or his people, and you will have deprived him of his uniqueness, his singularity.

Roman Vishniac's previous collection, *A Vanished World*, gives us a magnificent, kaleidoscopic view of Jewish life in distant cities and hamlets. Here the approach is more structured, more deliberate. After all, this is a posthumous book. . . . *To Give Them Light* takes us on a journey, an unforgettable journey, from Bratislava to Mukachevo and the Carpathians, where Jews believed in God's light alone; and on through the distinct and irreplaceable Jewish communities of Poland and Lithuania—Warsaw and Lodz, Lublin and Cracow, Slonim and Vilna. We meet Jews in those last minutes before they were torn from history by a tempest of fire and ashes; when their lives still coursed with energy and creativity. We encounter their towns and villages before they were consumed by flames.

Therein lies Roman Vishniac's genius: he illuminates all that came before, all that remains from long ago, all that preceded the tragedy of this century which is now drawing to a close. A privileged observer, fiercely conscious of his responsibilities, he was determined to hold back the threat long enough for one glance, one gesture, long enough for his eye to embrace an old man here, a child there, before they fell prey to the enemy, before they were crushed by his evil power.

In truth, in his lifetime, he impressed us as much with the scope of his imagination as with the depth of his memory. To listen to him discuss one of his photographs was an experience: every picture had its story, every story was an adventure, every adventure had its moral, philosophical message. A brilliant storyteller with a wry sense of humor, he enthralled us with his tales.

For him, words and images coincided. He made us see the scene not only as it was photographed but as it had revealed itself to him before he captured it with his camera. Suddenly, we felt that we were there with Roman, at his side, as he journeyed—as if for the last time—in search of a Jewish life far away, in a time beyond time, a time when memory refused to be silent and its echo refused to die away.

This volume enables us to experience Vishniac's vision of that time. Just as one speaks of "the light of Rembrandt," one will speak of "the time of Vishniac." For him, it was a time of passion and compassion.

The Jews in his photographs seem to have been invited into his world because they had nowhere to go. He loved them and he makes us love them. For that, we in turn love him.

And since with this volume he continues to share his vision with us, we choose to address him directly: Thanks to you, Roman, the executioner has not entirely prevailed. Granted, he has succeeded in killing his victims' future, but thanks to your art, their past has eluded his grasp.

Your old Jewish people with their sad, dreamy faces: I knew them well. Your Jewish children, so hopeful, so innocent, poring over the *Book of Books* under the watchful eye of the *melamed*: they were my schoolmates. Even as death lay in wait, you saved them from oblivion. You gave them your talent, your entire being. Few have done as much for their memory.

I study your photographs which are unlike any others, and I wonder: who will speak to us as you did? Who else will evoke for us incandescent memories where hope and despair, tears of joy and stifled screams of pain are mingled? Who will speak to us of "carriers of heavy loads" who, between sighs, recited Psalms? Who will bring us back to the very moment when the universe seemed destined to plunge into the abyss?

Often, as we listened to you, Marion and I felt that though you were among us, you were elsewhere, still wandering in faraway places, over there. . . . At the court of a Hasidic rebbe surrounded by fervent disciples, or in a distant yeshiva buried in the Carpathians, observing the students as they rock back and forth, exploring the deeper meaning of an ancient law. Or at one of the ubiquitous markets, among the peddlers of everything from "Jewish radishes," as you called them, to nuts and bolts. Or in the narrow, winding streets of the shtetl in the company of waifs who followed you because you intrigued them, and also because you made them laugh . . . and dream. You loved them, these Jews whom nobody loved.

Did they know that the enemy had already marked them for suffering, exile, and fire? You, Roman, you knew; you understood. And therefore you loved them a thousand times more. The enemy gave them death; you gave them light. . . .

December 1992
Elie Wiesel
(Translated from the French by Marion Wiesel)

And the Lord went before them by day in a pillar of cloud, to lead them the way; and by night in a pillar of fire, to give them light . . . —Exodus

BRATISLAVA

BRATISLAVA was, for centuries, part of Hungary. Its Jewish community dates back to 1251. With the creation of the Czechoslovak republic in 1918, it became a center of considerable Jewish national and Zionist activity. At that time, it also became the capital of Slovakia, and remained so until 1939, when the Nazis declared an "independent" Slovakian state. After World War II, Bratislava reverted to Czechoslovakia.

From the outset, Jews were persecuted. In 1360, the first of many expulsions occurred, and toward the end of the sixteenth century, all Jews were required to wear cloaks and hoods. Not until 1867 were Bratislava Jews emancipated.

After 1872, there were two distinct Jewish communities in the city, one Reform, the other Orthodox. However, the Orthodox community remained dominant.

From 1918 to 1938, Bratislava Jews made great political and economic strides as a result of the democratic initiatives of the new Czechoslovak republic.

But on November 11, 1938, yet another reign of anti-Semitic violence began. It did not abate until the massive deportation of Jews was completed just weeks before Hitler's defeat. Few Bratislava Jews survived.

Roman Vishniac wrote of his spring 1938 visit to Bratislava: "Jews were worried but did not dare to think that the disaster was so close. . . ." A prominent member of the Jewish community offered to guide him through the city. Vishniac recalled their walk: "Stories and legends were dredged up from the dreadful past: pogroms, burnings, expulsions—whole Jewish communities massacred. As my companion spoke, the tragedies seemed to cling to the houses and squares. . . ."

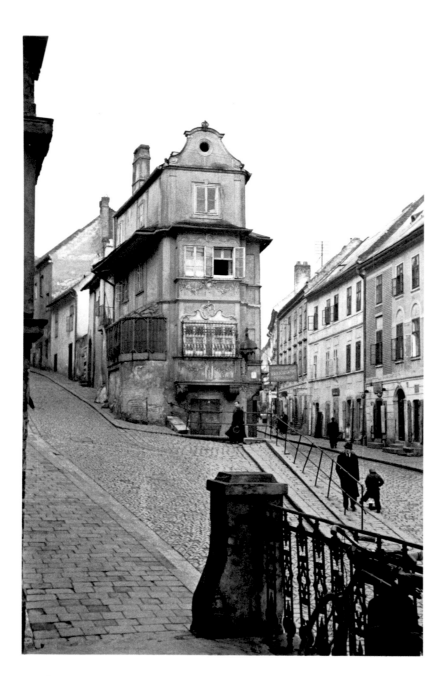

Early morning.

Where High and Low streets meet.
According to legend, Jews were executed here
in the sixteenth and seventeenth centuries.

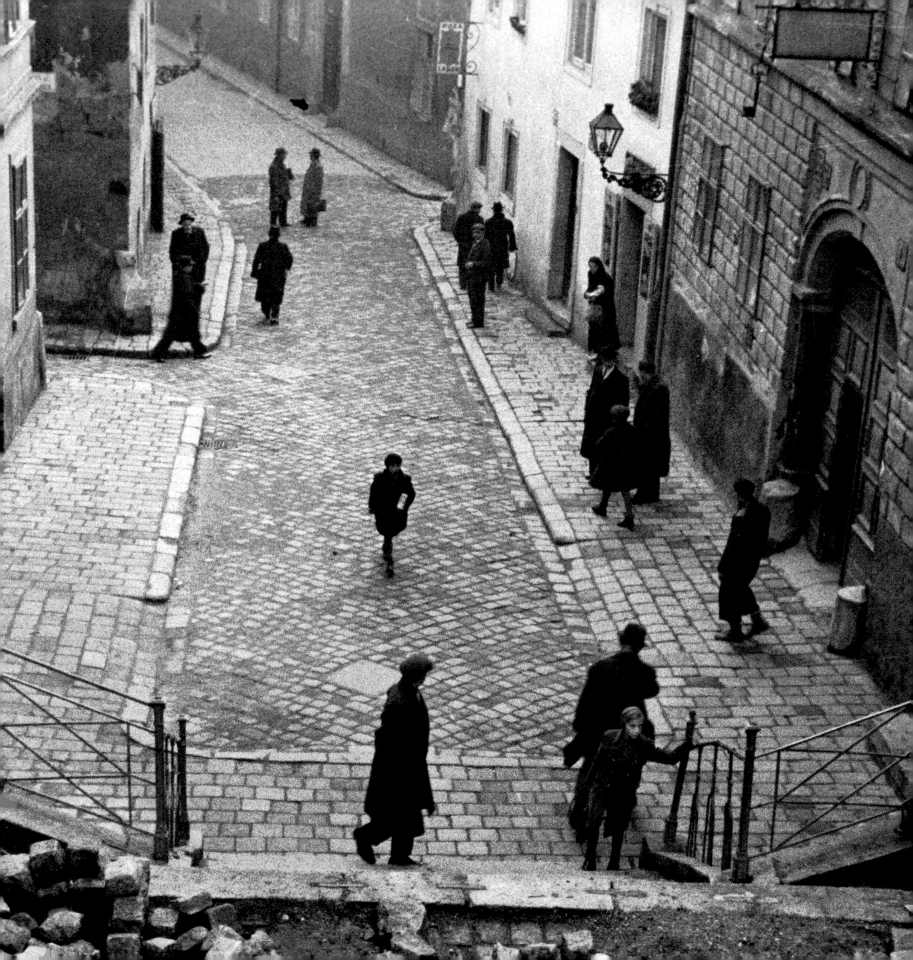

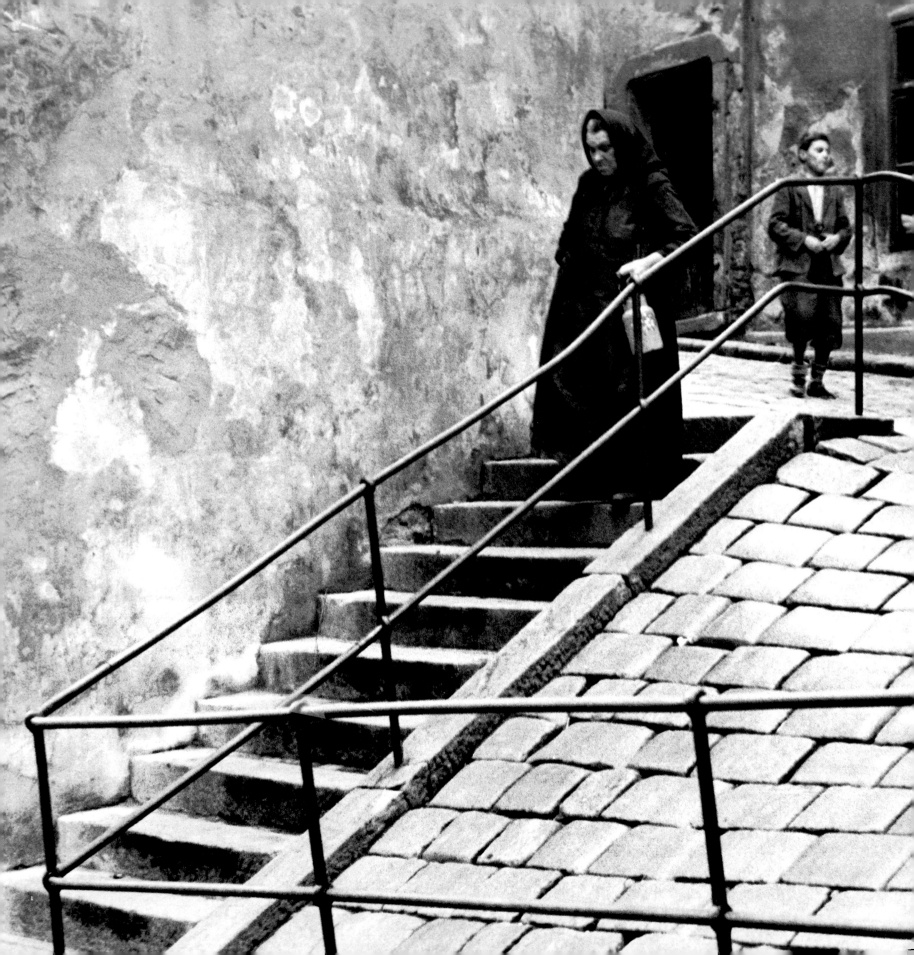

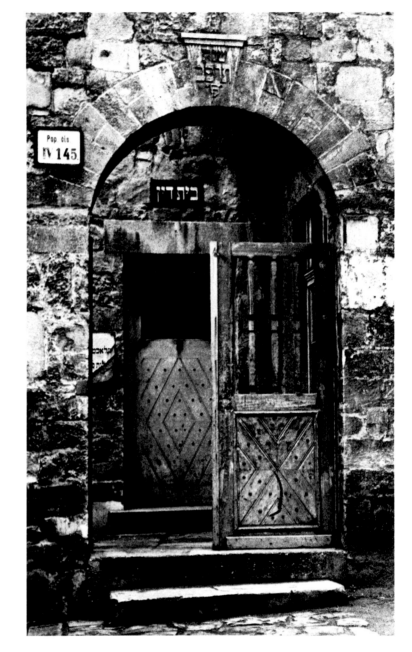

The Bet Din (Jewish Court of Law).

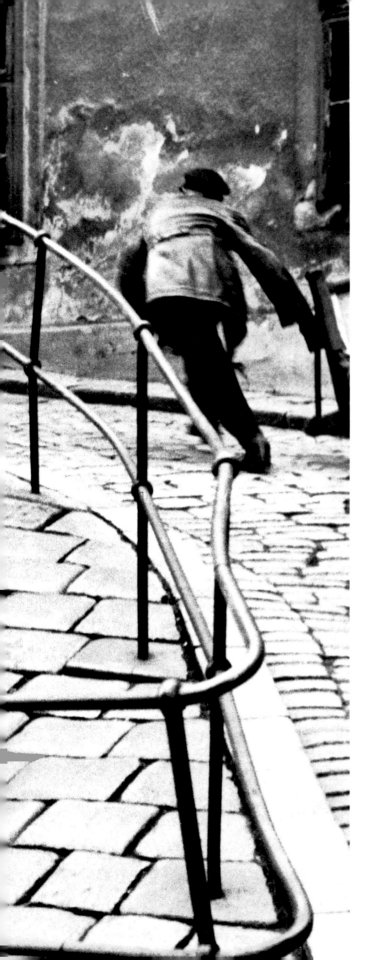

Inside the ghetto.

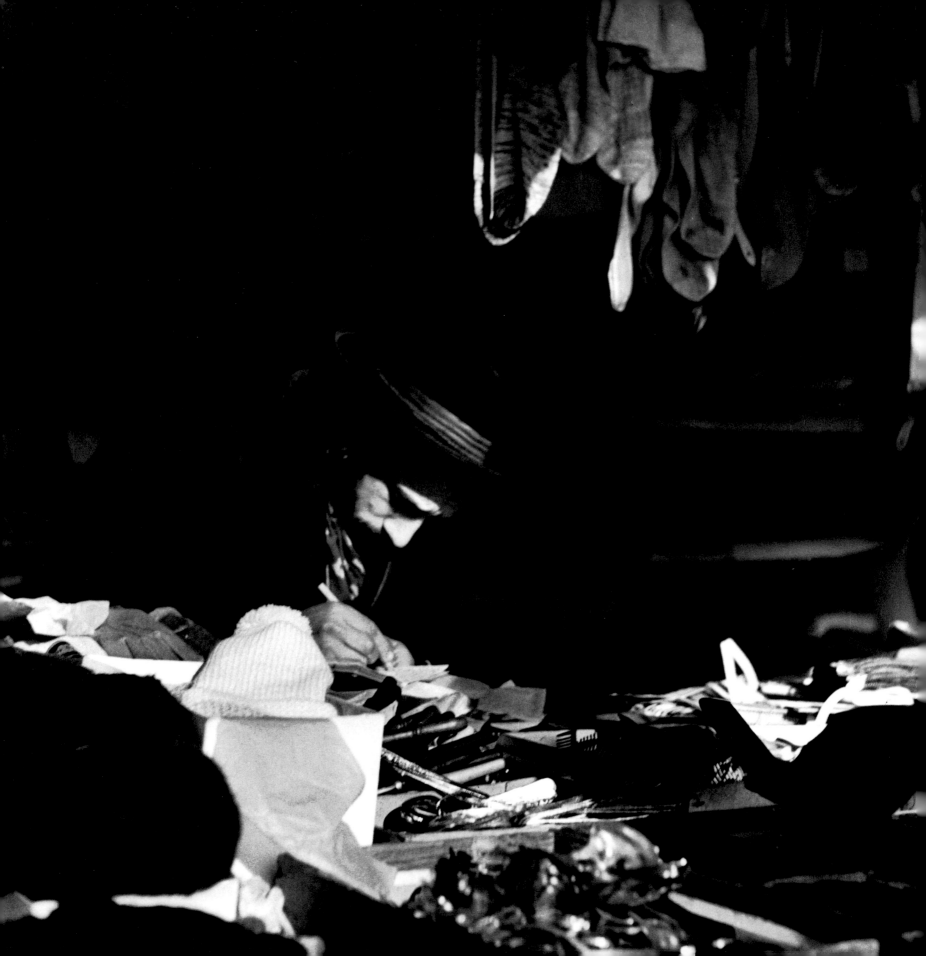

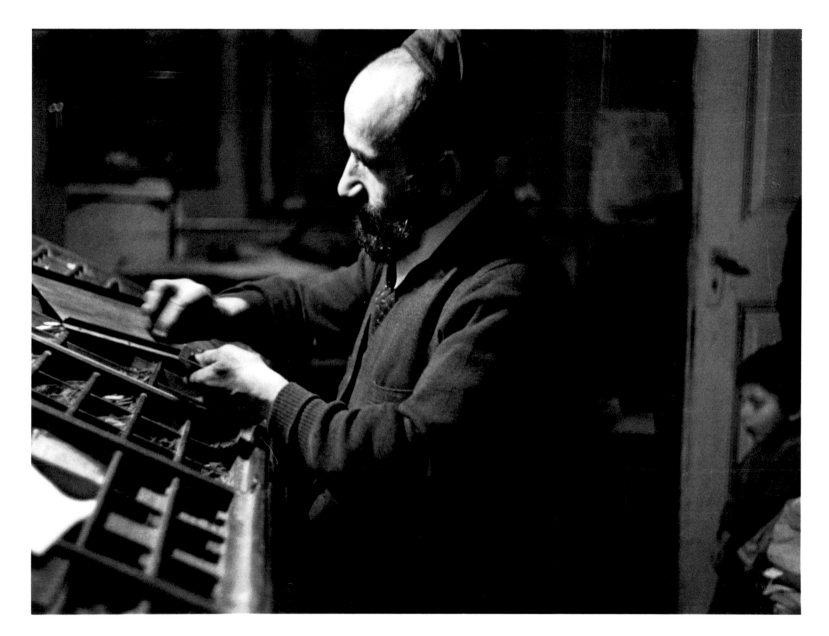

A printer.

Keeping accounts.

OVERLEAF
The secondhand dealer
and the stamp collector.

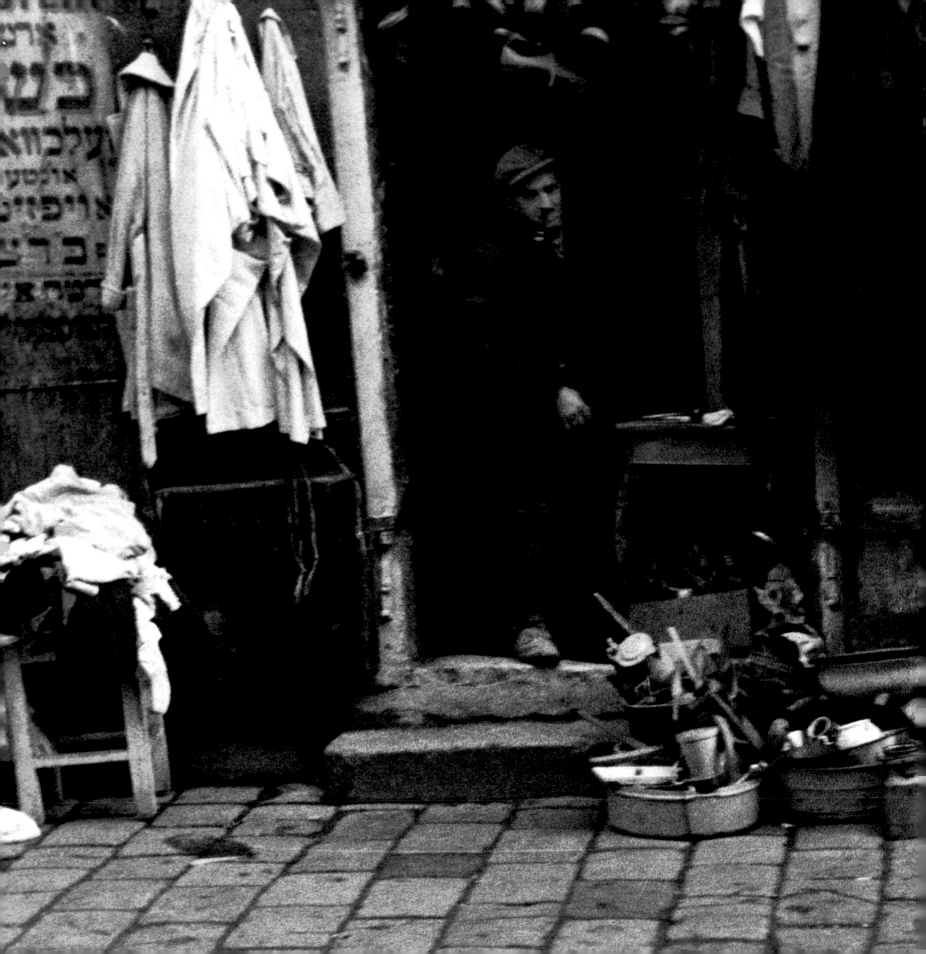

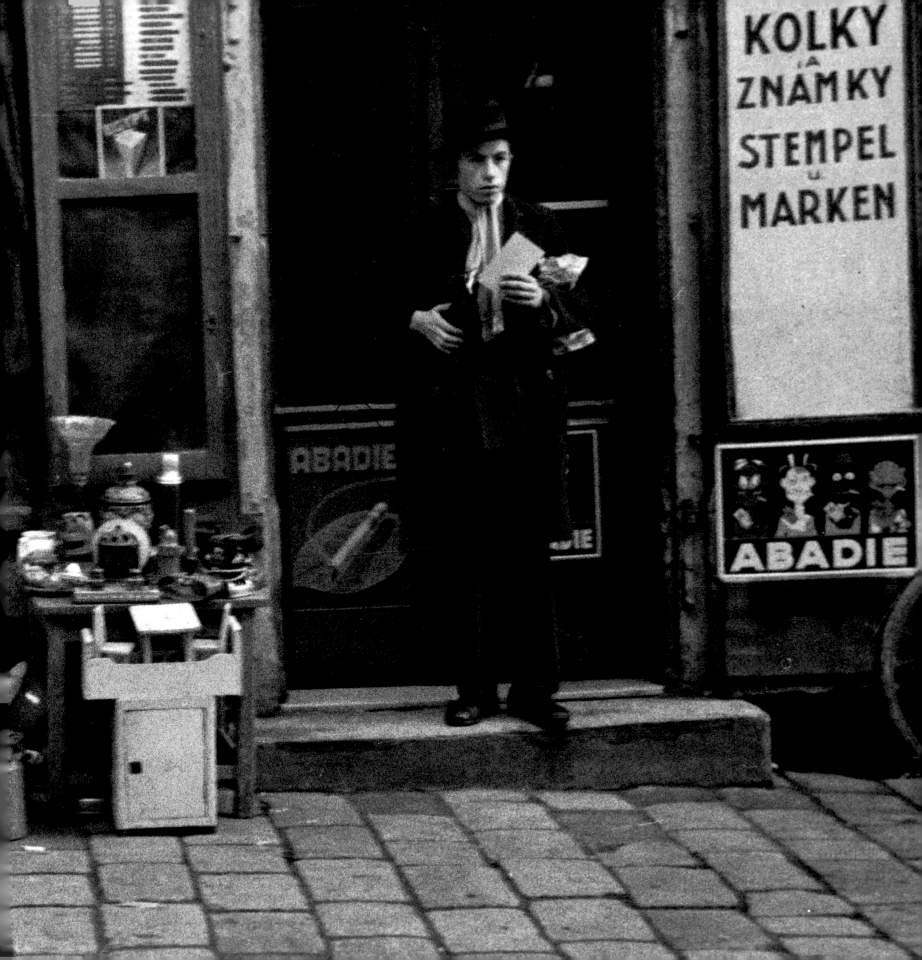

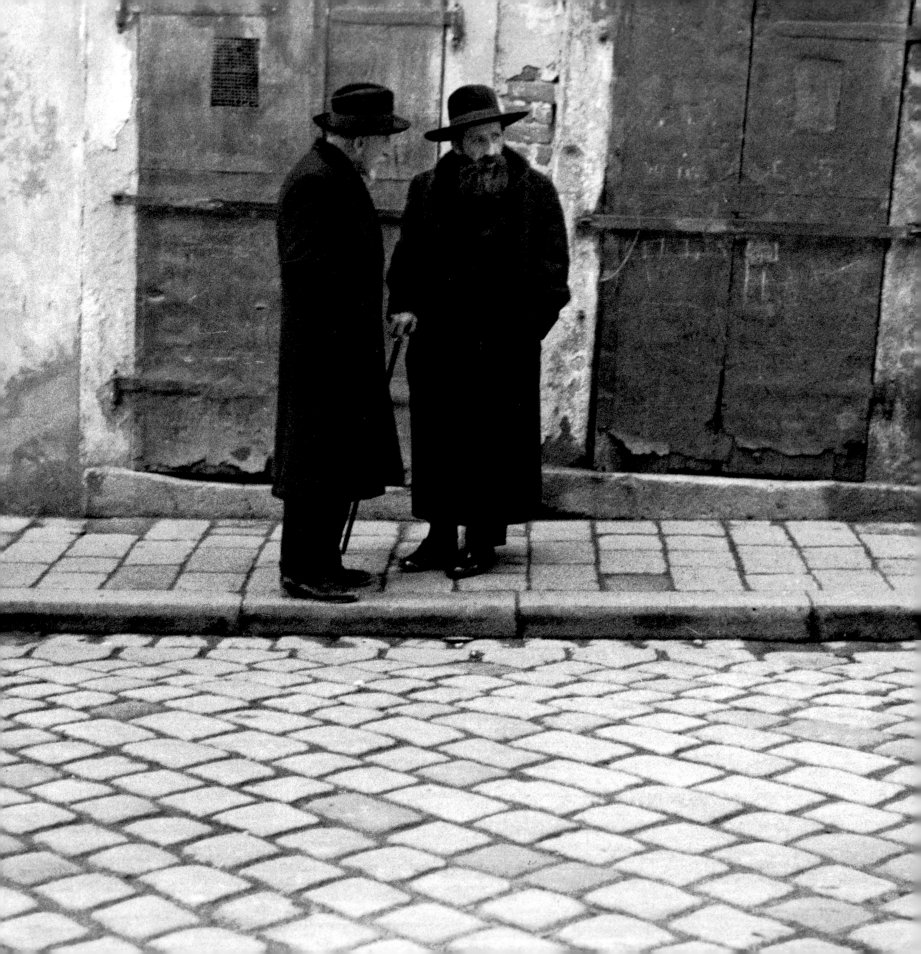

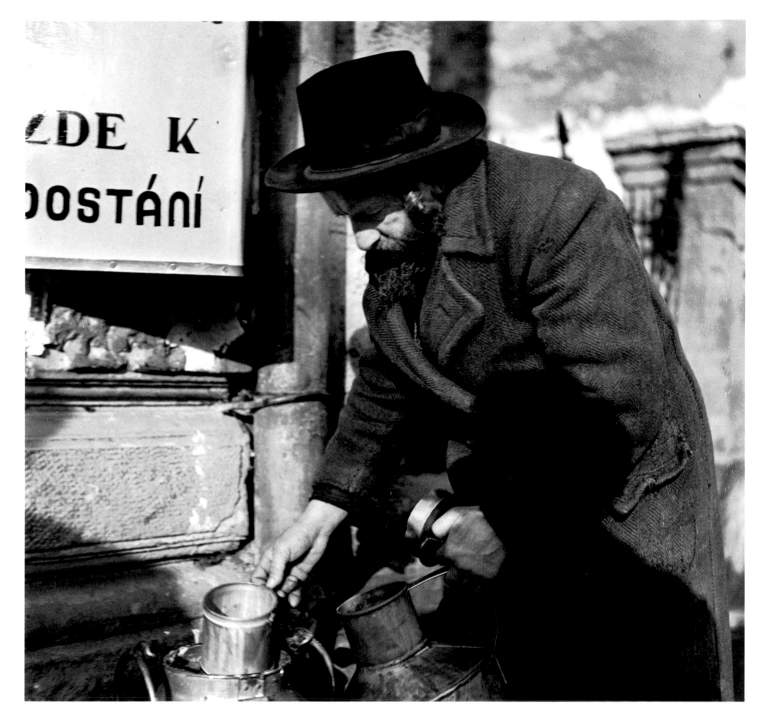

The milkman.

Exchanging news.

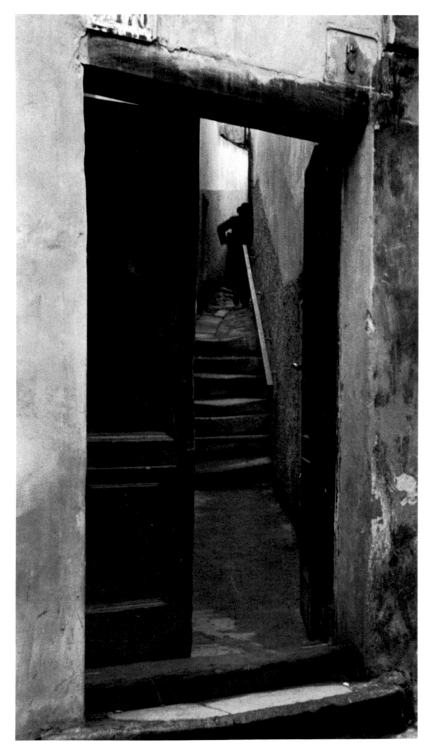

Side entrance to the Jewish quarter.

"A coat, a suitcase? What is your pleasure?"

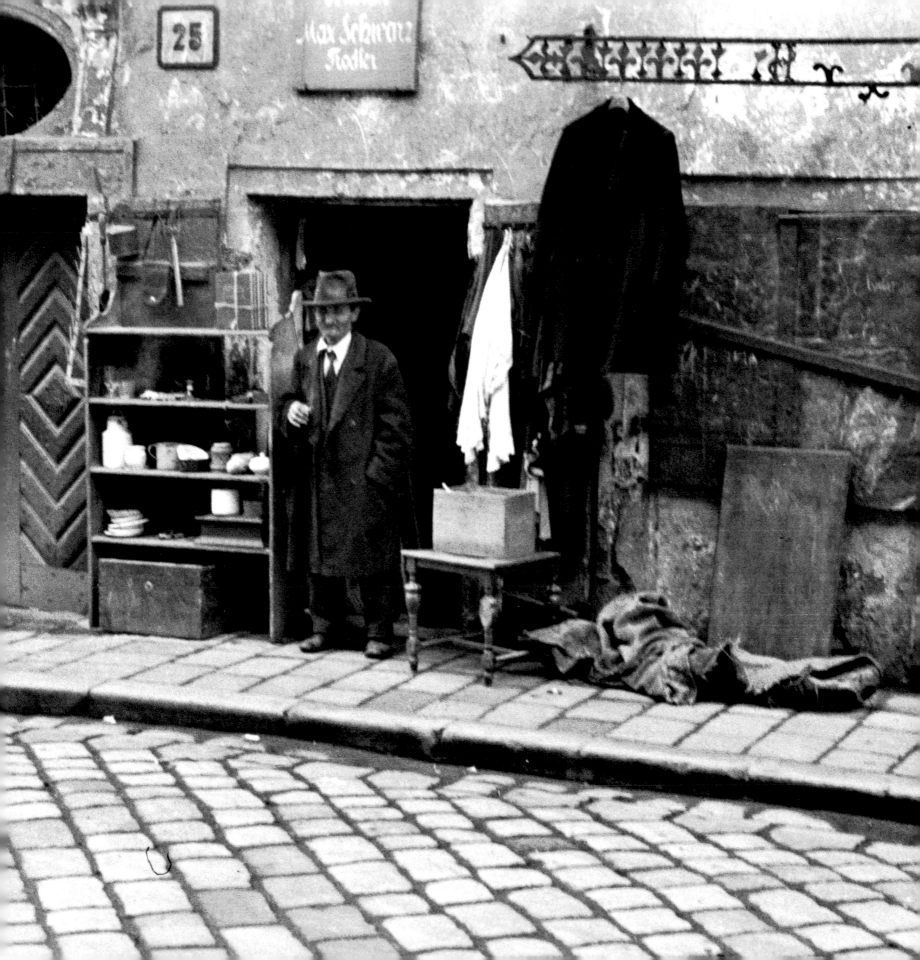

CARPATHIAN RUTHENIA

NOW PART OF UKRAINE, the region in the Carpathian Mountains to the south of Galicia was often referred to as Carpathian Ruthenia. It adjoined Romania, Hungary, Czechoslovakia and Poland. Part of Hungary until the First World War, Carpathian Ruthenia was incorporated into Czechoslovakia and Romania in the years between the two world wars.

Jews first settled in the region in the early seventeenth century, and were principally involved in farming, as well as the operation of distilleries, and flour and lumber mills. "What kind of beasts of burden were these Jews of the Carpathians?" Vishniac wondered. "From the mountains to the Tisza River, the lumber industry used Jews as woodcutters, log carriers, and raftsmen. Their tools were as primitive as their arguments were refined. As I shared a meal with the workers, I listened to one of the men comment upon the *Merkava,* the mystical concept of the celestial chariot. . . . Another discussed Jewish gnosticism. . . . Later, an admirer of Rabbi Mendel of Kotsk showed how to move a five-hundred-pound log to the sawmill using wooden sticks. . . ."

Carpathian Ruthenia included some of the poorest and most pious Jewish communities in Eastern Europe. Before the outbreak of World War II, more than 100,000 Jews lived in the region. In the spring of 1944, most Carpathian Jews were deported to Auschwitz.

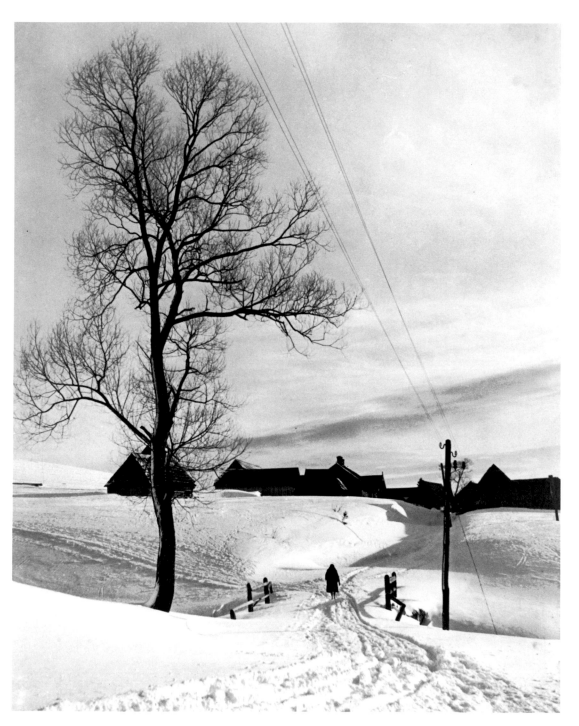

The outskirts of the Jewish village of Tjacovo.

A salesman on his way to the railway station.

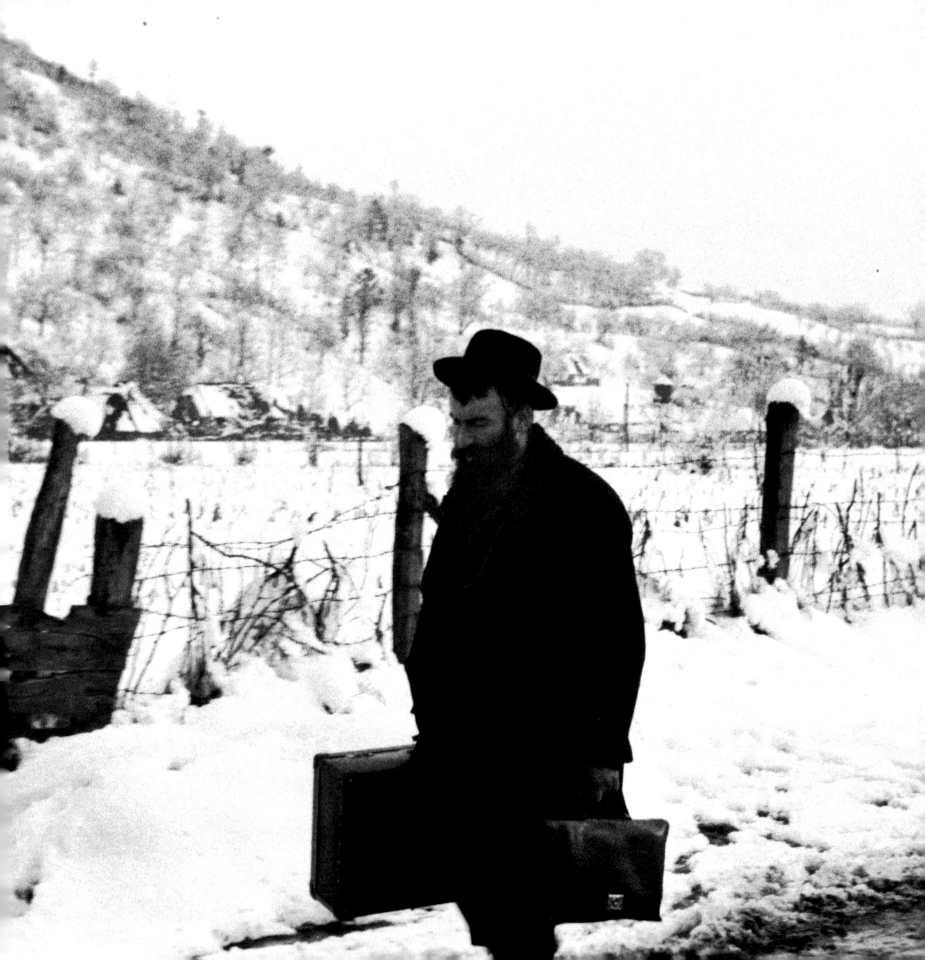

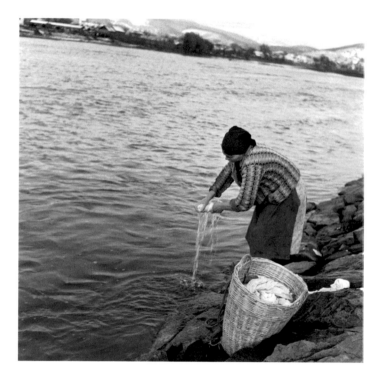

A washerwoman.

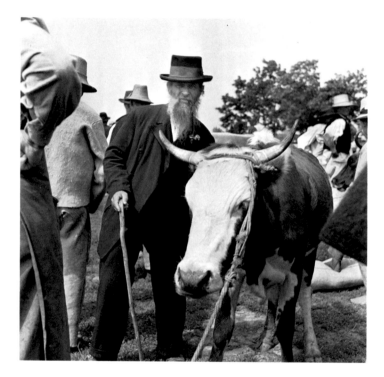

A cattle trader.

Resting.

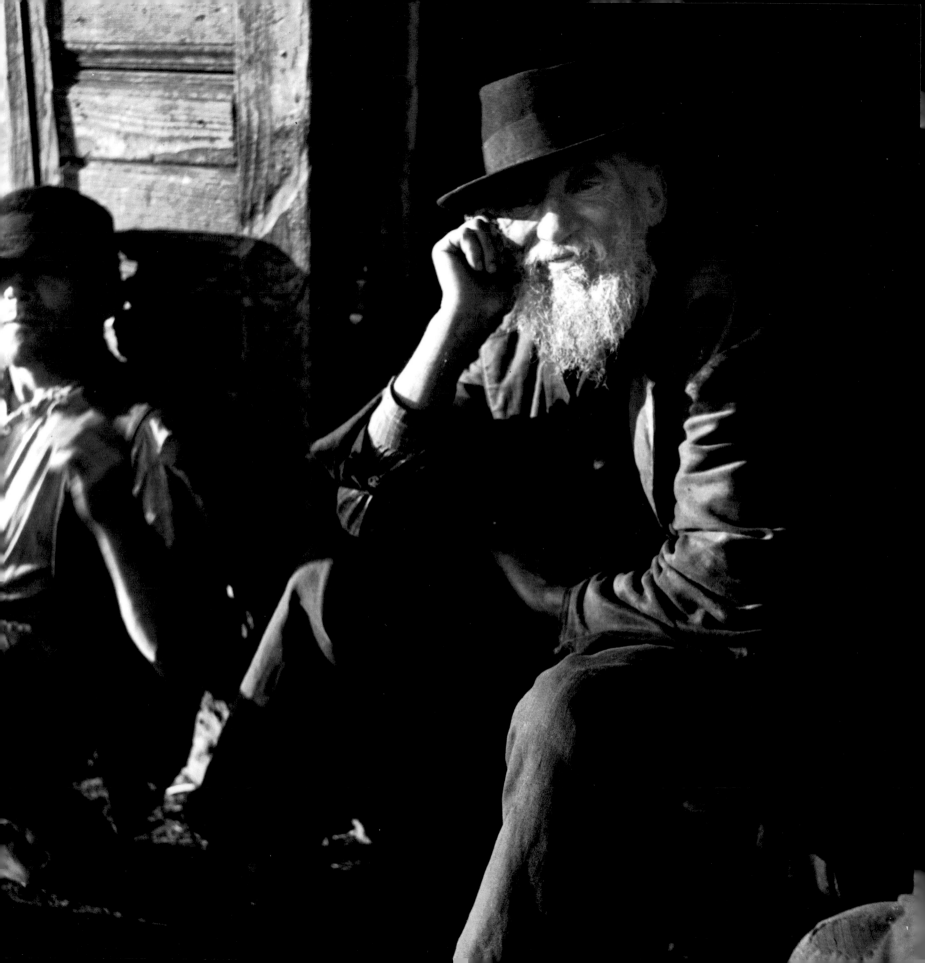

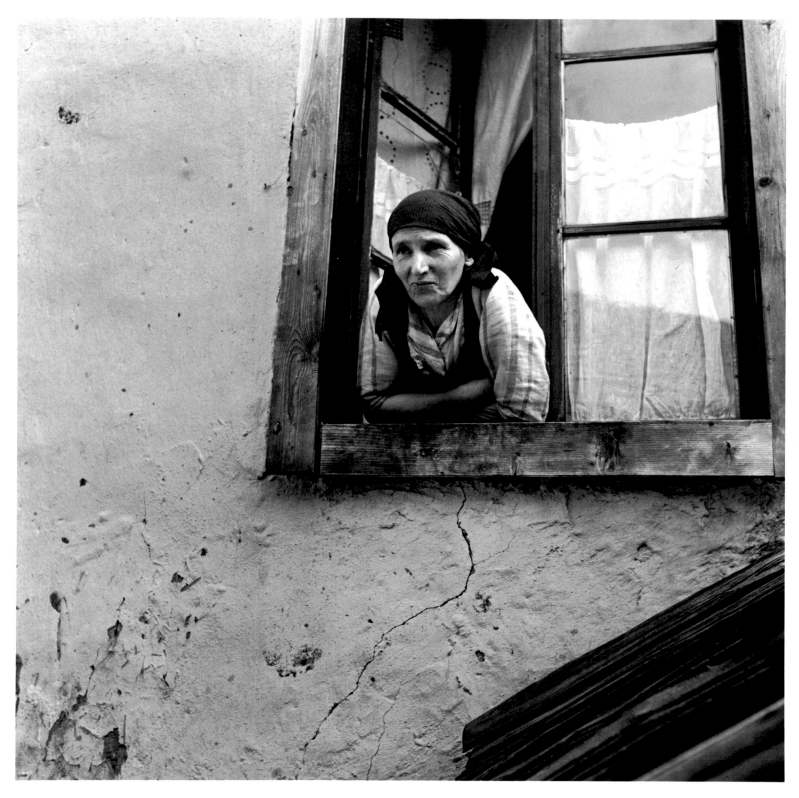

A housewife.

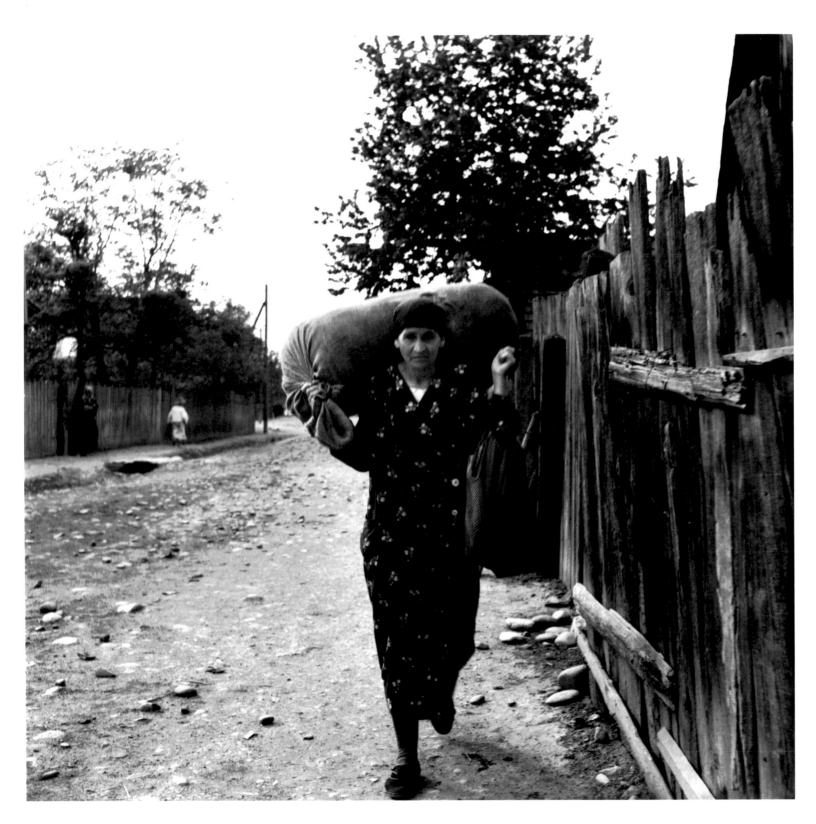

Provisions for winter.

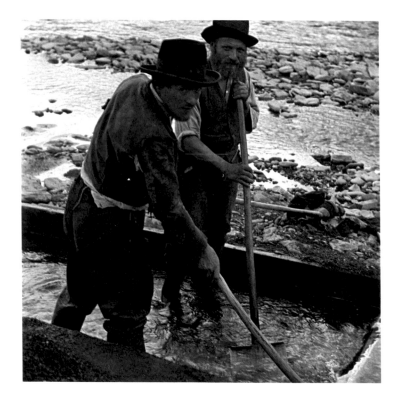

Working on the Tisza River.

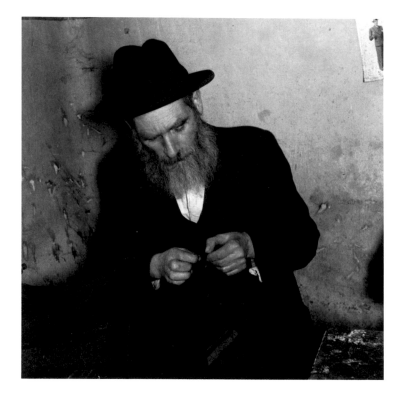

A tailor.

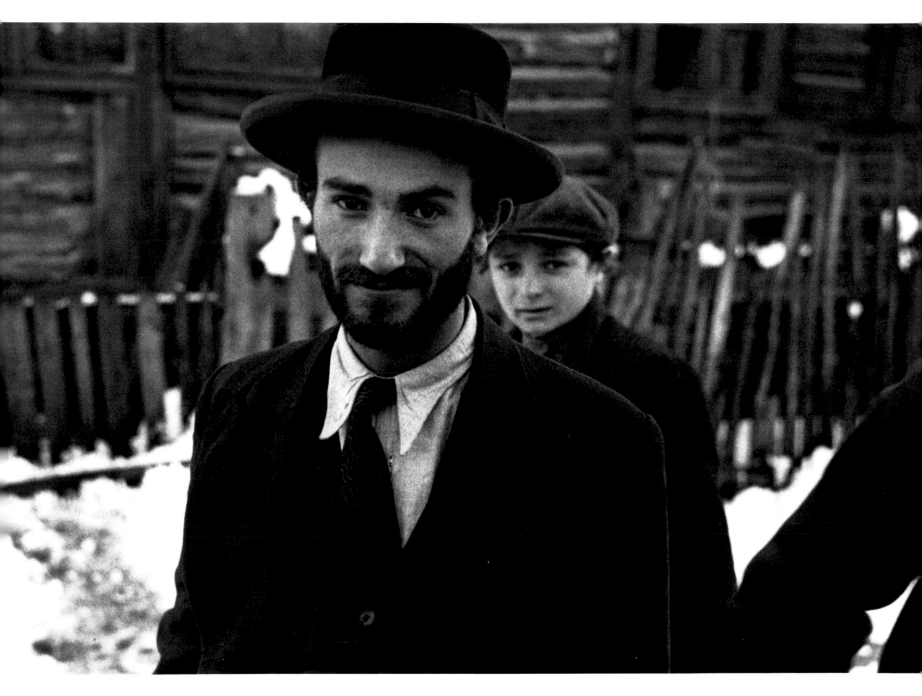

At the knitting mill.

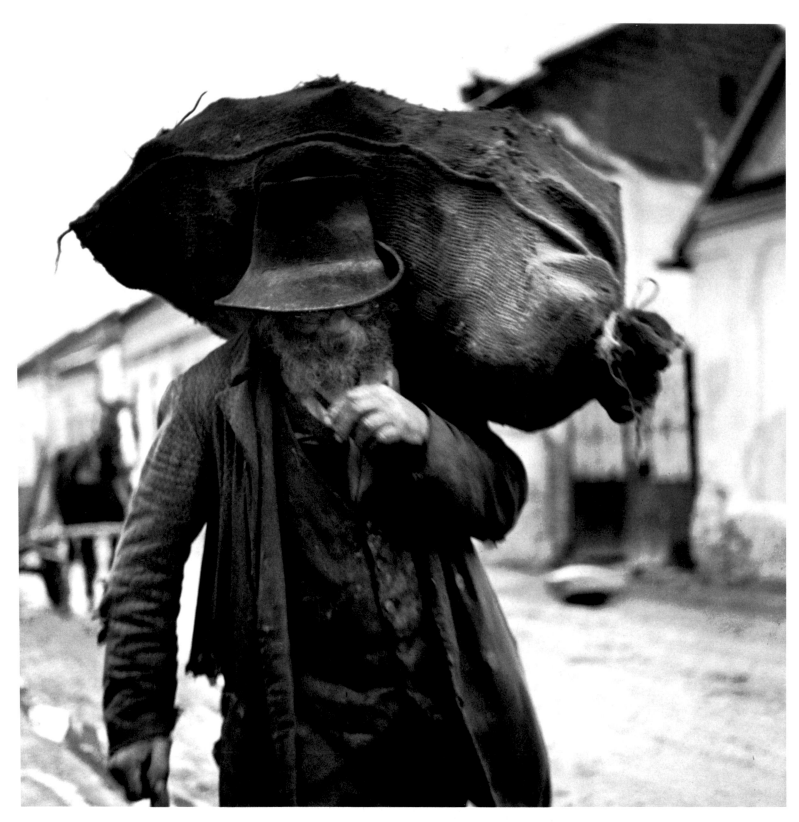

The coal man.

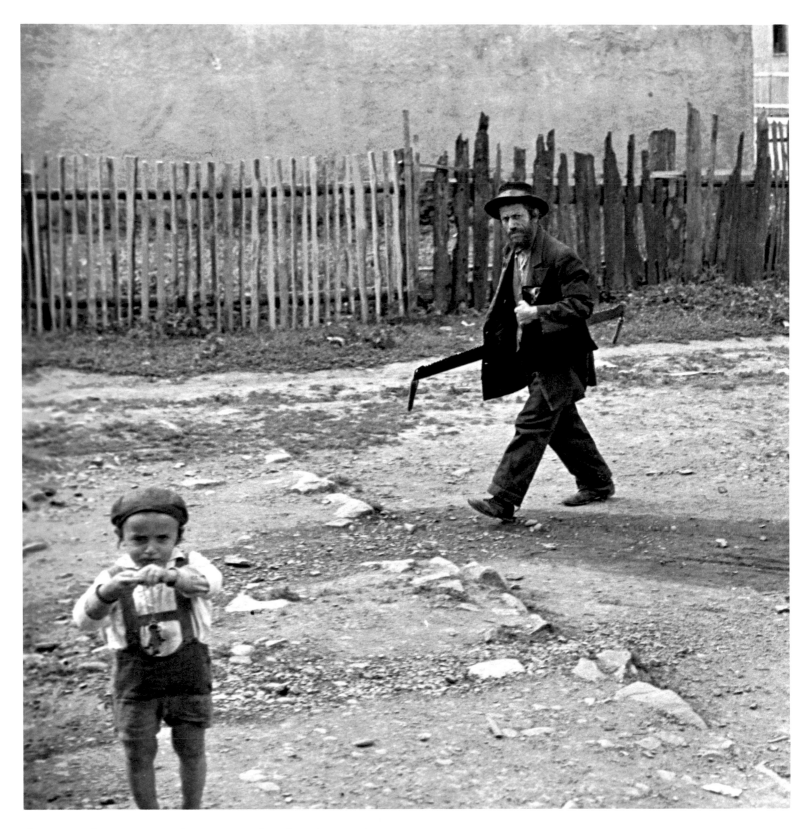

A saw under one arm, his prayer shawl under the other.

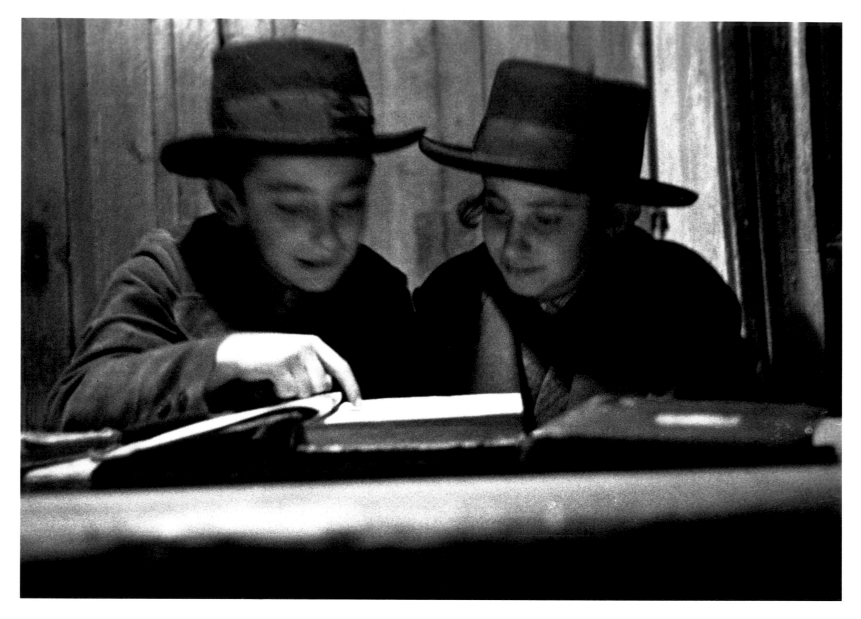

In a cheder in Uzhgorod.

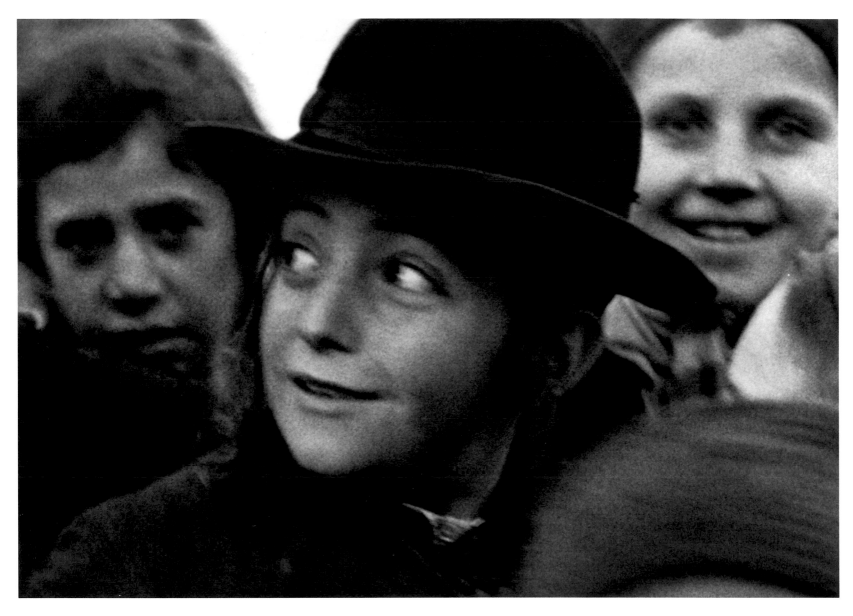

Cheder boy.

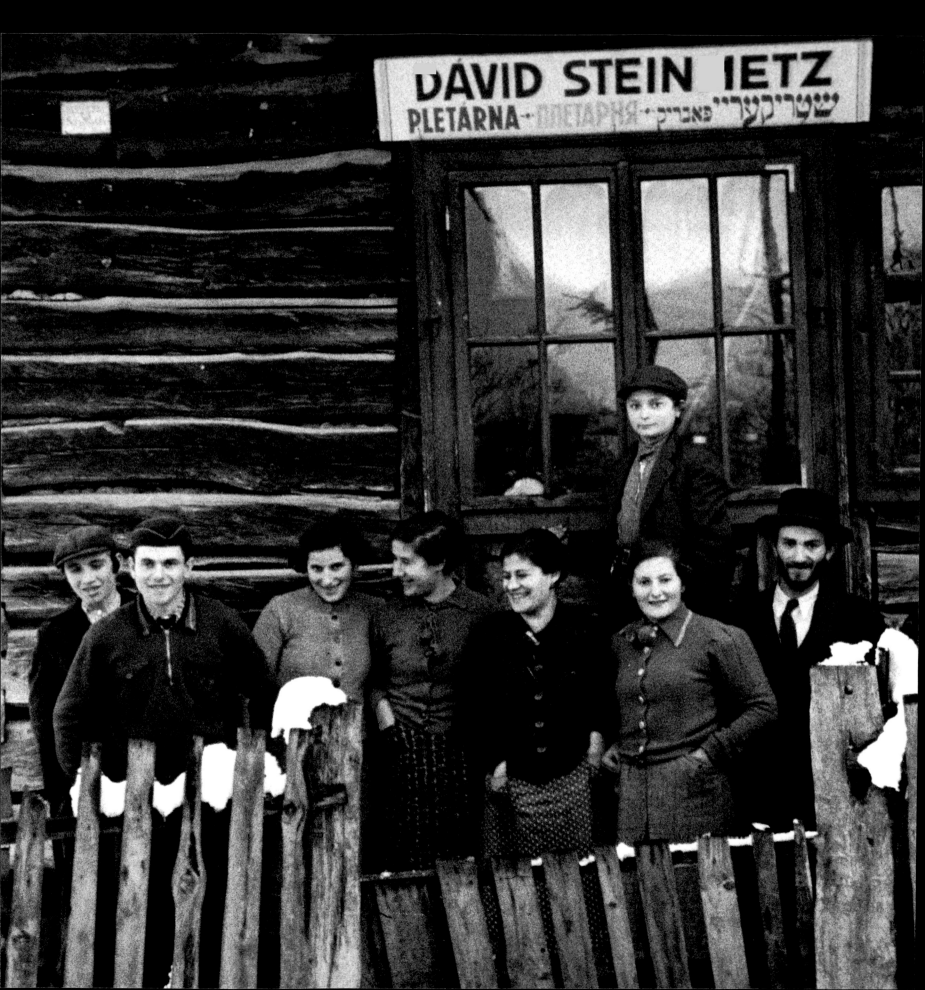

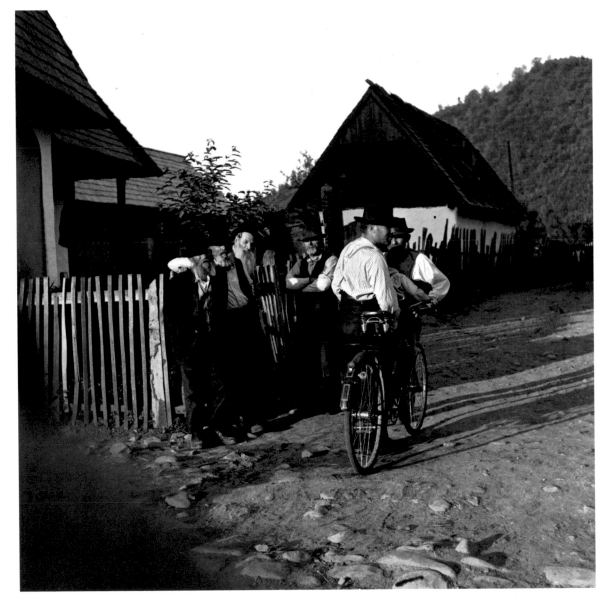

His first bicycle ride.

At the Steinmetz knitting mill.

45

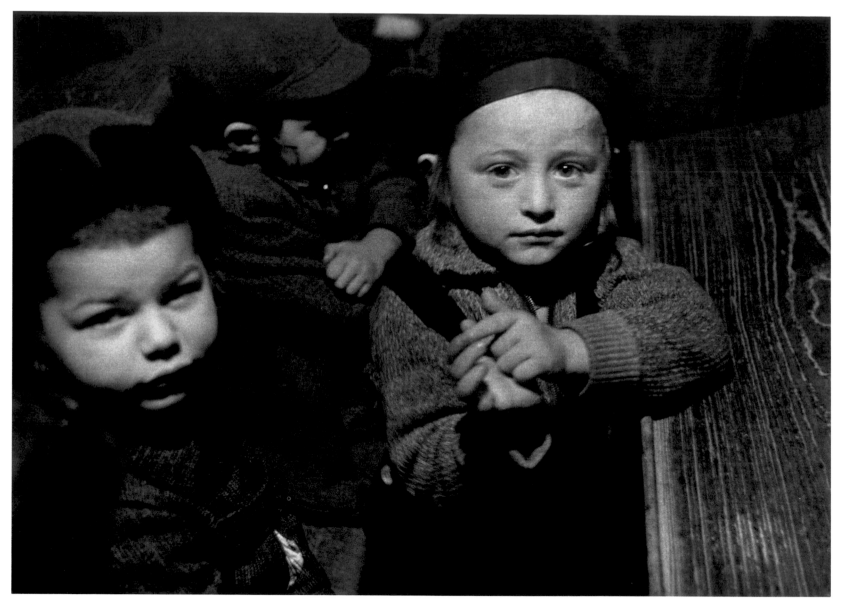

Small boys.

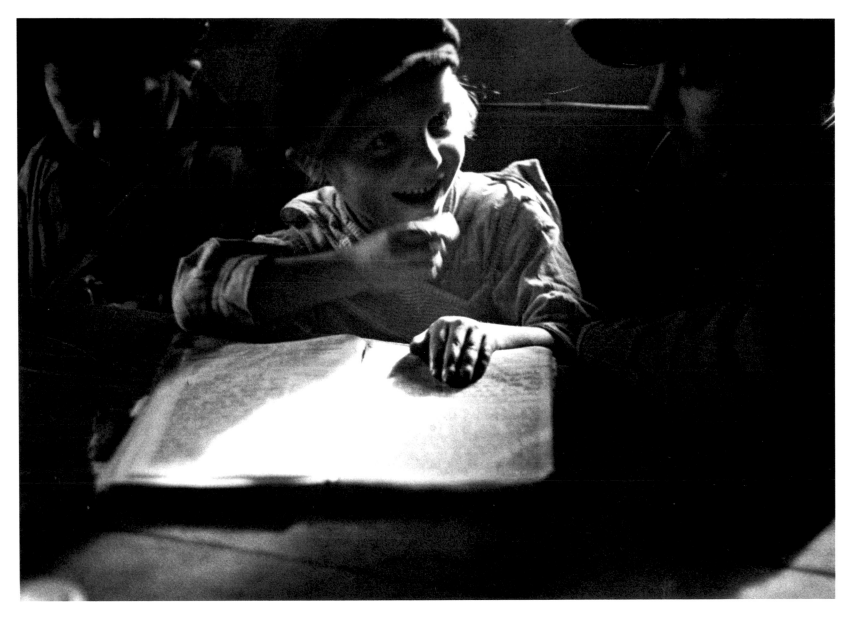

"*How many verses do you know?*"

Jewish homes.

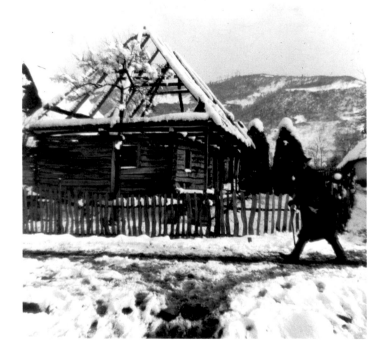

The money ran out.

Carpathian geese.

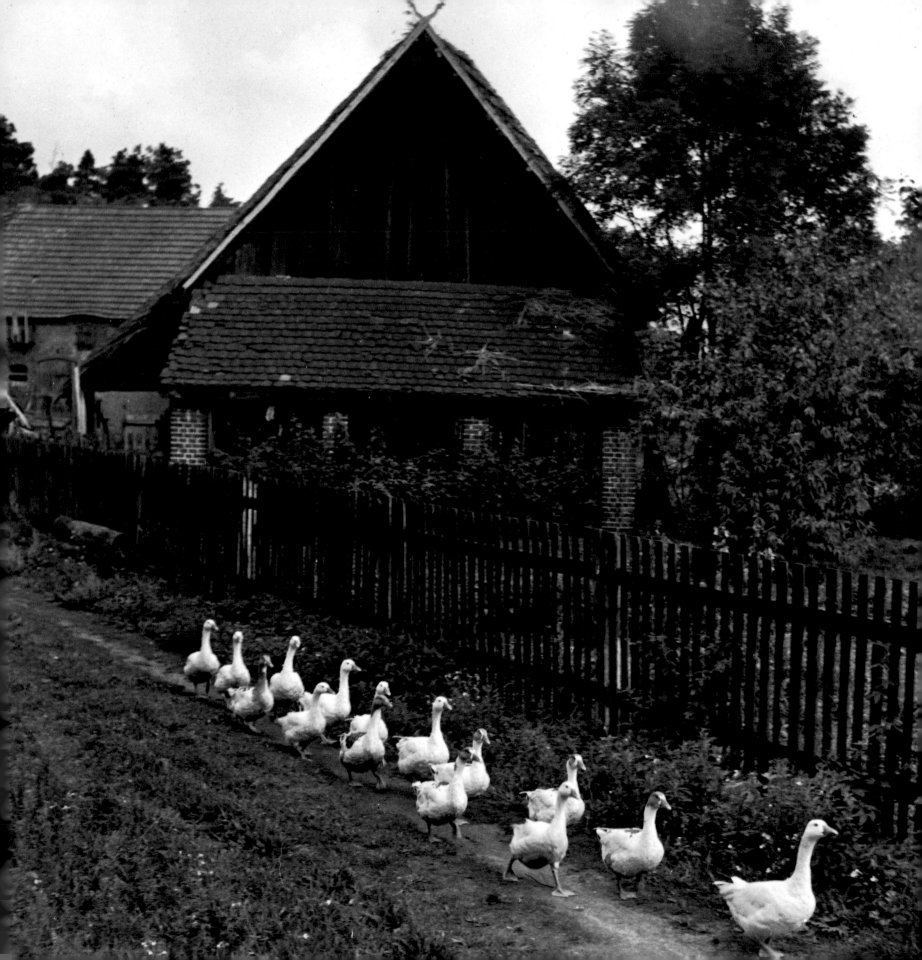

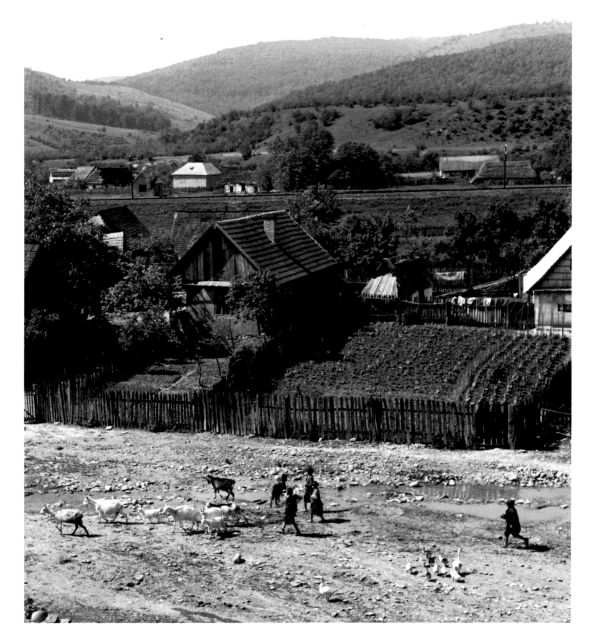

Shepherds in a village near Vrchni-Apsa.

Tilling the fields.

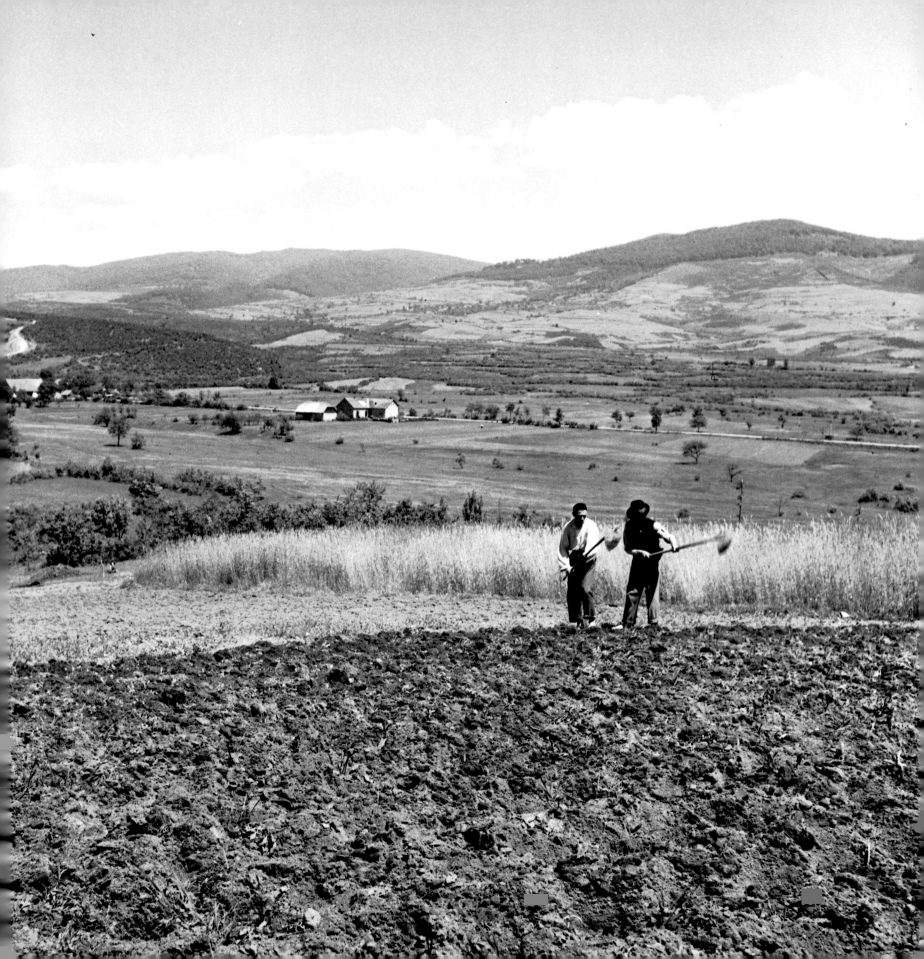

MUKACHEVO

The "capital" of Carpathian Ruthenia, Mukachevo was an important center of Hasidism and Jewish culture. Hungarian except for the period from 1919 to 1938 when it was part of Czechoslovakia, Mukachevo was annexed by the Soviet Union in 1945.

Jews first settled here in the latter half of the seventeenth century, and in 1741 the first synagogue was built. By the late 1930s, nearly half its population of 27,000 was Jewish. In April 1944, the Germans began massive deportation of Jews, and by the end of May the city was deemed *judenrein*. After World War II, Mukachevo's thirty synagogues were seized by the Soviets.

Roman Vishniac said that his Mukachevo photographs reveal "all that vanished with the destruction of the shtetl." His guide was the cantor and traveling salesman Henryk Schwartz (see pages 8 and 65), whom he had met on a train bound for Mukachevo. As Vishniac recalled, "Through the rattling of the train I heard somebody singing a beautiful religious melody. I walked to the end of the car where several Hasidim were listening, their eyes closed. I stood at the door, enthralled. At first, the Hasidim disregarded me—it was best to avoid strangers. Then, the cantor ended his song and with a smile opened the door of the compartment. . . ."

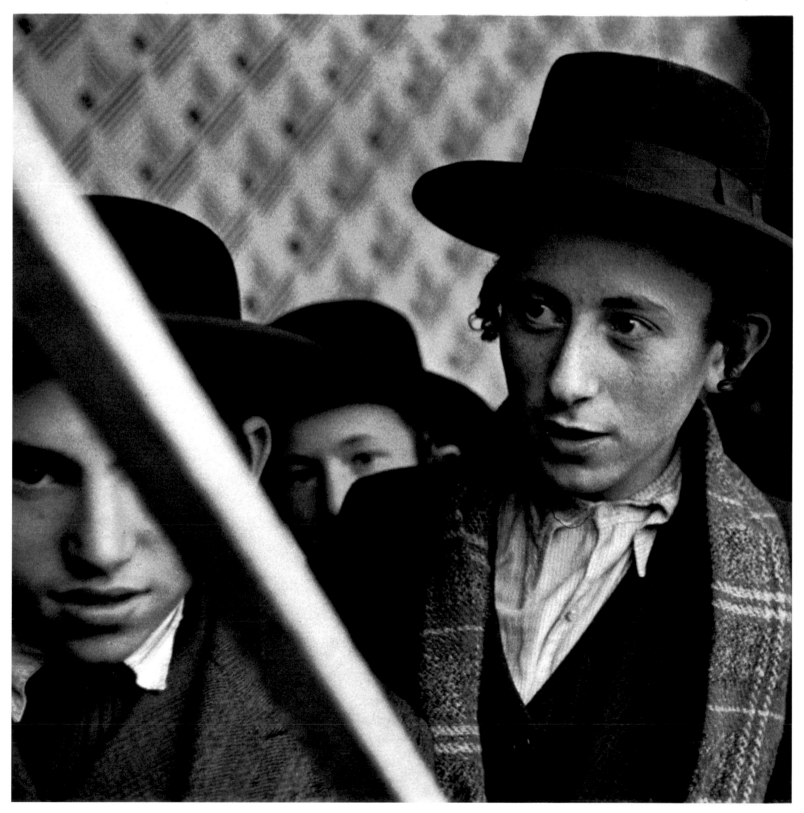

Yeshiva students.

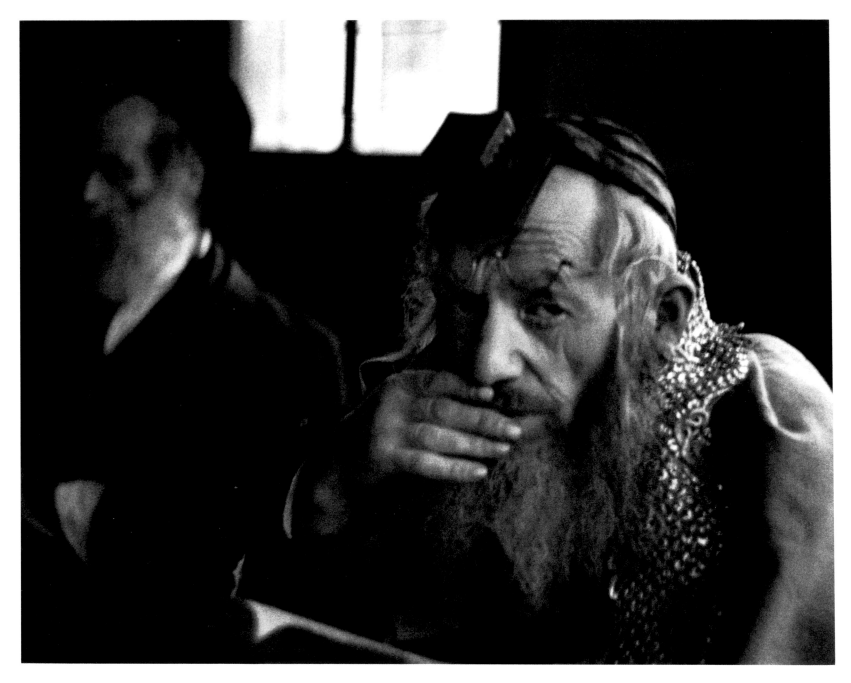

In the Bet Midrash (House of Study).

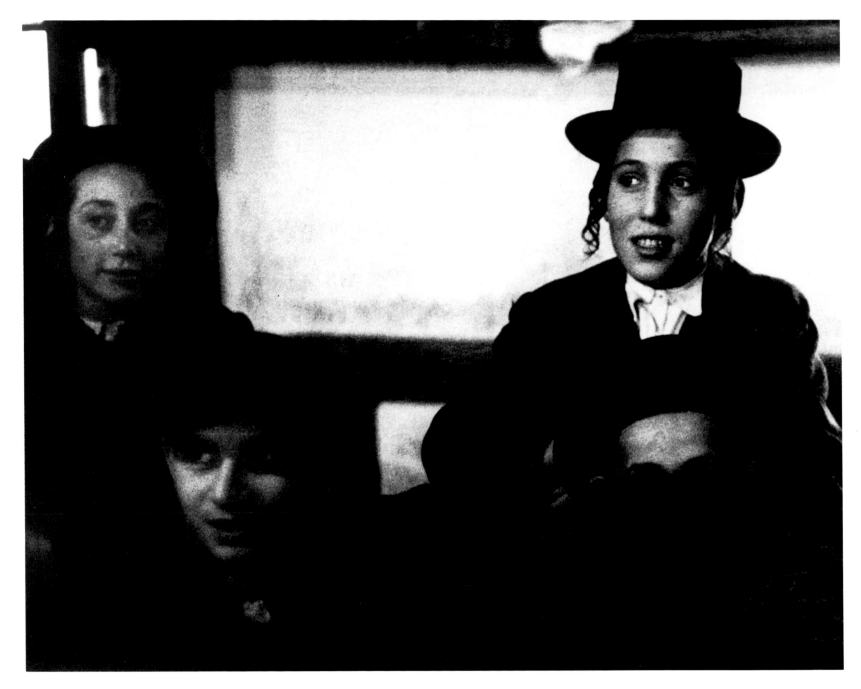

A light moment in the Yeshiva.

OVERLEAF
Two young women.

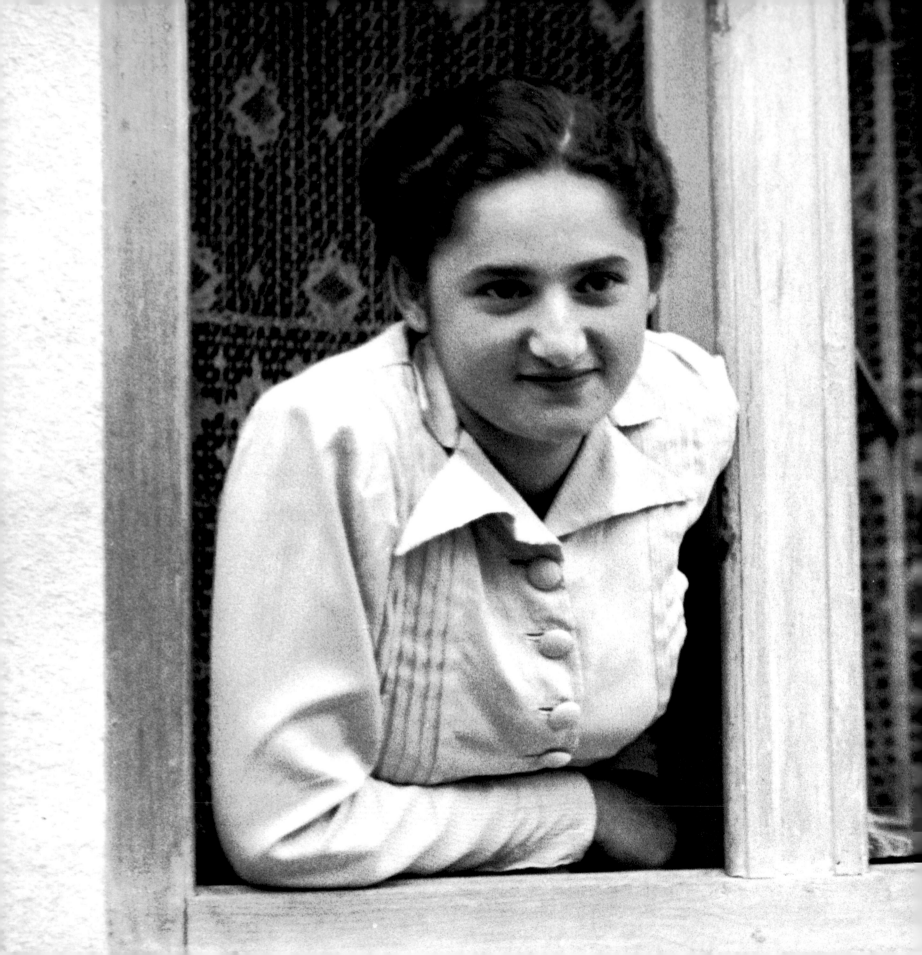

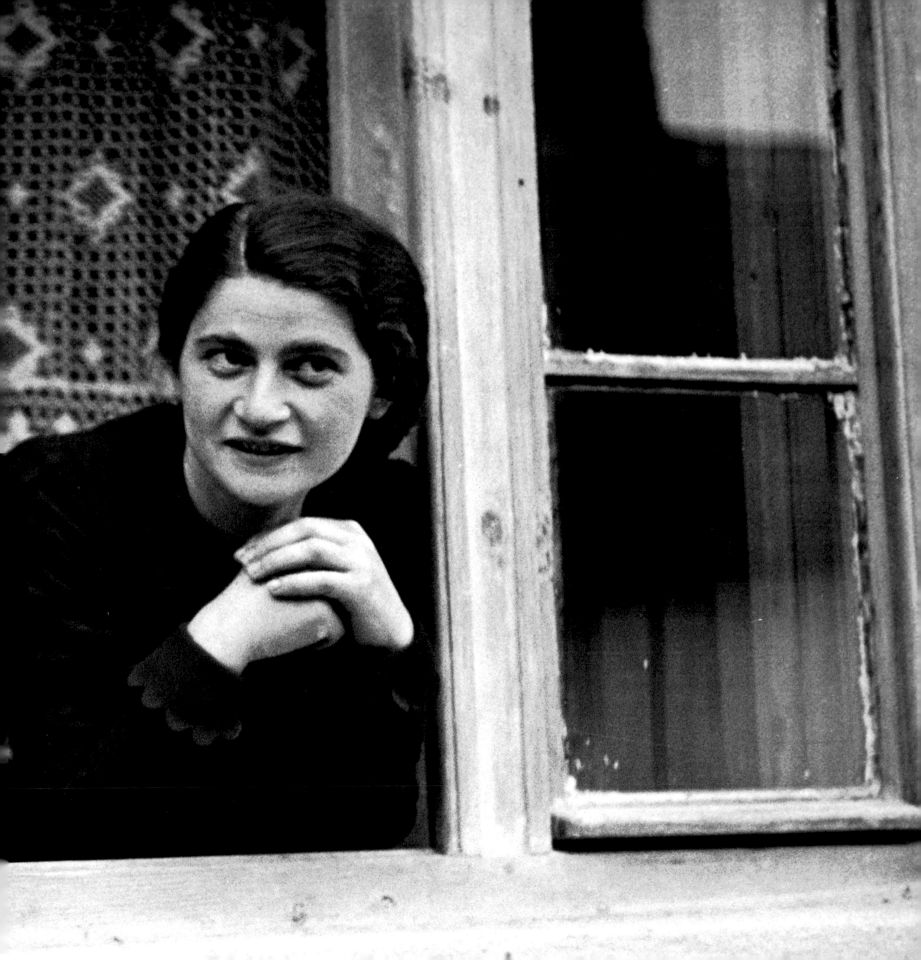

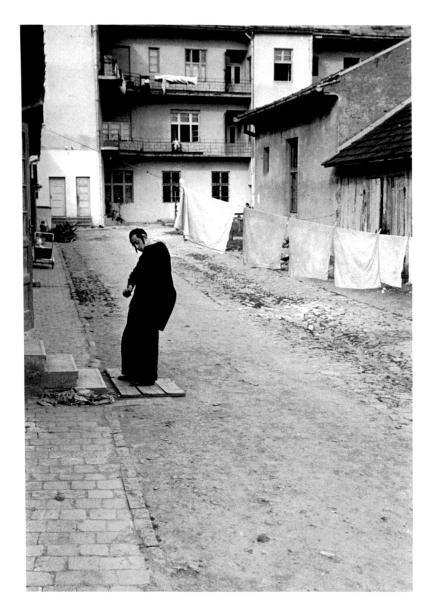

A *yeshiva student brushing his coat for shabbat.*

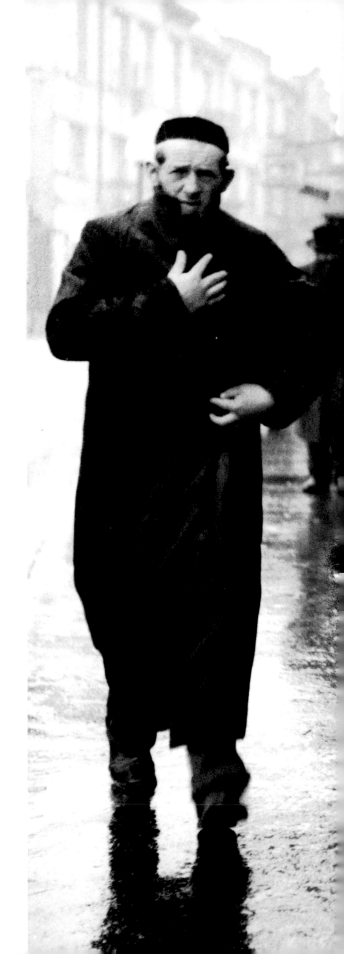

Going home for shabbat.

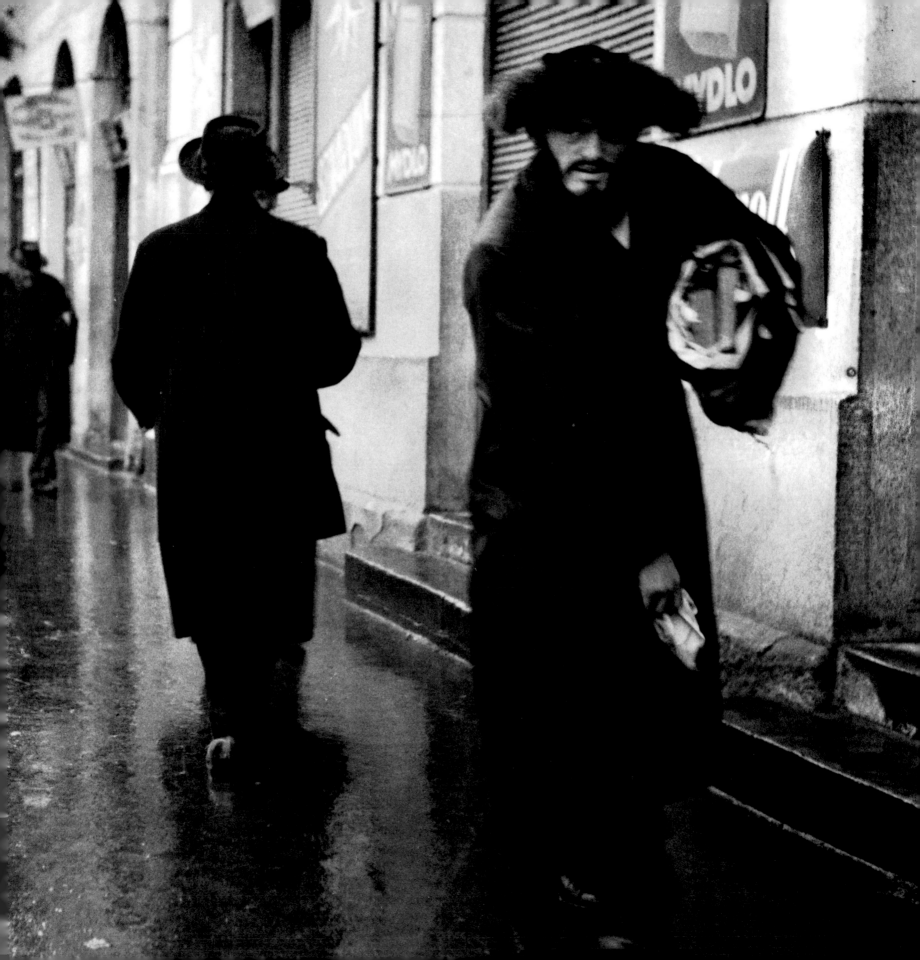

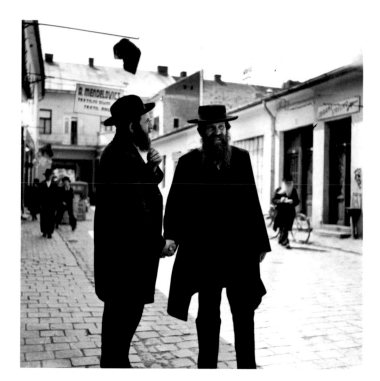

Two acquaintances.

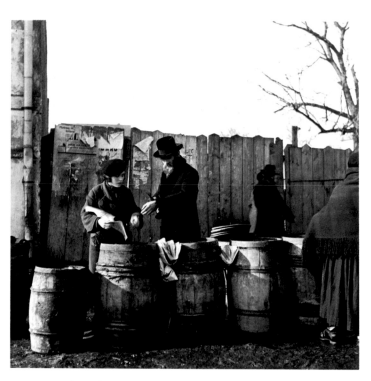

Herring for the traditional third meal of shabbat.

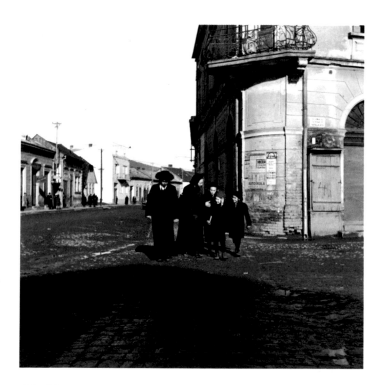

Shabbat.

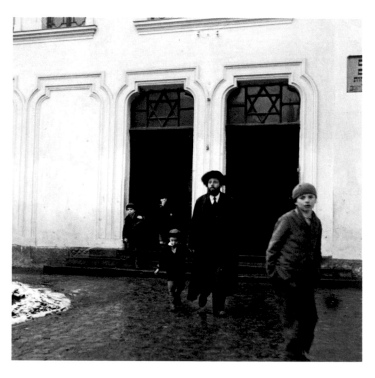

Leaving the synagogue.

After services.

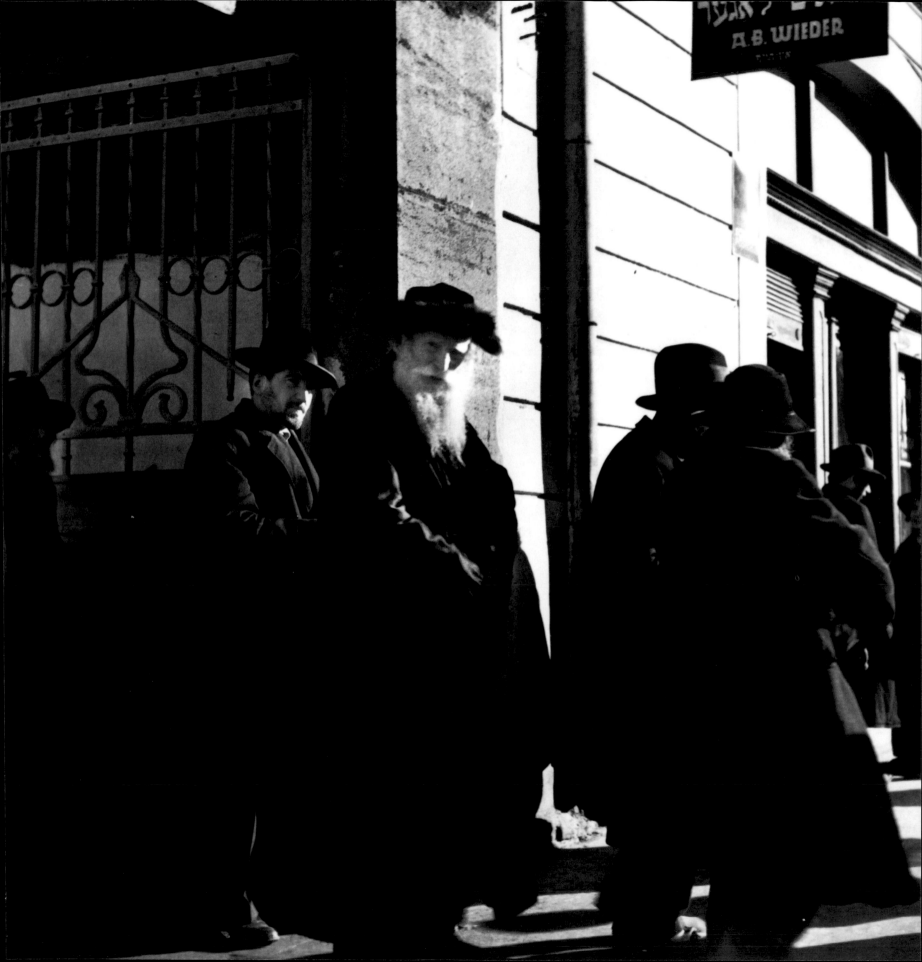

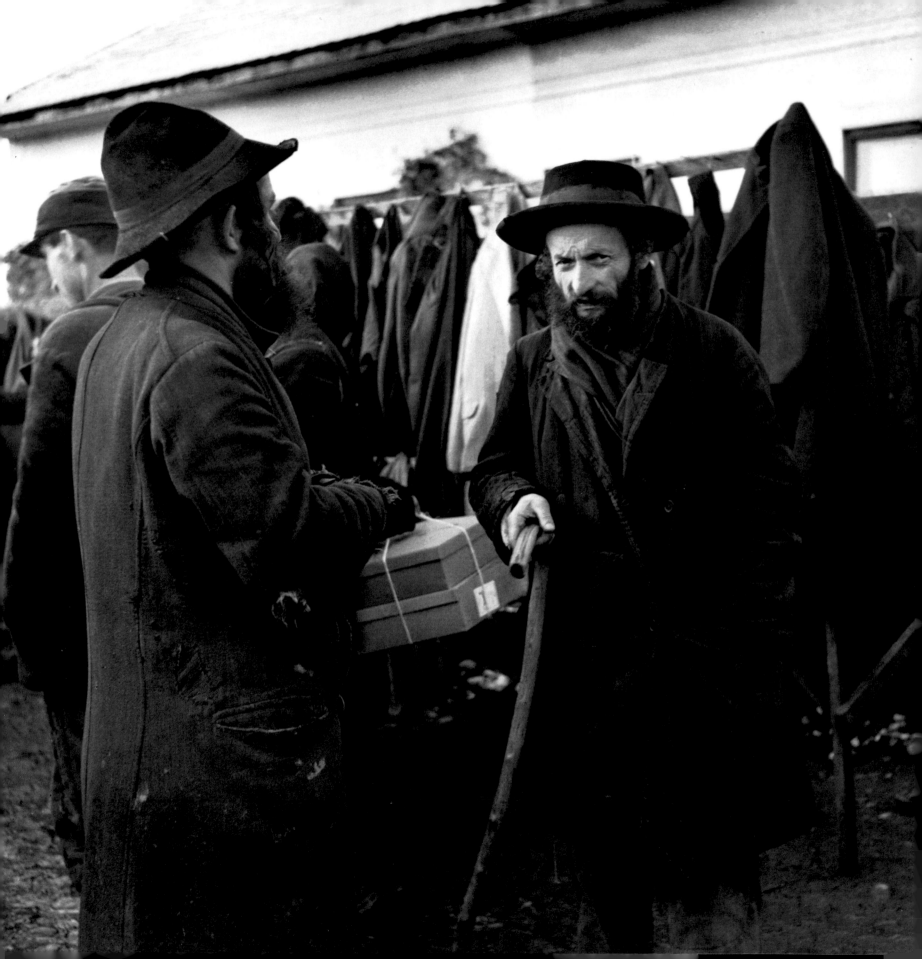

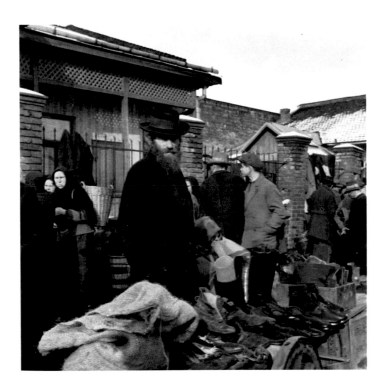

Used shoes.

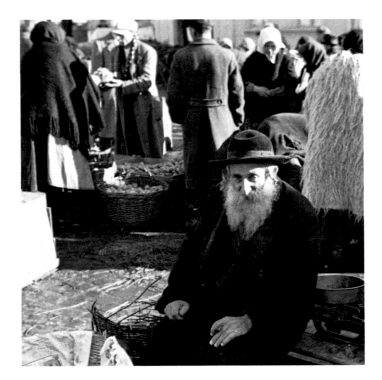

A brief respite.

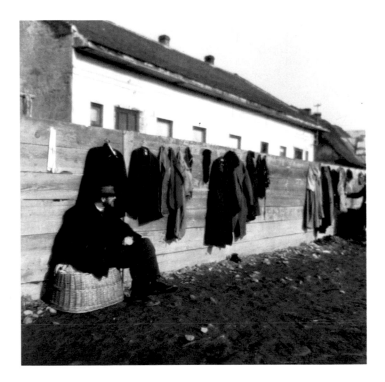

Waiting for customers.

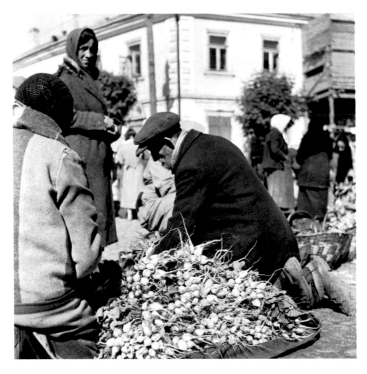

Radishes for sale.

The secondhand market.

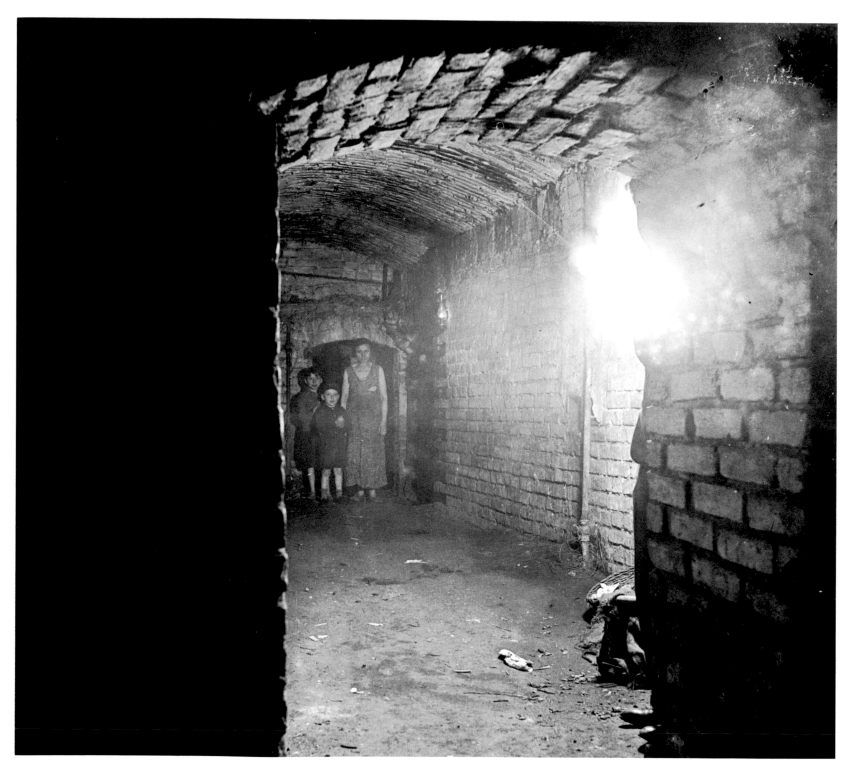

Basement dwelling.

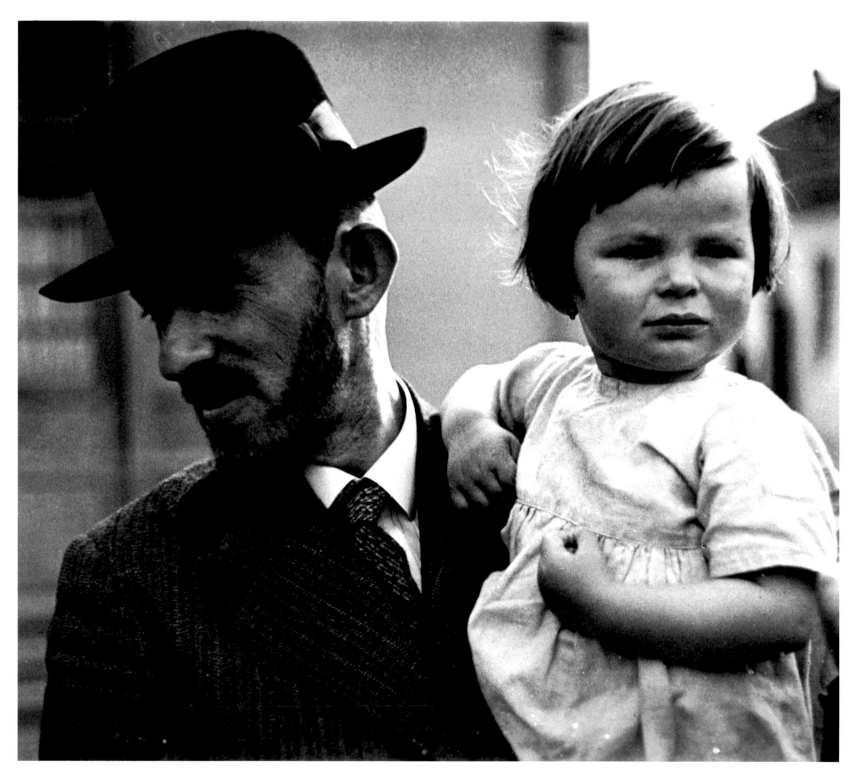

Henryk Schwartz, the cantor who became Vishniac's friend and guide, with his daughter.

WARSAW

WARSAW WAS THE PREEMINENT political, cultural, and spiritual capital of European Jewry in the years between the two world wars.

Jews began settling here in the fourteenth century and continued to be a presence—however small—even after being exiled in 1483. For the next century, it was Warsaw's "privilege" not to tolerate Jews. Not until the early sixteenth century did significant numbers of Jews filter back into the city; and it was only in 1788 that official permission to settle was granted.

By the end of the eighteenth century, the Jewish community was extremely diverse. It included Hasidim as well as *maskilim* (followers of the Jewish Enlightenment movement), German Jews, and Russian Jews. Full citizenship and voting rights were granted in 1861, and in the 1880s, with the influx of refugees fleeing the Russian pogroms, Warsaw's Jewish community became the largest in Europe.

Warsaw Jews of the late nineteenth and early twentieth centuries typically earned their living as shopkeepers, peddlers, laborers, and craftsmen, and were active in a variety of political and cultural movements ranging from assimilationism to socialism and Zionism. During these years, Warsaw became a thriving center of Hebrew and Yiddish publishing: in 1939, some eighty Jewish periodicals were available.

The Nazis occupied Warsaw on September 29, 1939, and approximately one year later the Warsaw ghetto was established. By July 1942, when mass deportations began, the ghetto contained as many as 500,000 Jews. Despite extreme deprivation, the ghetto inhabitants created an elaborate network of hospitals, orphanages, and schools. Somehow they even managed to organize concerts, lectures, and plays.

After mass deportations to Treblinka began, a Jewish resistance movement emerged, whose final act was the heroic April 19, 1943, Warsaw ghetto uprising. Approximately one month later, the resistance was defeated, and the ghetto liquidated. When Warsaw was liberated in 1945, only two hundred Jewish survivors were found.

Vishniac had special affection for the Jewish porters of Warsaw, whom he called "carriers of heavy loads." As he wrote in his journals: "They carried on their backs roughly hewn crates filled with merchandise. They pushed handcarts and pulled carriages meant for horses."

Vishniac described the complex of subterranean quarters where one porter lived: "The cellar was divided by board partitions into small compartments numbered one to twenty-six. On sunny days, five of them received some light that filtered through thick glass tiles inserted into the sidewalk. When people walked over them, the light was cut off. . . ."

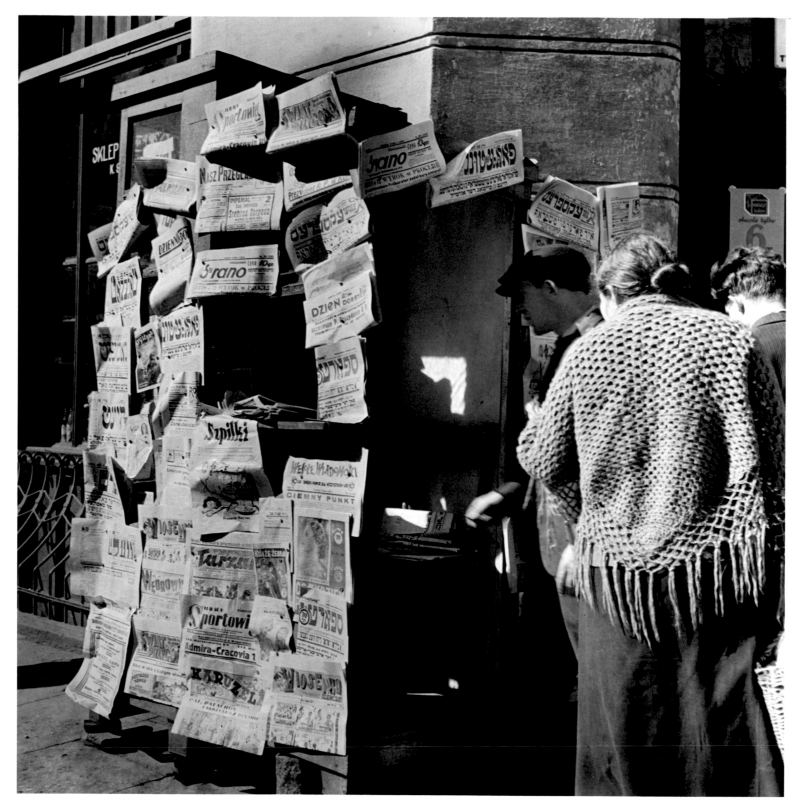

Twenty-seven Jewish dailies to choose from.

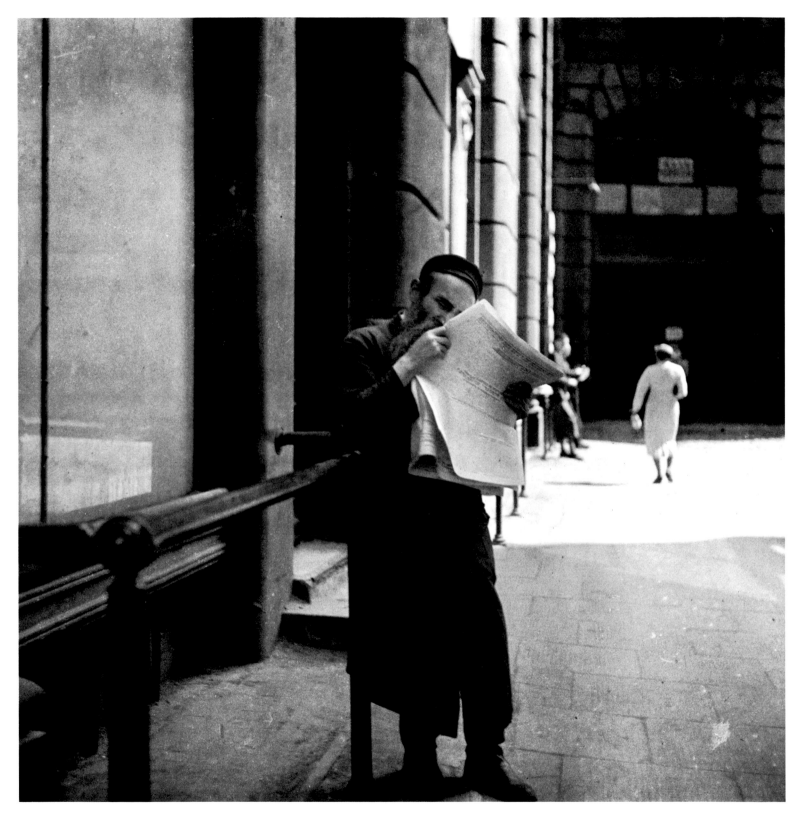

Catching up on the news.

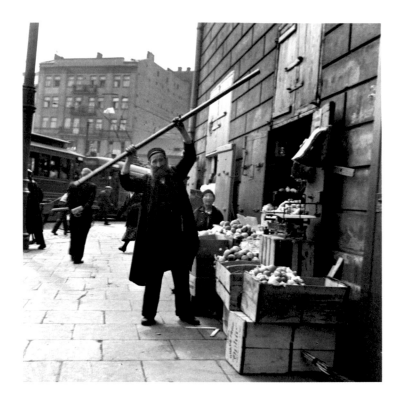

The start of a new day.

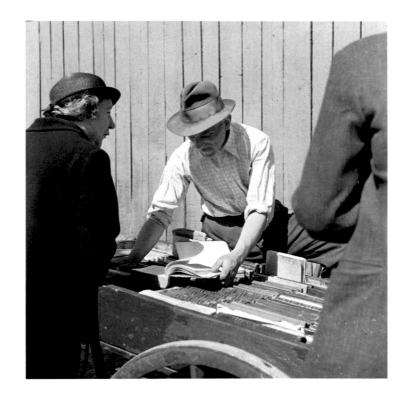

Browsing.

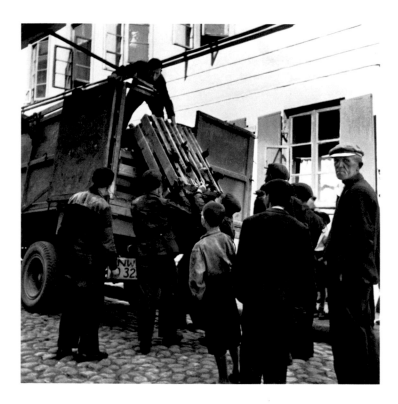

The chickens are here.

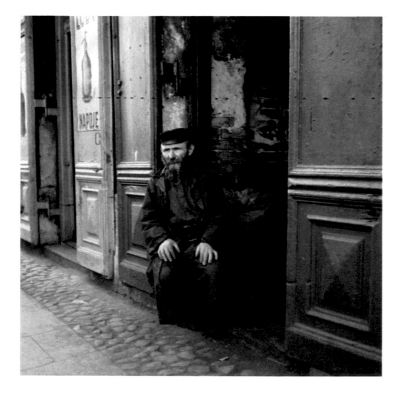

The potato vendor.

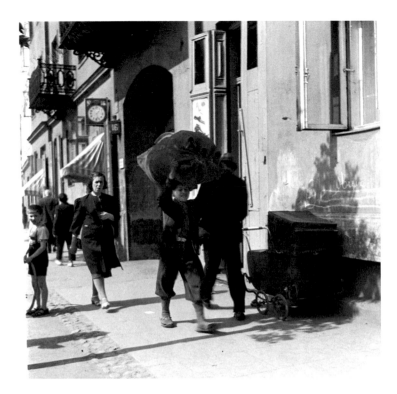

A heavy sack for a young boy.

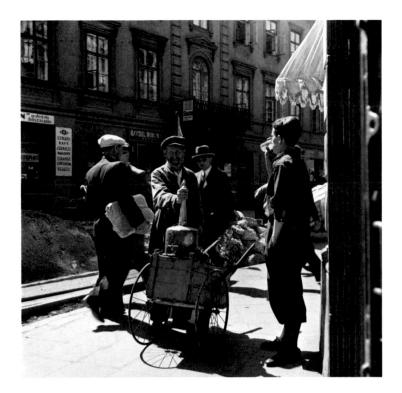

The lemonade vendor.

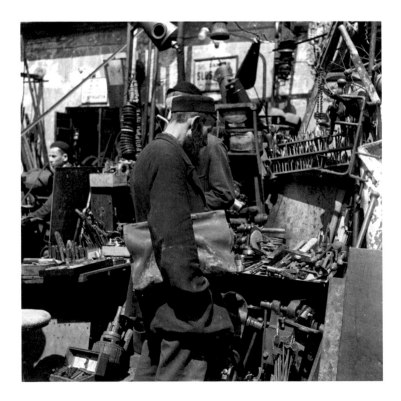

Old tools and scrap metal.

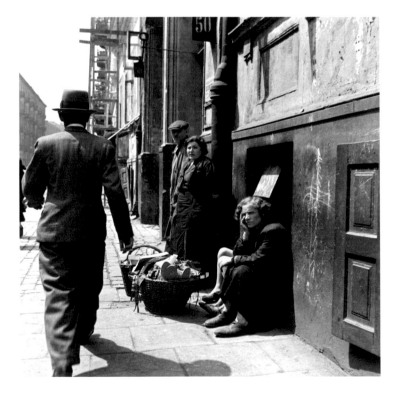

Each passerby raises hopes.

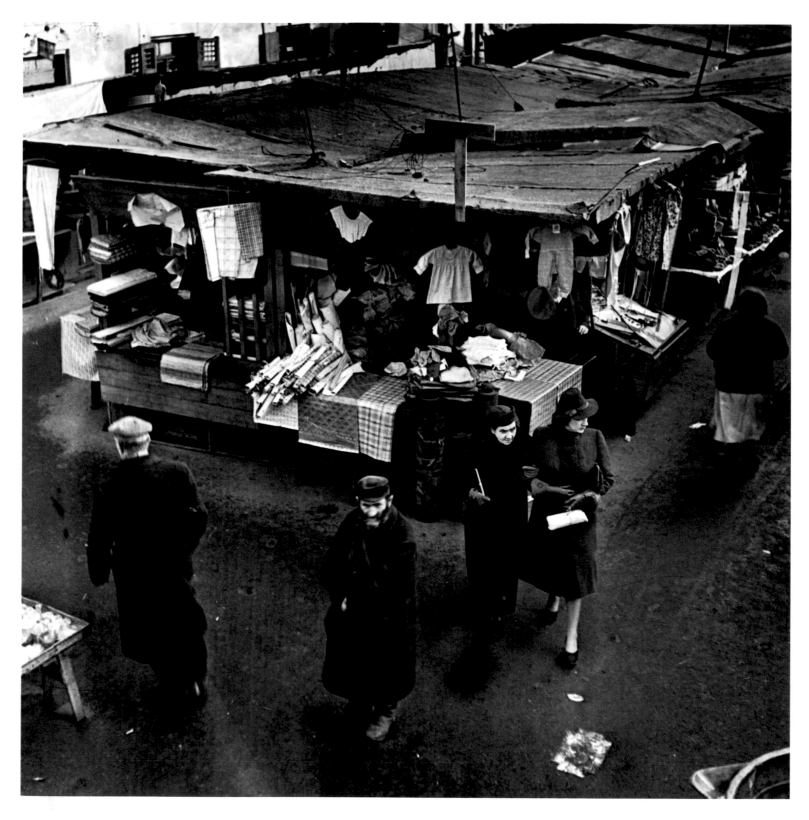

Bargains at the Karcelak market.

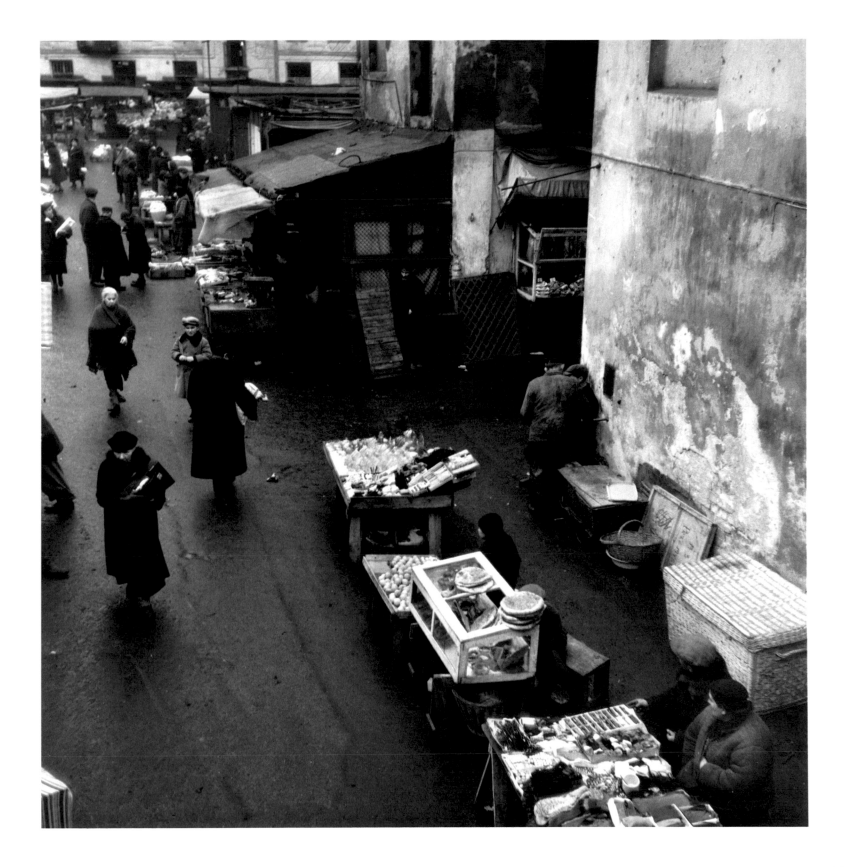

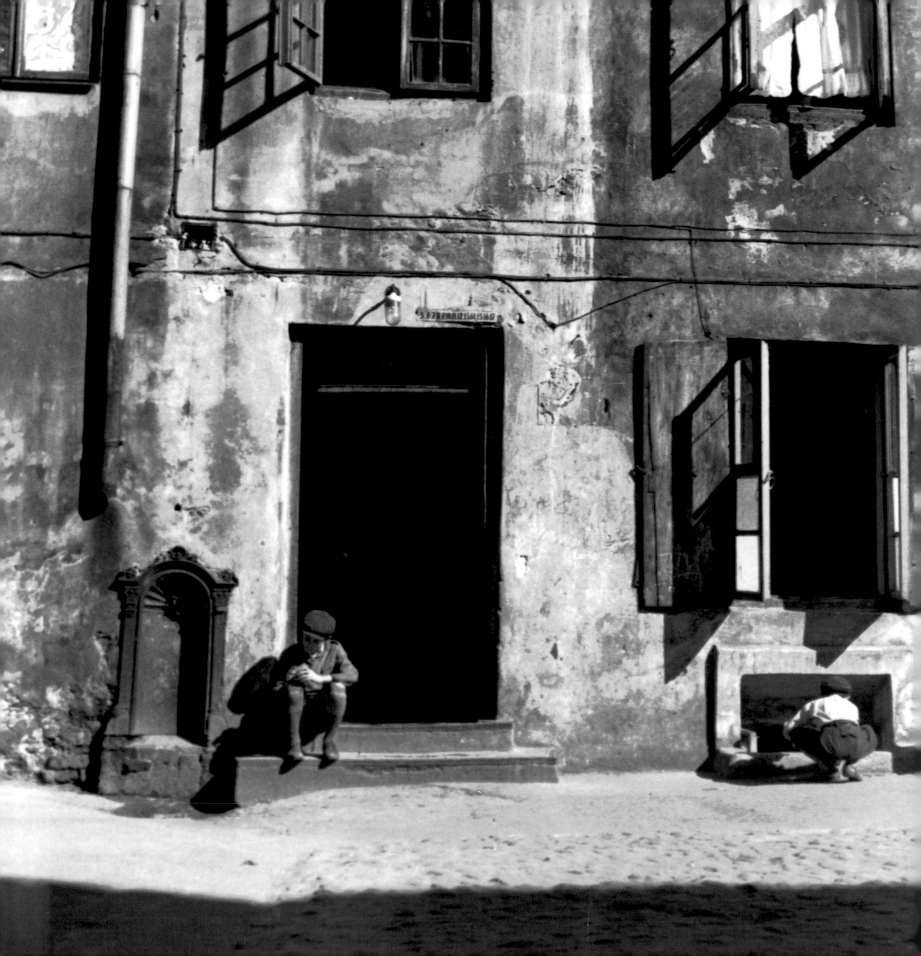

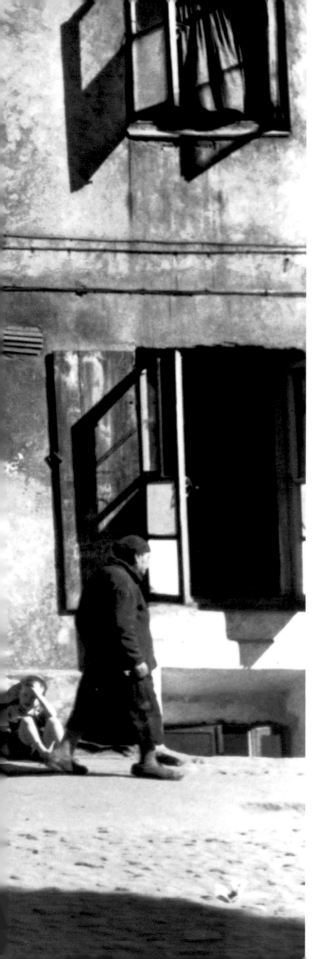

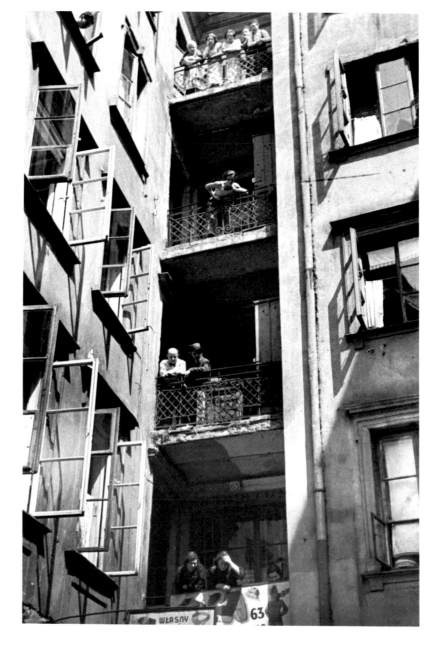

In the Nalewki Street courtyard.

Inside the Jewish quarter.

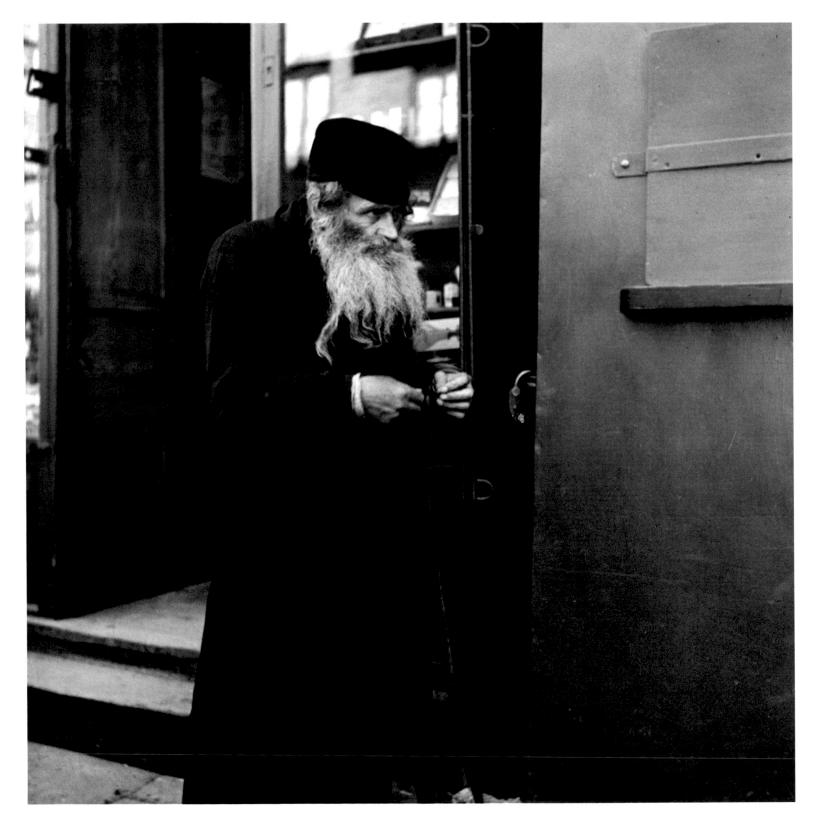

Old man of the Jewish quarter.

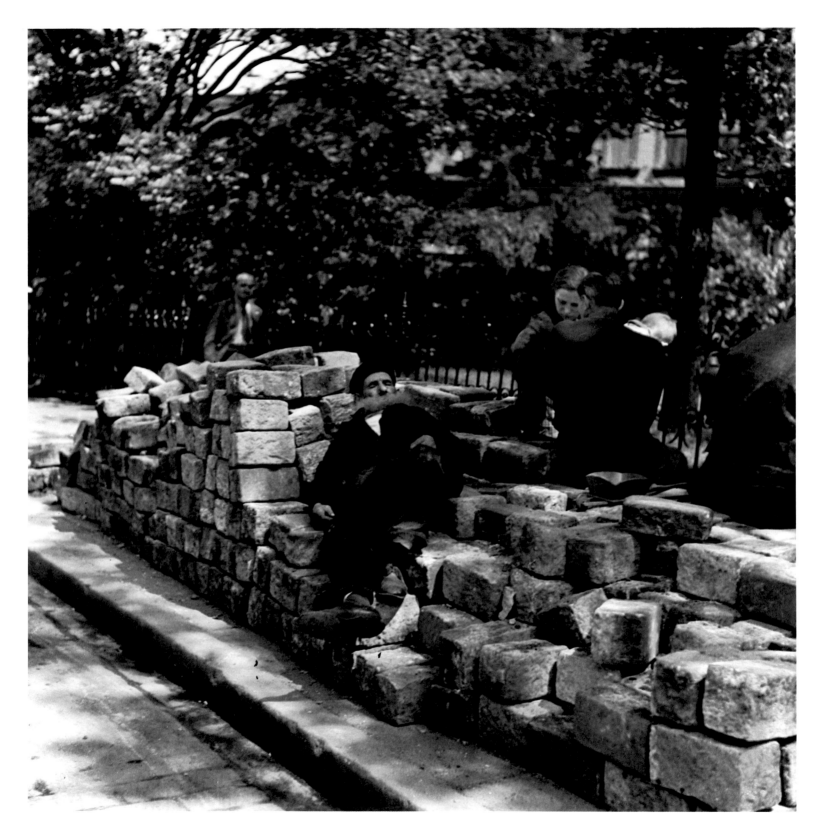

A porter resting.

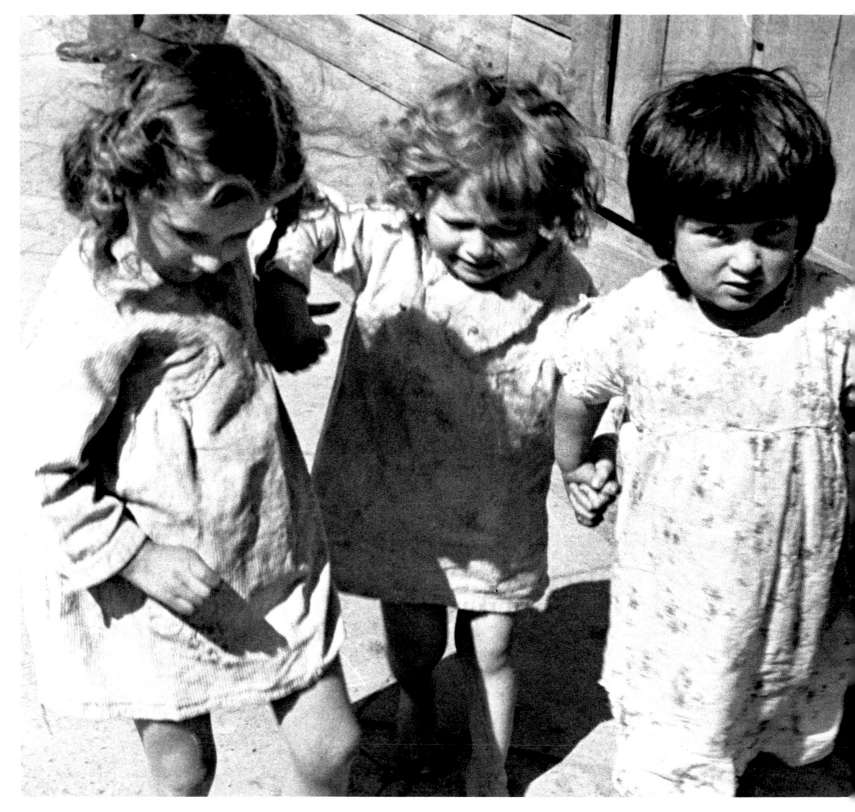

Children of the Jewish quarter.

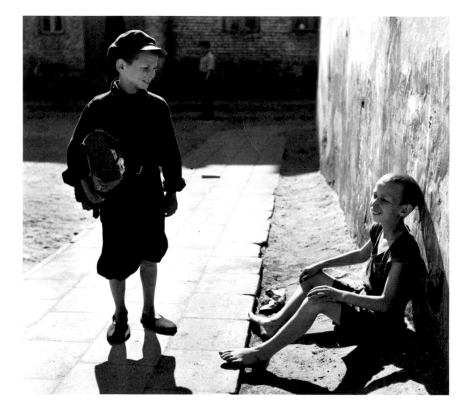

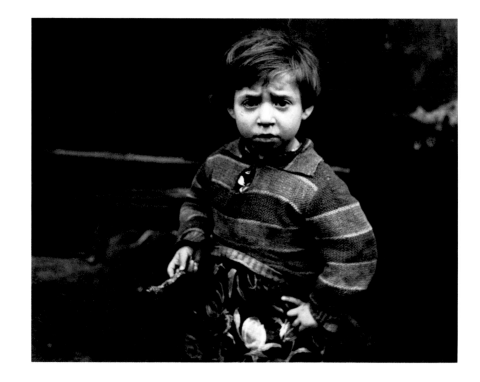

Entrance to basement dwelling; twenty-six Jewish families lived here.

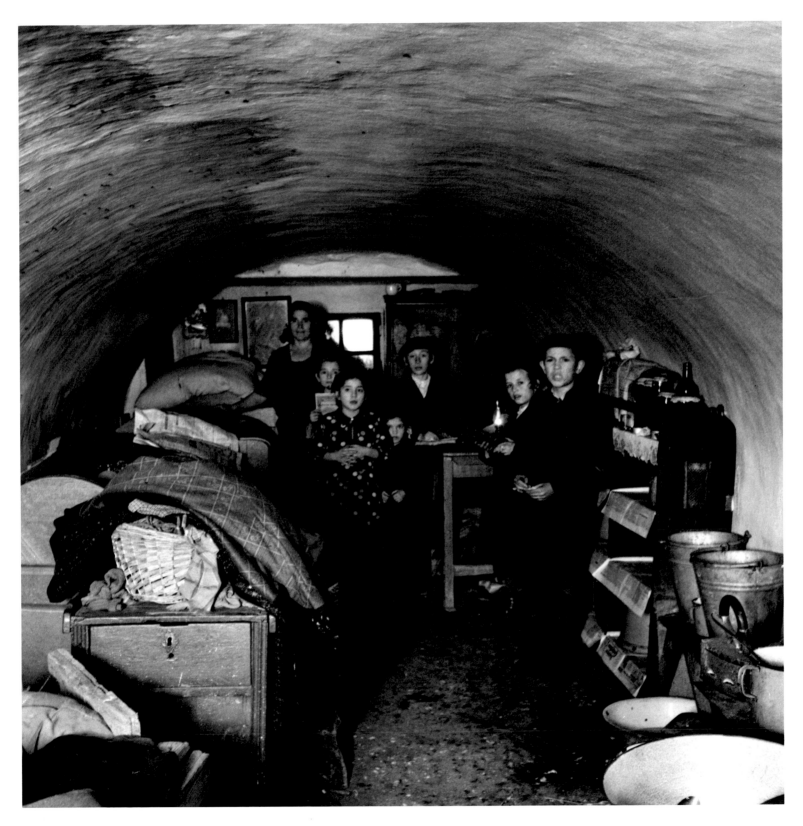

Basement home of a porter and his family.

81

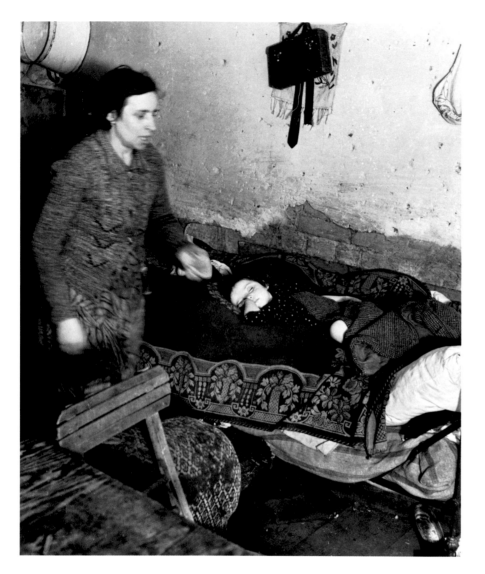

Mother and child.

Basement kitchen.

82

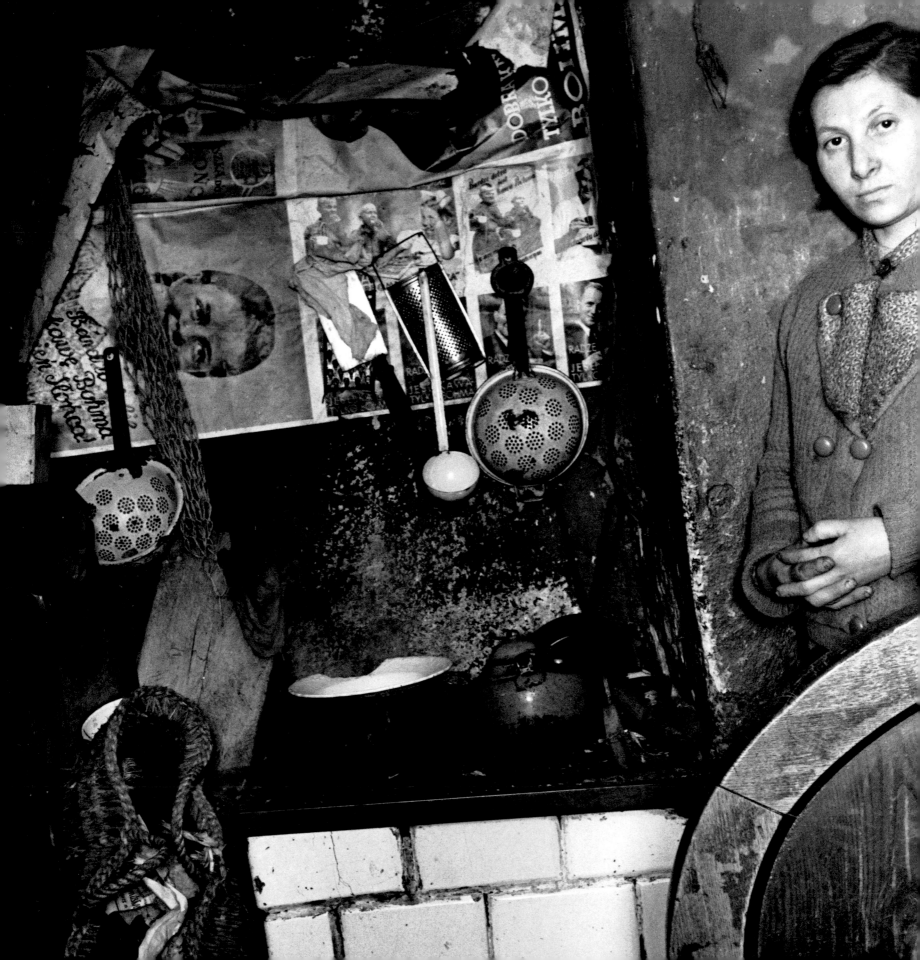

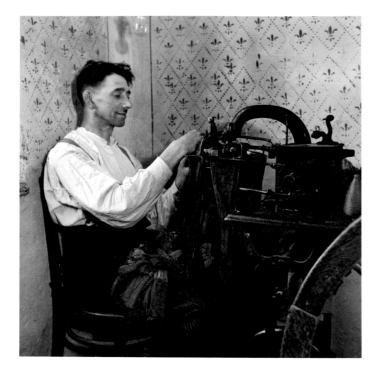

At a knitting machine.

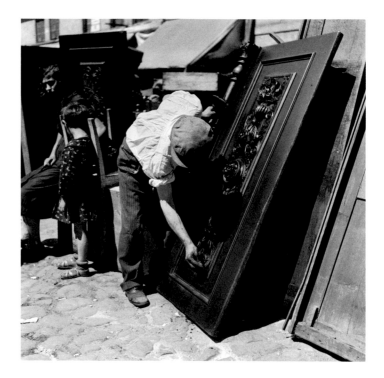

A new life for old furniture.

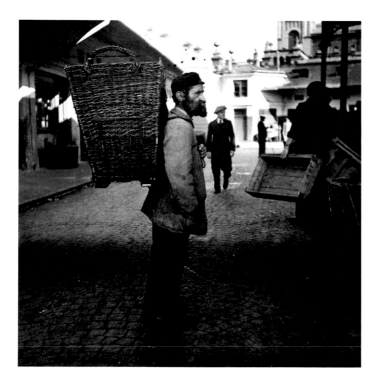

A porter.

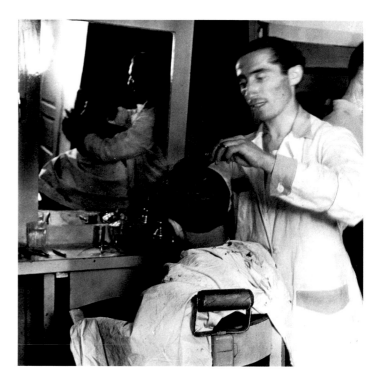

A barber.

Hosiery workshop in Grodzisk (outside Warsaw).

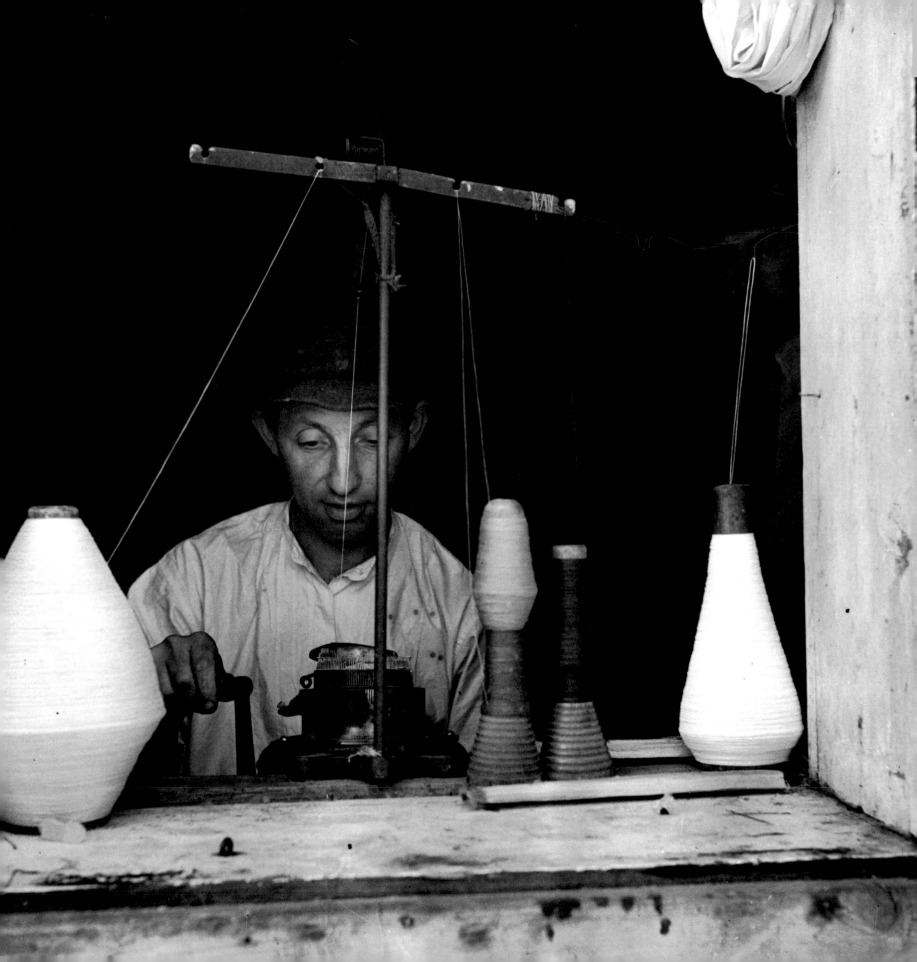

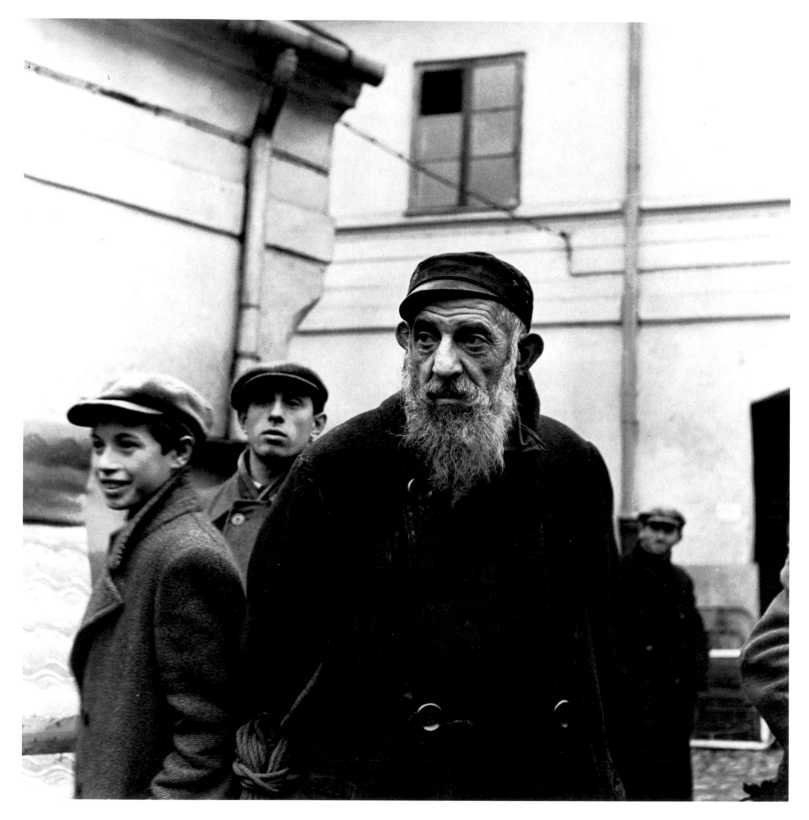

A porter waiting for work.

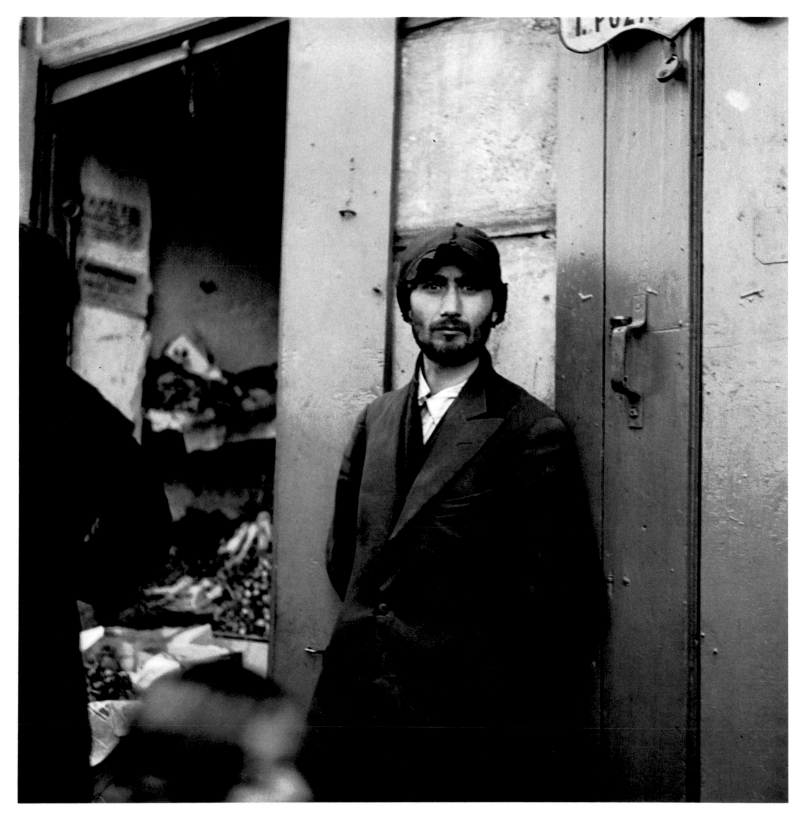

Unemployed.

LODZ

POLAND'S SECOND LARGEST CITY and its industrial capital, Lodz was known as the "Polish Manchester." From the time of its establishment in the early fifteenth century until the end of World War I, when it became part of independent Poland, Lodz alternated between Prussian and Russian rule.

In 1793, there were only eleven Jews in Lodz. By 1939, the population had grown to nearly 250,000, largely because of the city's thriving textile industry. Despite official restrictions, Jews lived throughout Lodz but tended to settle in the Old City, the Baluty quarter, and the neighboring towns of Pabianice and Lask.

In addition to working in the textile industry, Jews were merchants, brokers, and craftsmen. Though Lodz was more provincial than Warsaw or Vilna, it was an important center of Jewish labor activity, and many Jewish schools, newspapers, theaters, and charitable institutions flourished.

The Nazis entered the city during the first days of World War II. By early 1940, some 160,000 Jews had been isolated in the ghetto, and by May 1 it was officially sealed and placed under the authority of the *Judenrat*, headed by Chaim Mordechai Rumkowski. Run as an immense labor camp that produced a wide variety of goods, especially military uniforms and other war-related items, the ghetto continued to function even after mass deportations to Chelmno death camp began. Final liquidation did not commence until mid-1944, with further transports to Chelmno and, later, Auschwitz. When Lodz was liberated in January 1945, fewer than 900 Jews remained.

During his passage through Lodz in the late 1930s, Vishniac photographed many children. Just a few years later, in October 1941, the literary critic Oskar Rosenfeld wrote in his Lodz journal: "Gangs of scruffy children, their yellow, wrinkled faces, looking aged, walked wearily through the streets. Sometimes one sees a fleeting smile on their faces, hears singing from their bloodless lips. Sometimes they throw a snowball like children elsewhere. No one can say what will happen tomorrow. . . ."

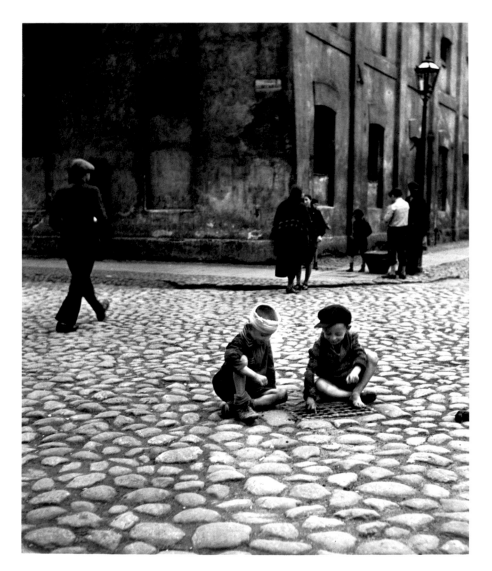

Children of the Baluty quarter.

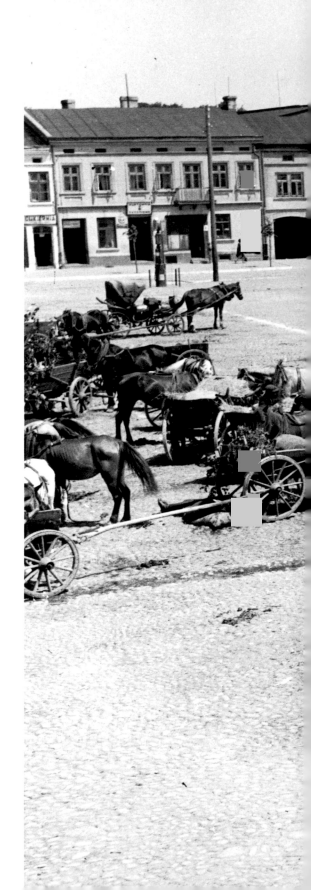

Early morning at the market in Lask

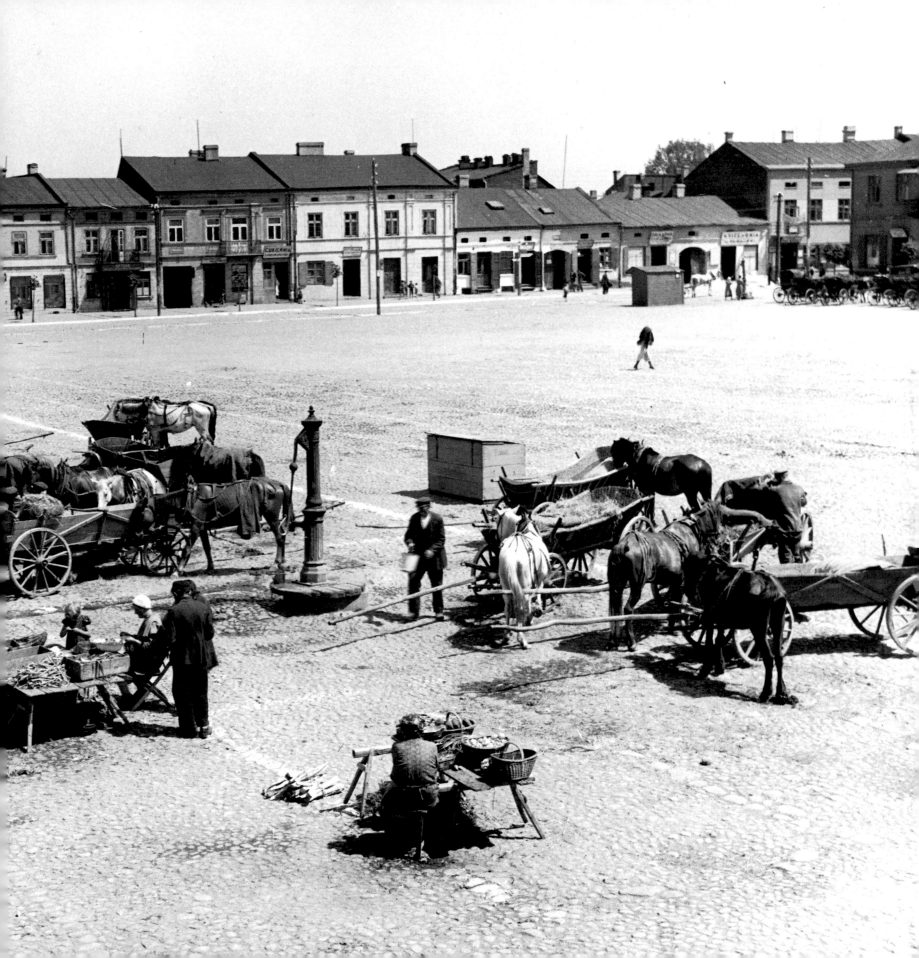

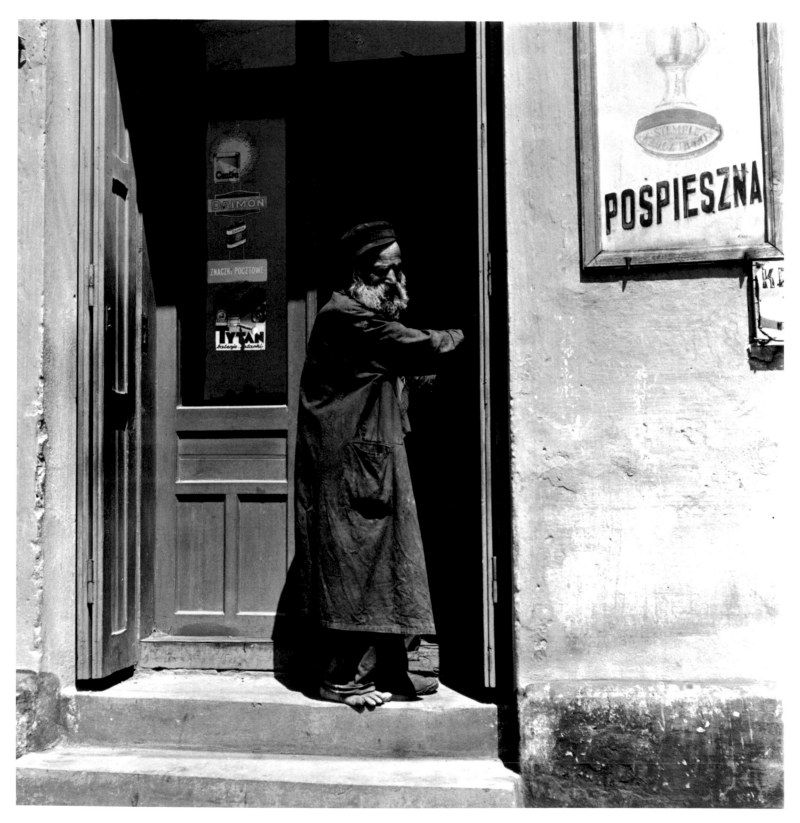

A Jewish printing shop . . .

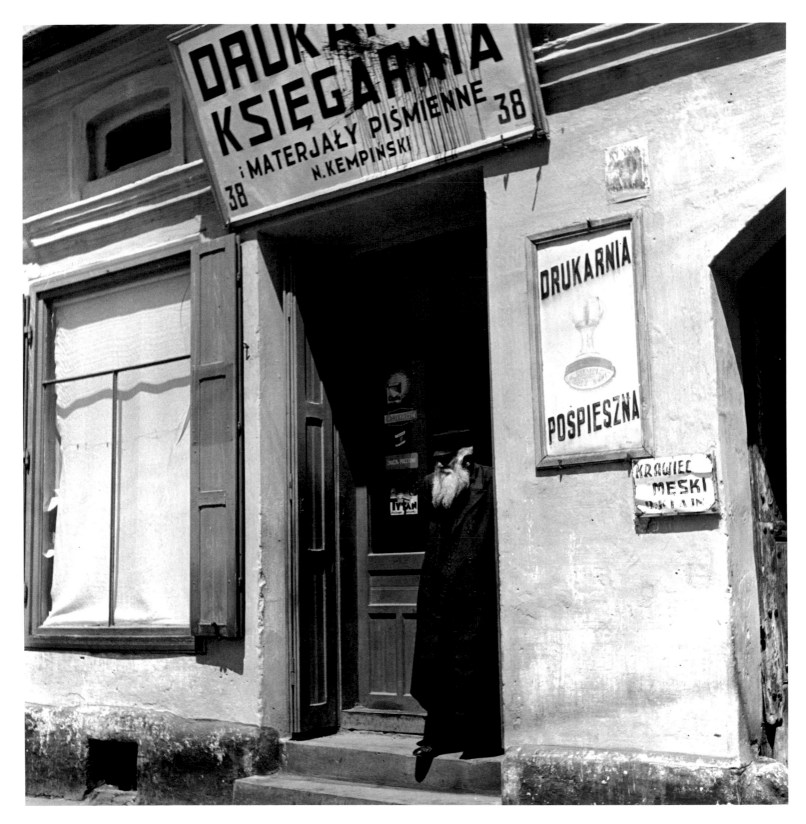

. . . its sign defaced by vandals.

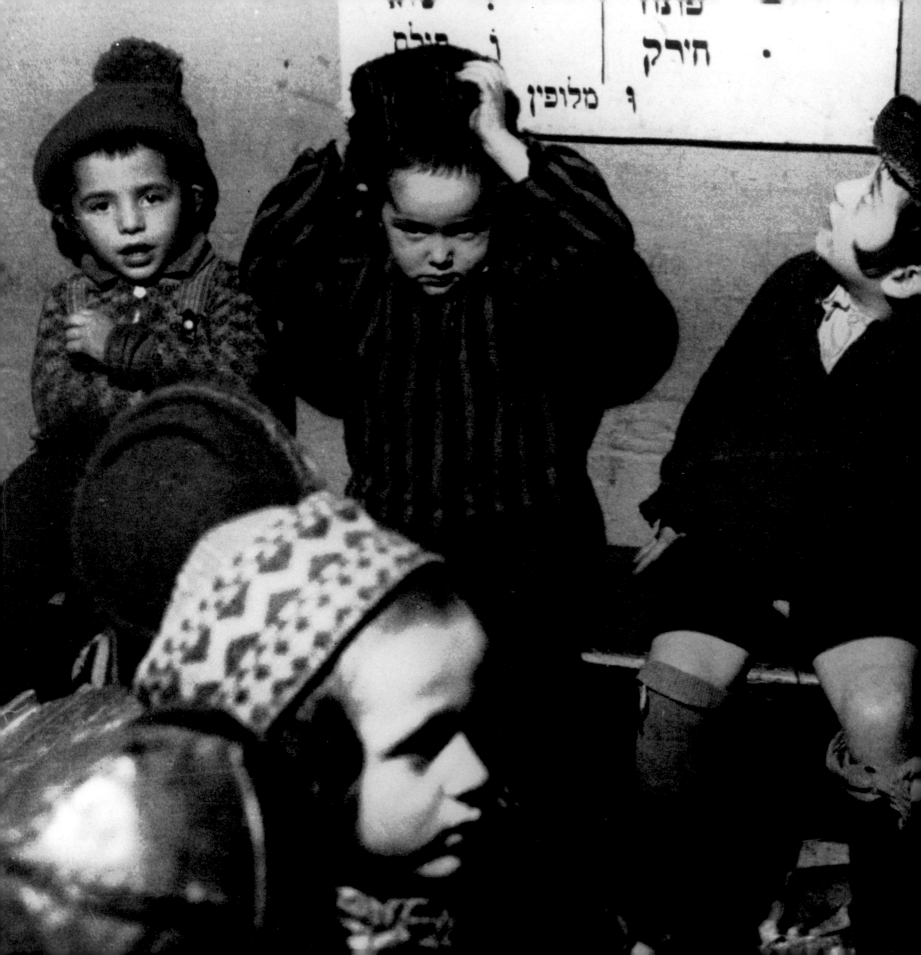

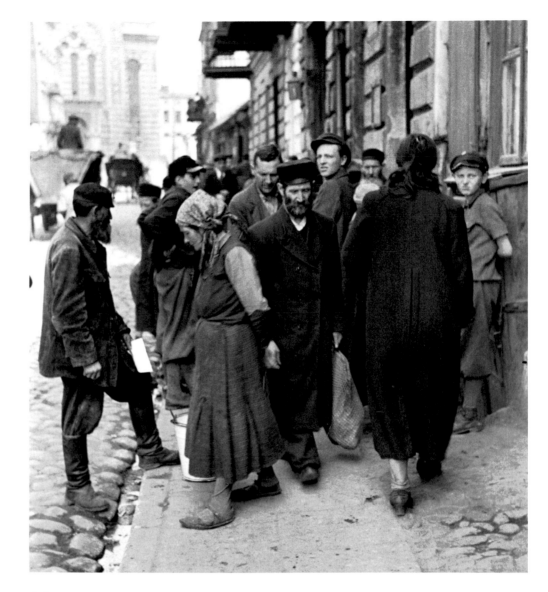

A busy street.

Children in cheder.

A *ceremonial circumcision chair in the Lask Synagogue.*

Altar of the Lask Synagogue.

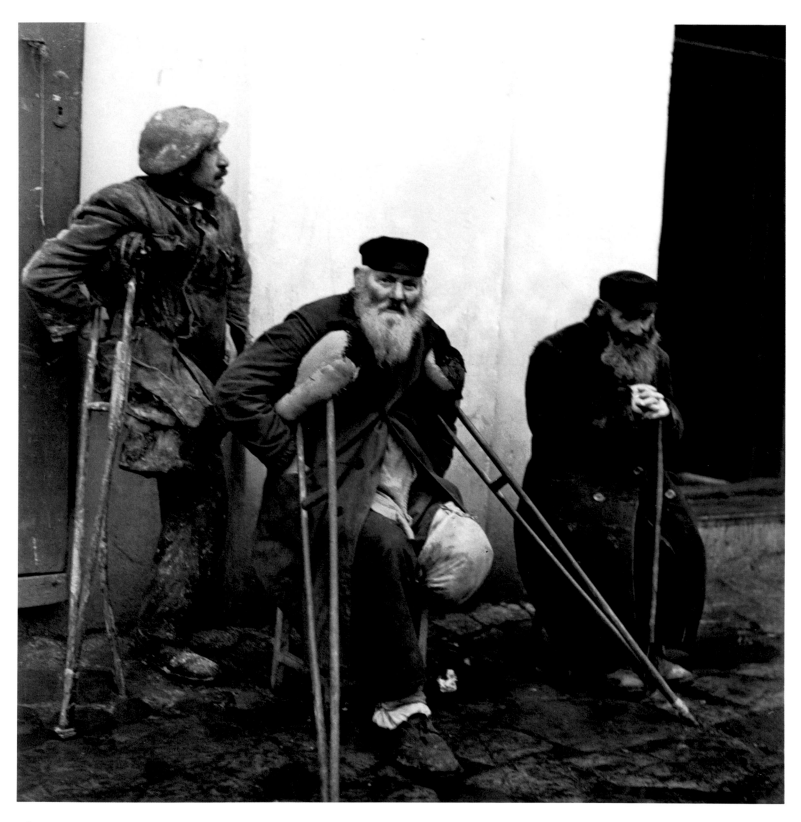

Three veterans.

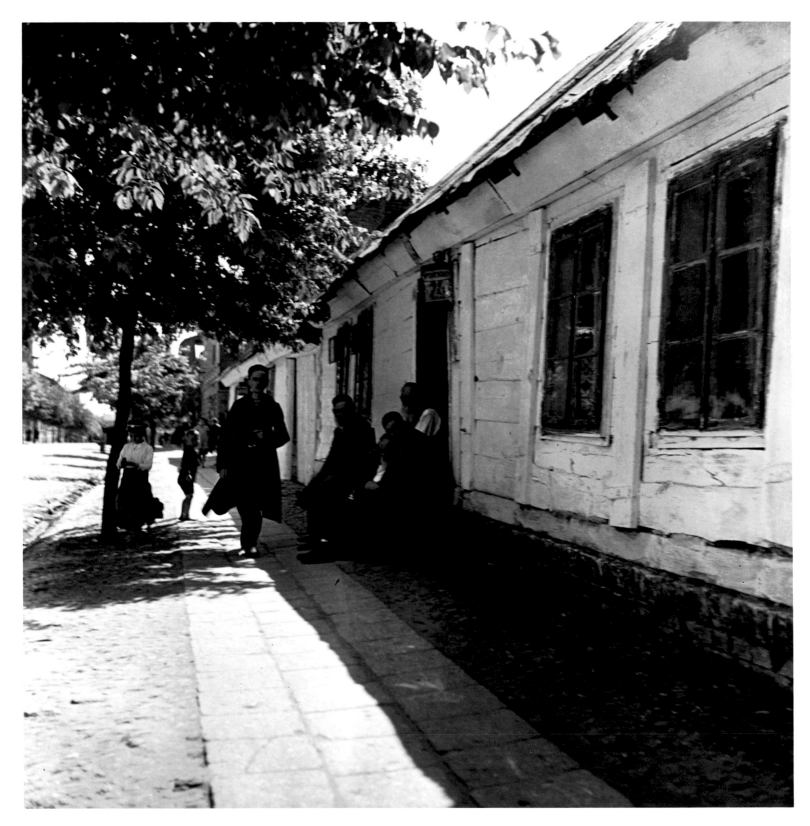

Early afternoon in Pabianice, near Lodz.

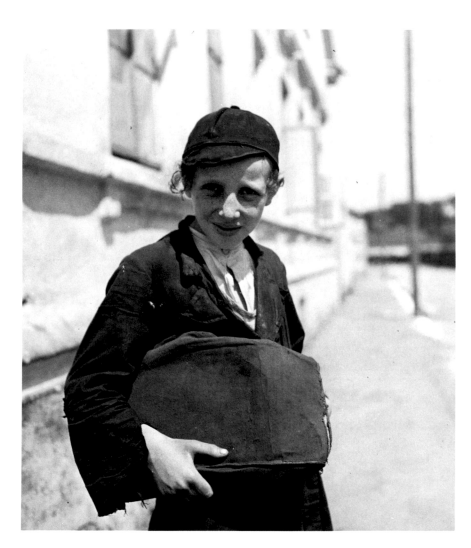

A boy clutching his satchel. Pabianice

Children of the Baluty quarter.

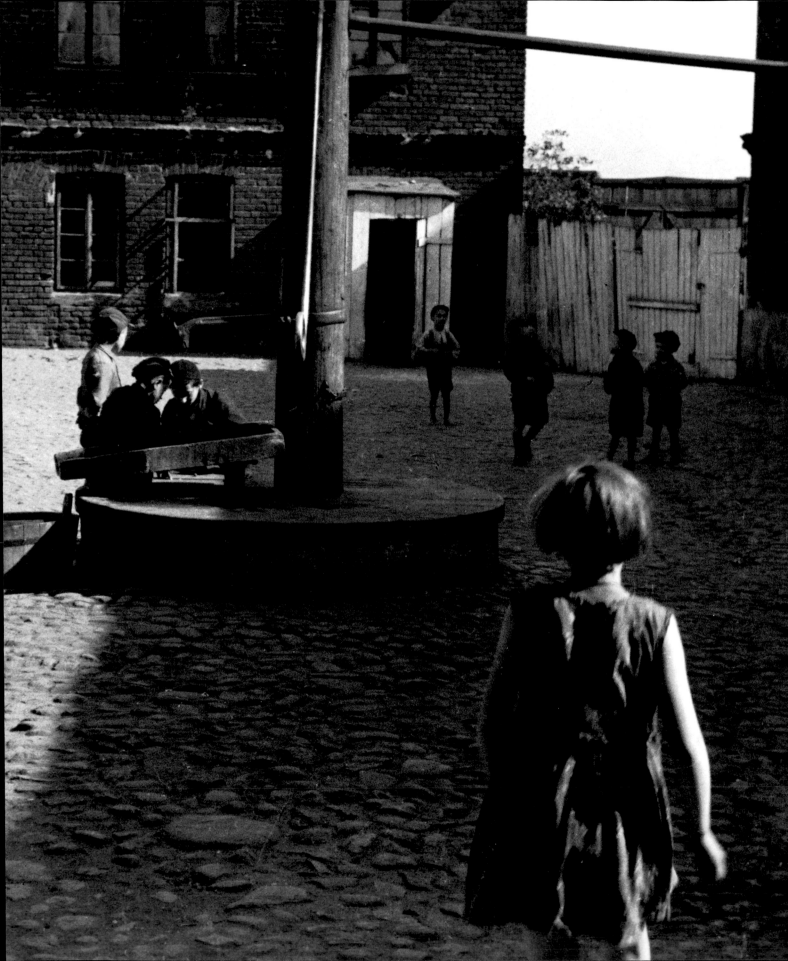

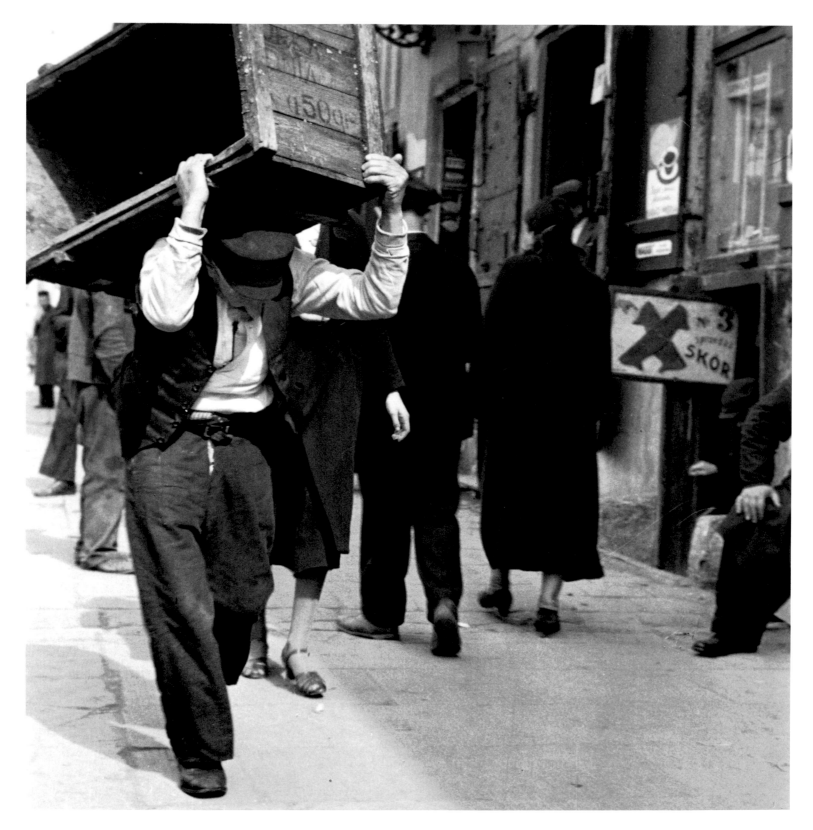

A porter.

102

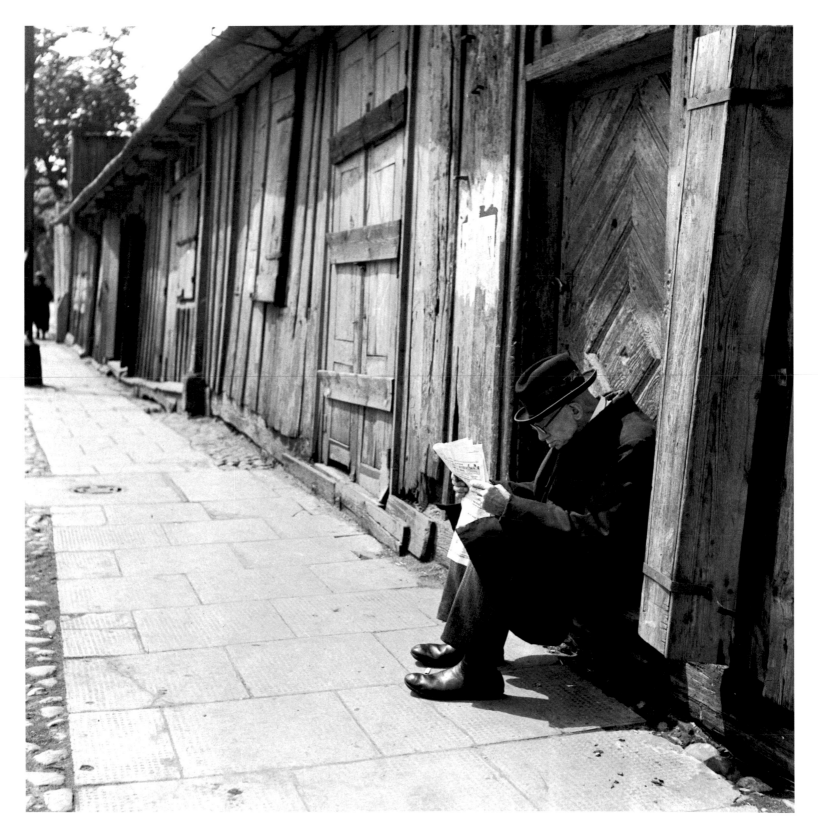

A quiet spot in Pabianice.

103

LUBLIN

FOUNDED IN THE THIRTEENTH CENTURY, Lublin is one of the oldest cities in Poland, and was, from the perspective of Polish Jewry, one of the most important.

In the fourteenth and early fifteenth centuries, Jews were restricted to the nearby village of Piaski Zydowskie (Jewish Sands); and from 1761 to 1863 they were banished from the city to which they had only been admitted in 1523. Still, the Jewish community of Lublin grew to prominence.

In the mid-sixteenth century, a distinguished Hebrew printing press was founded in Lublin; and in the sixteenth and seventeenth centuries, the Jewish community prided itself on its many great rabbis and noted physicians. In the latter part of the nineteenth century, Lublin played a key role in the developing Hasidic movement. The "Seer of Lublin," one of Hasidism's most luminous and revered Tzaddikim, drew disciples from all over Europe.

Throughout the nineteenth century, there was a dramatic expansion of commerce and industry in the city due to the opening of Russian markets. An active Jewish labor movement followed.

The Germans took Lublin on September 18, 1939, and on April 24, 1941, its ghetto was sealed with approximately 35,000 Jews within. Massive deportations began in March 1942, mostly to Belzec and, toward the end, to Majdanek. When Lublin was liberated on July 24, 1944, there were no Jewish survivors left in the city.

Roman Vishniac arrived in Lublin in 1938. "I walked the streets of the Old City," he wrote. "The ghetto had obviously changed little since medieval times. I watched the Jewish women peddling at the ancient city wall, and I was certain they had stood there for hundreds of years."

Vishniac described Hakhmei Lublin, which was considered one of the great modern yeshivas of Europe: "The new yeshiva was opened in 1930, with six stories and one hundred and twenty rooms, but darkness prevailed in the classrooms. During daytime, twilight reigned; at dusk a little candle burned. I could see the entranced young faces looking beyond earthly existence. . . ."

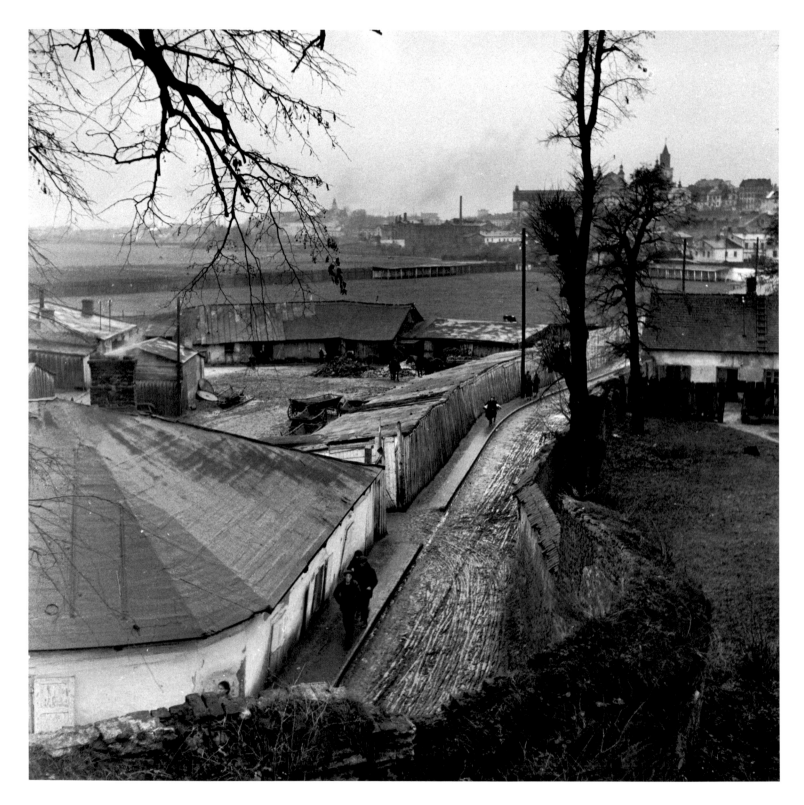

View of the city from the old cemetery.

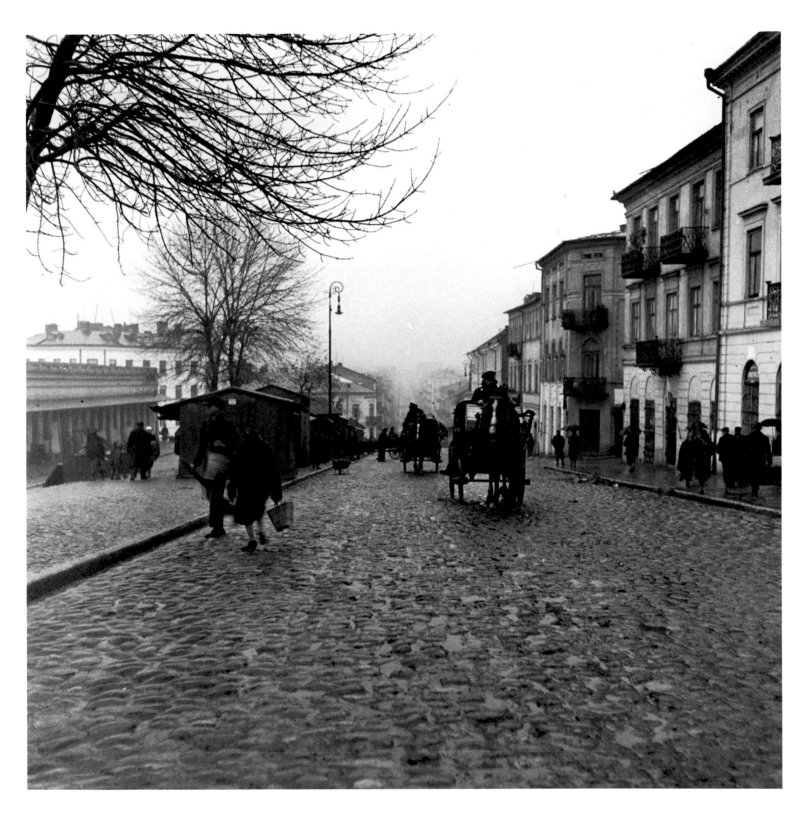

A rainy day.

OVERLEAF
A busy thoroughfare. 107

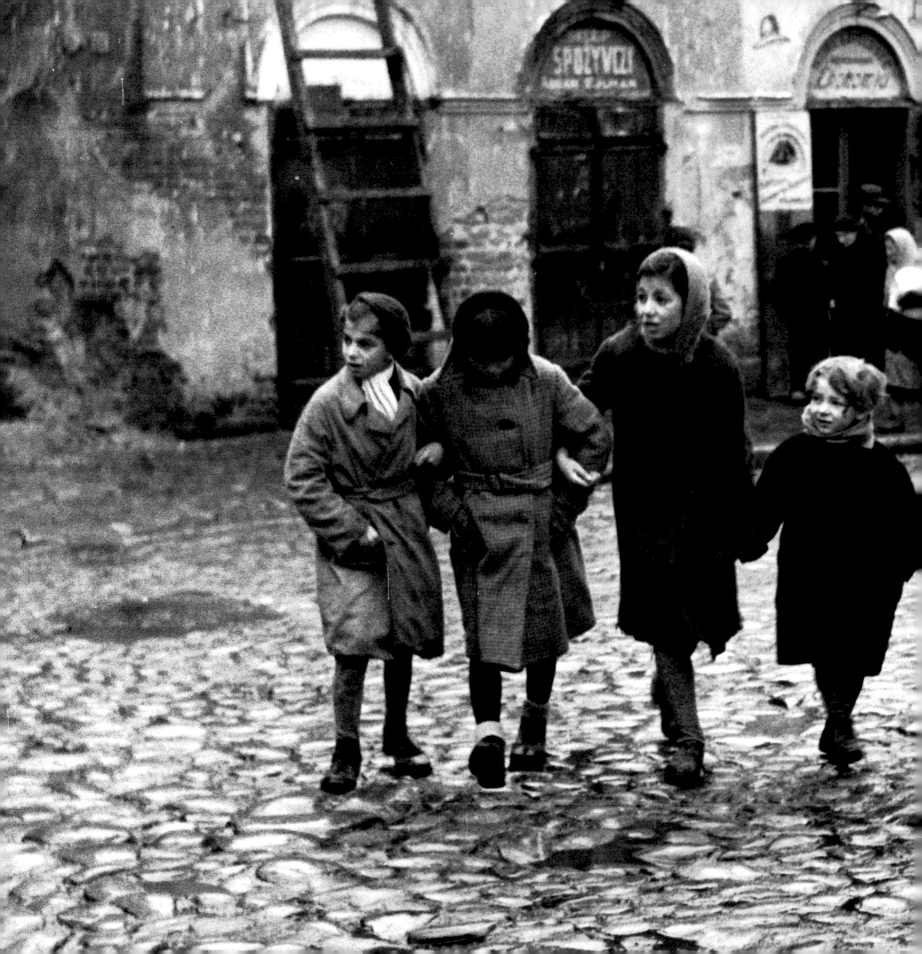

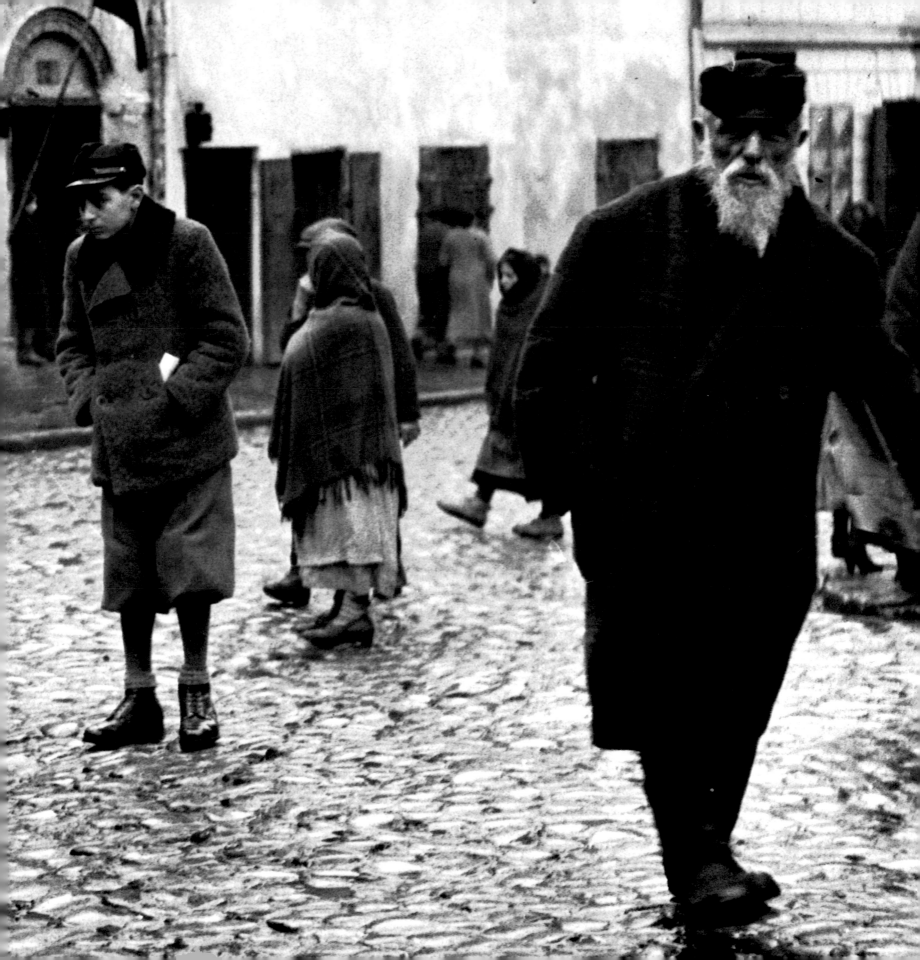

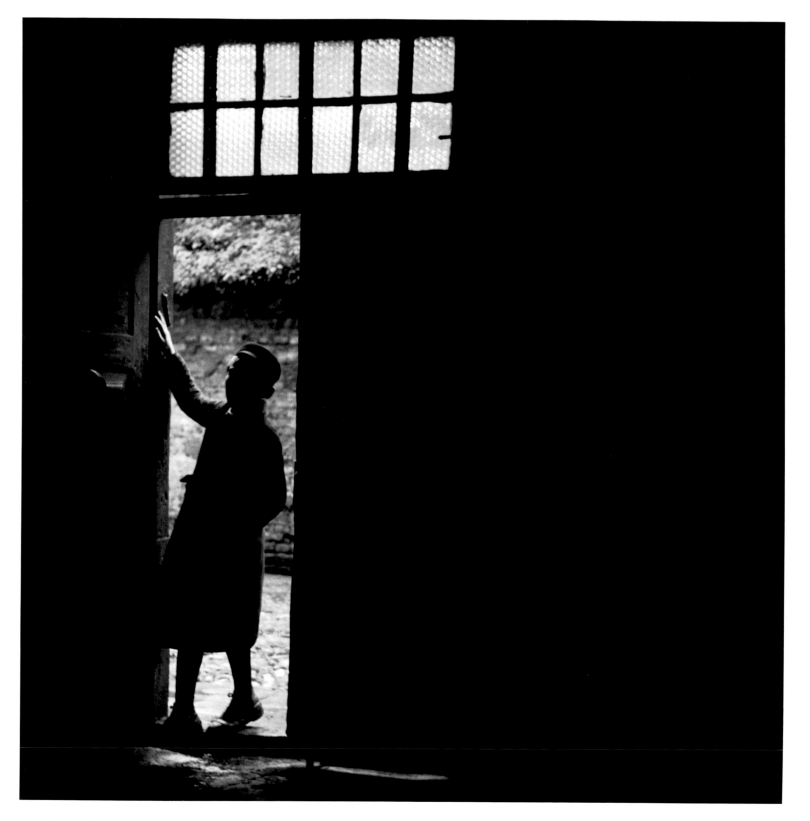

Touching the mezuzah.

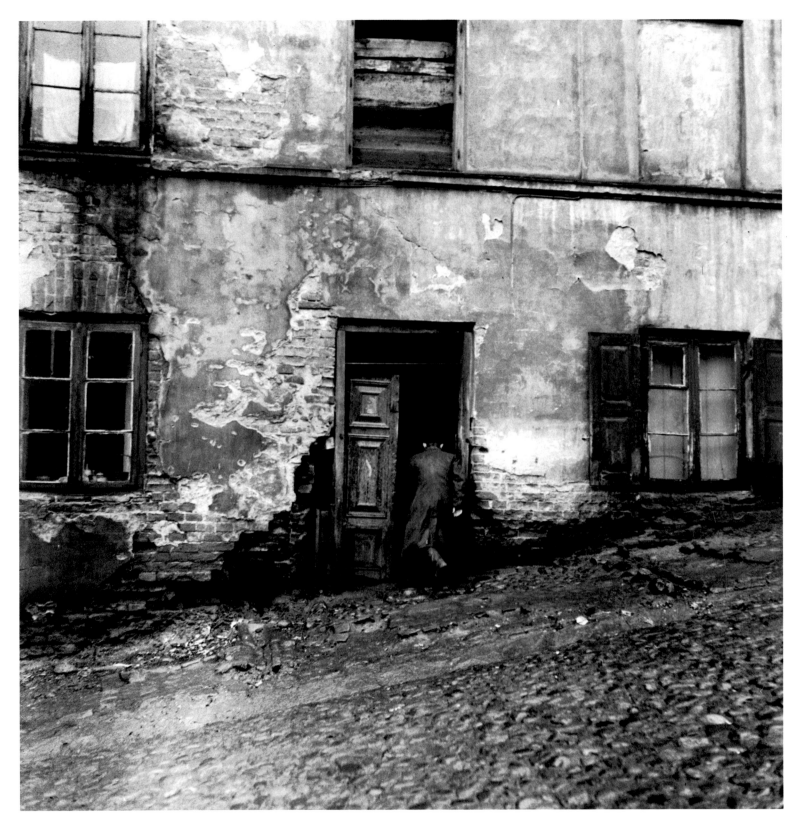

In the Jewish quarter.

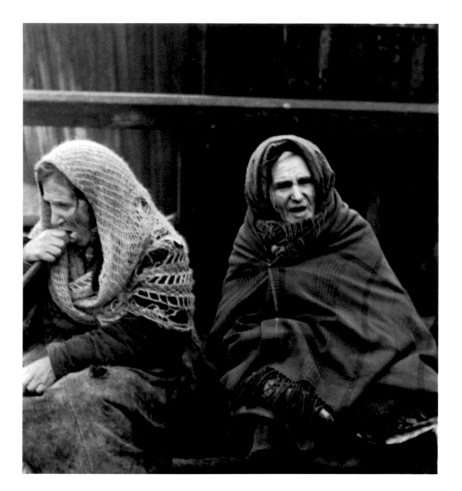

Waiting.

Selling baked goods at the Old City wall.

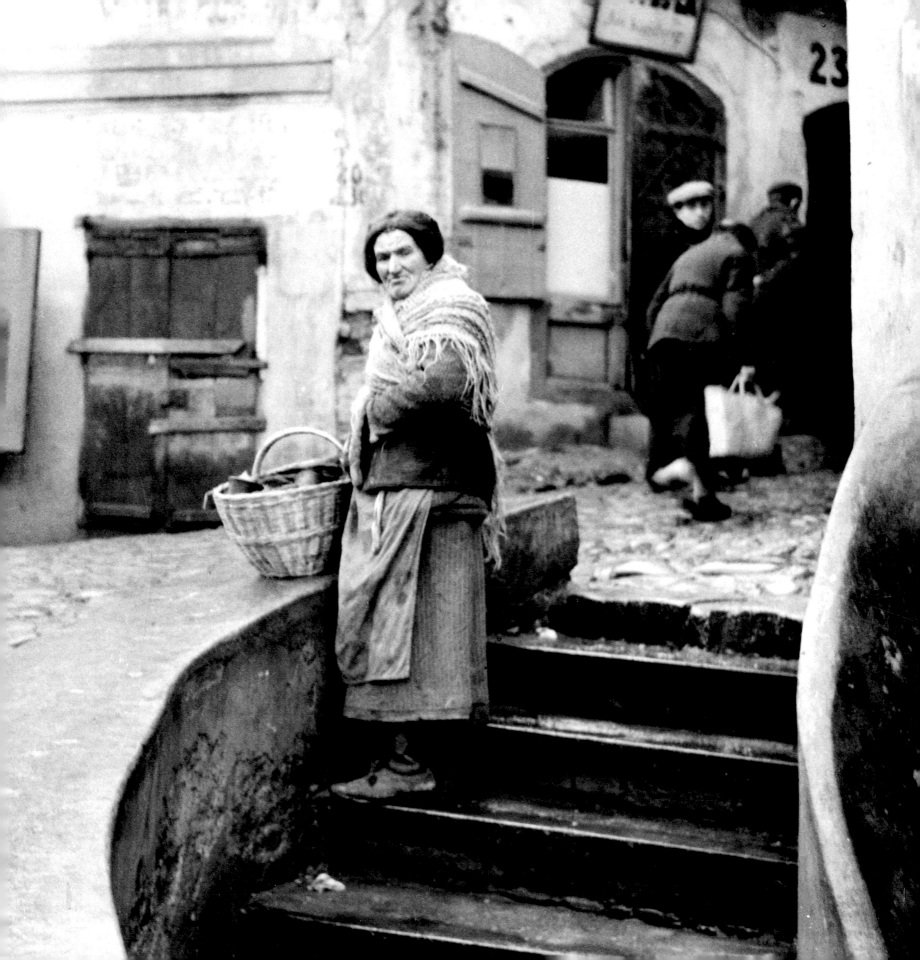

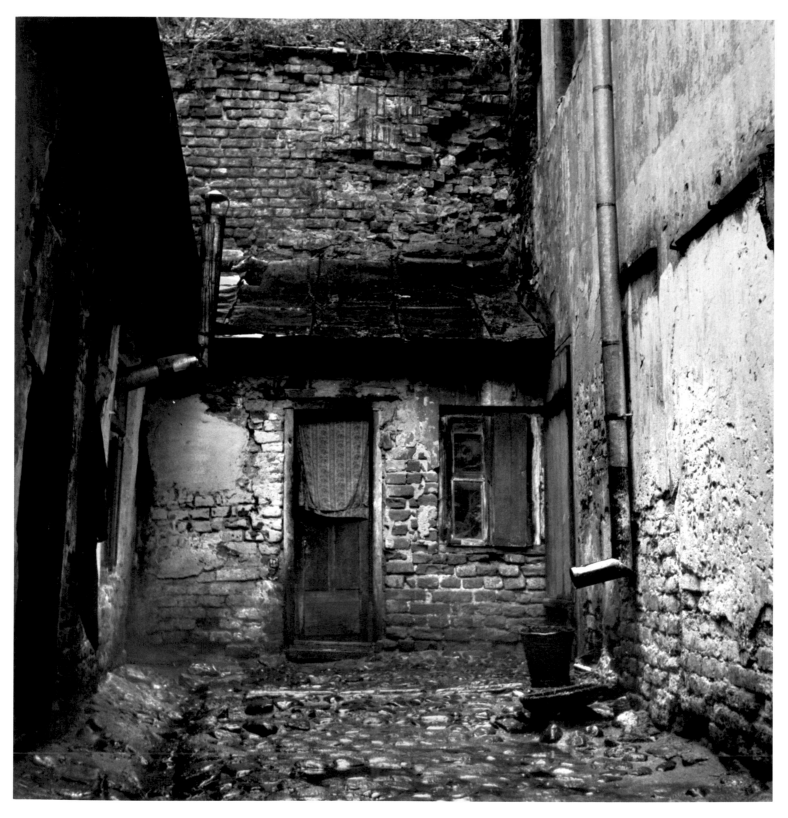

The Jewish quarter.

114

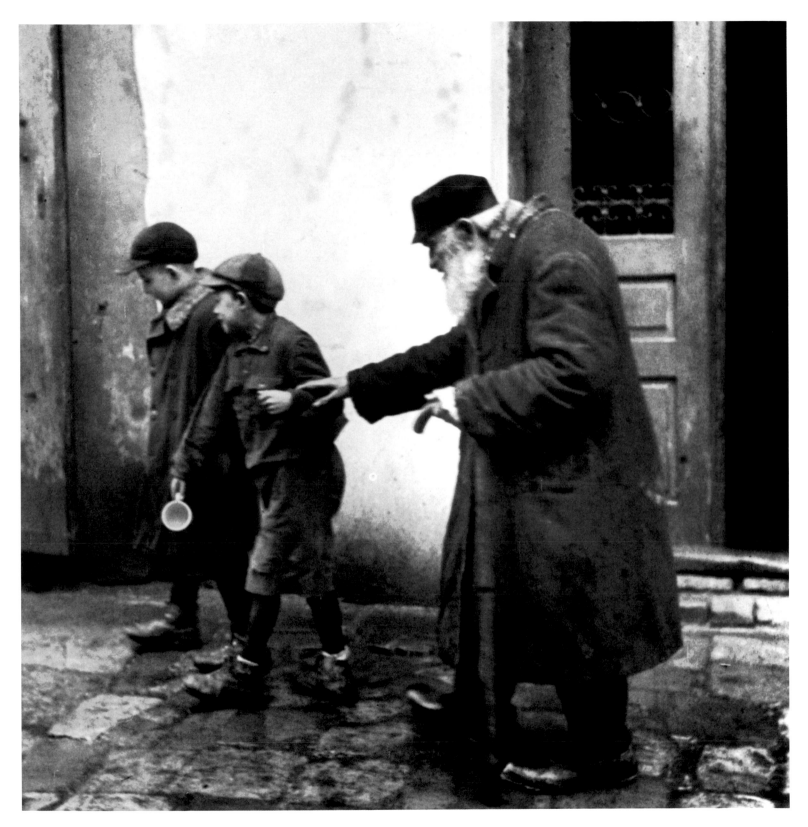

Children leading a blind man.

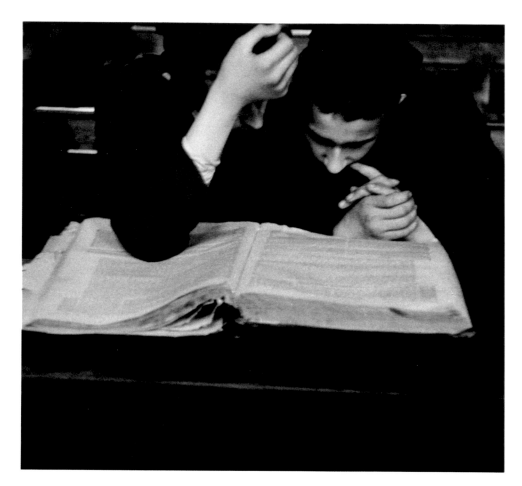

Searching for truth in the Talmud.

Immersed in study.

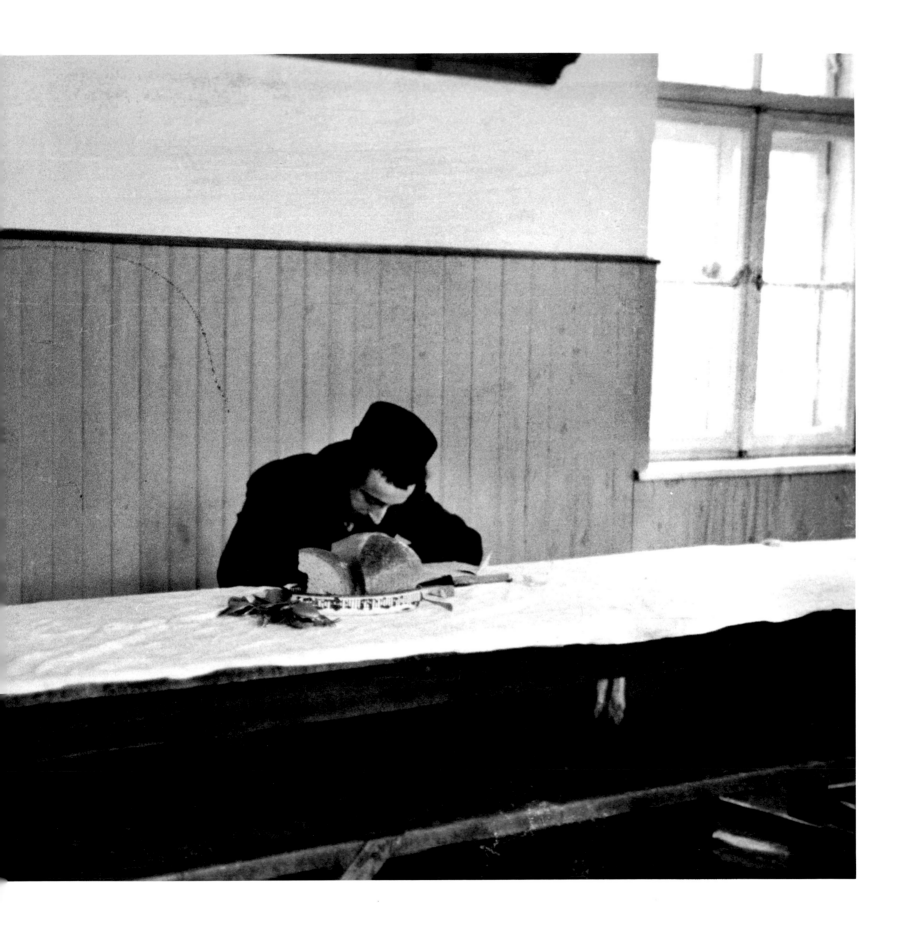

SLONIM

A TOWN IN THE BIALYSTOK REGION of Poland, Slonim became part of Russia in 1795, and was not restored to Poland until after World War I. In 1939, with the Nazi-Soviet pact, Slonim came under Soviet rule. It is now part of the independent state of Belarus.

Jews began settling in Slonim in the mid-sixteenth century, and in 1642 the Great Synagogue was erected. A magnificent stone structure, it was surrounded by twelve houses of study, the "Tailors' Synagogue" and the "Shoemakers' Synagogue" among them.

The late seventeenth century saw a marked deterioration in the relations between the Jews and their Christian neighbors. Sporadic outbursts of anti-Semitic violence continued into the nineteenth century. At the end of that century, scores of Jewish houses were burned. Nevertheless, in certain ways, Jewish life continued to flourish, as evidenced by the emergence of an important Hasidic sect, the Slonim dynasty. In the wake of the Bialystok pogrom in 1906, Zionists formed self-defense groups.

On June 25, 1941, German troops gained control of Slonim from the Soviets; and by the end of that year, more than 10,000 of its Jews had been massacred. Soon after, the Germans sealed the ghetto with 15,000 Jews inside, and on June 29, 1942, they set it on fire. When the Soviet army liberated Slonim on July 10, 1944, there were few Jewish survivors.

Slonim was the birthplace of Roman Vishniac's father. Vishniac's grandfather Wolf had been a prominent citizen of the town—a writer, philosopher, and banker who was known for helping fellow Jews. As Vishniac wrote, "Slonimer were eager to tell me what their grandfathers had told them about him. The shtetl kept the names of its worthy constituents alive for a long time, remembering them and their deeds for generations. . . ."

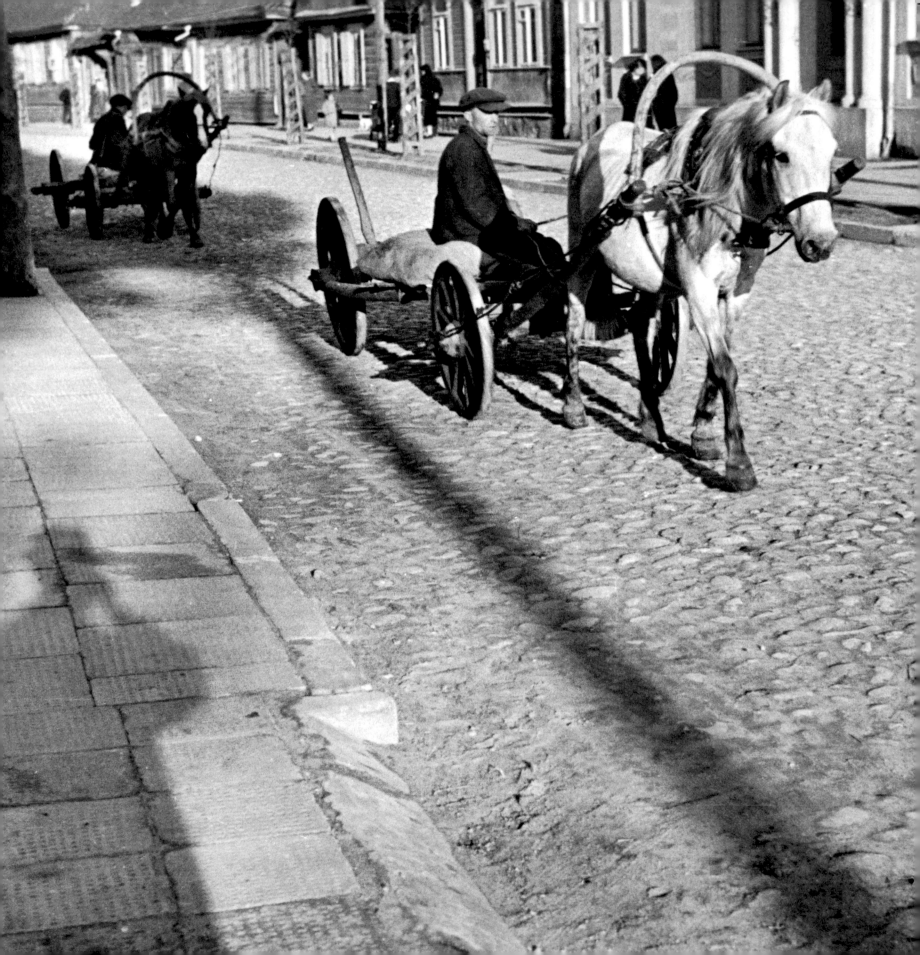

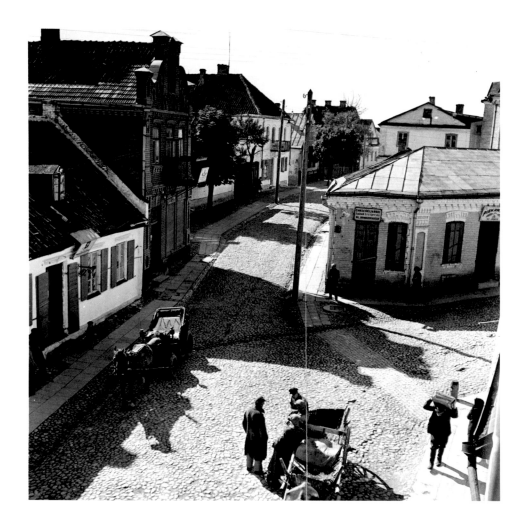

Noon.

Entering town. (Note Vishniac's shadow in the lower left-hand corner.)

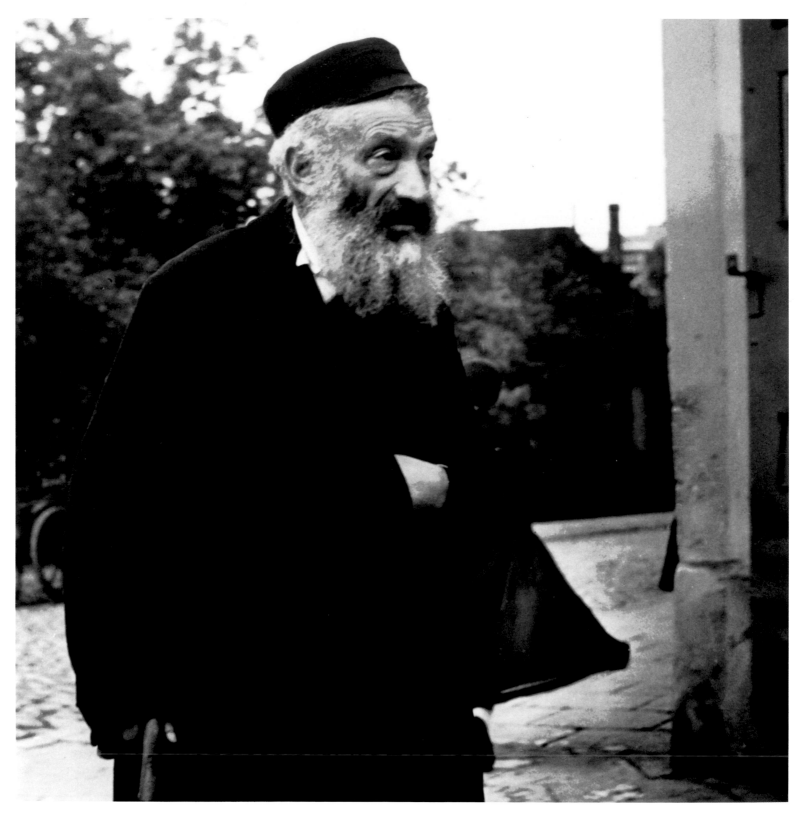

A town elder.

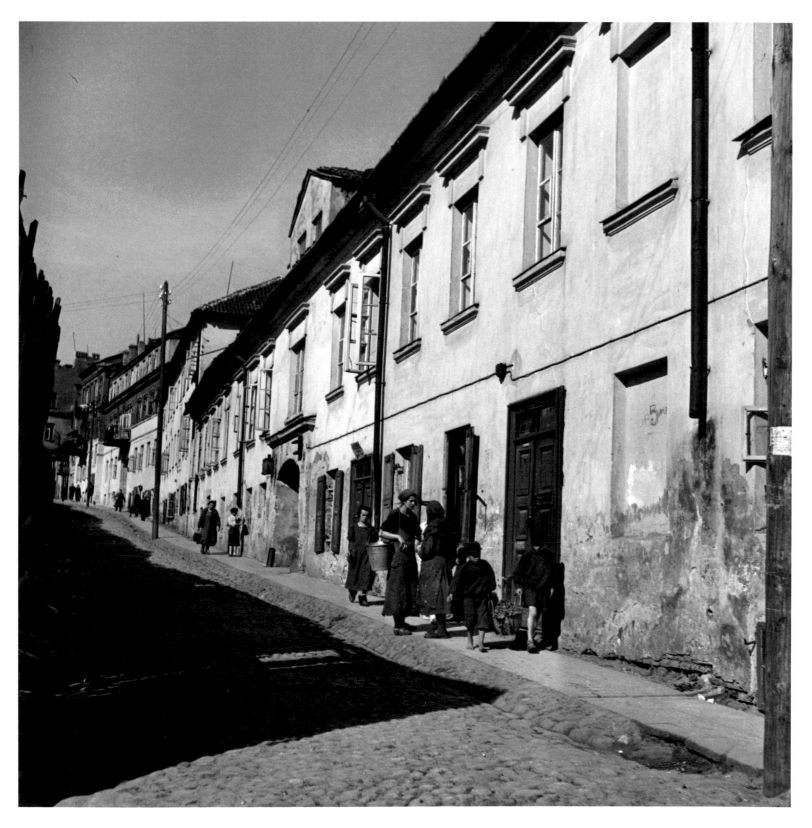

Jewish Street.

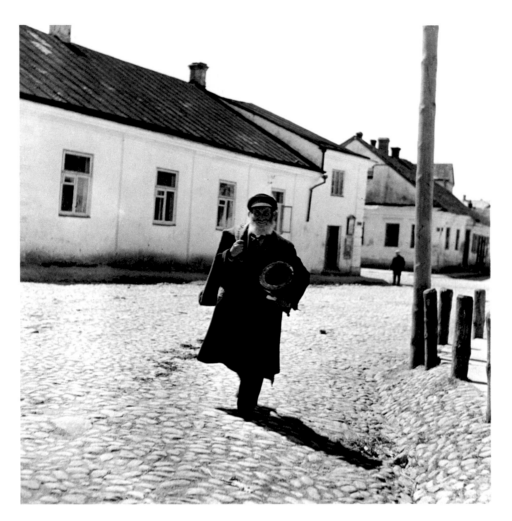

Going to work.

Street scene.

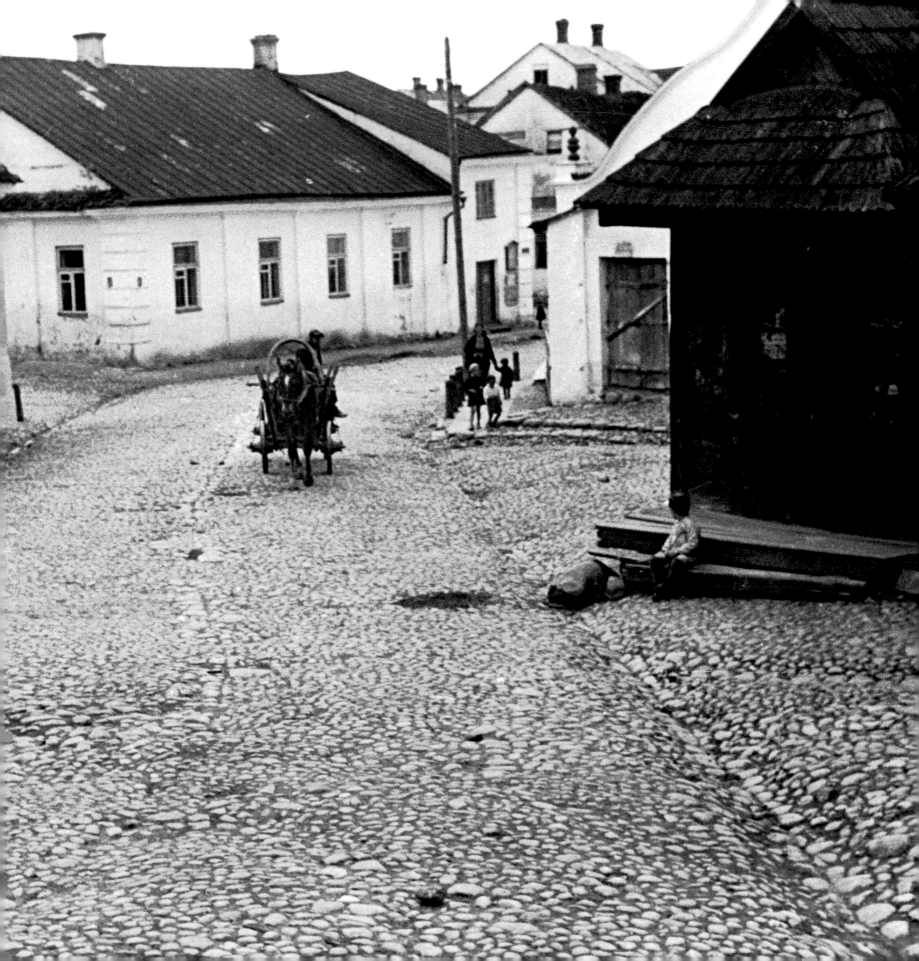

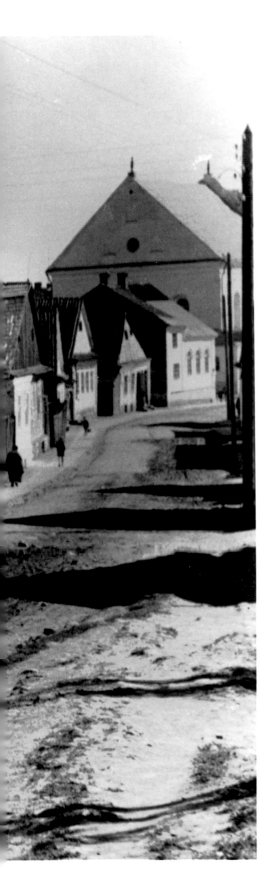

Jewish Street.

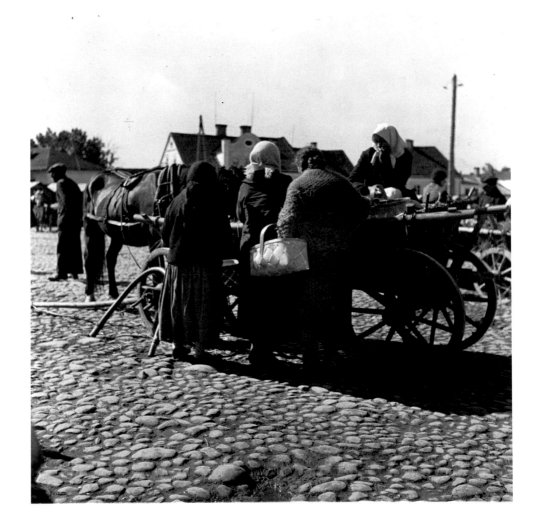

At the market.

127

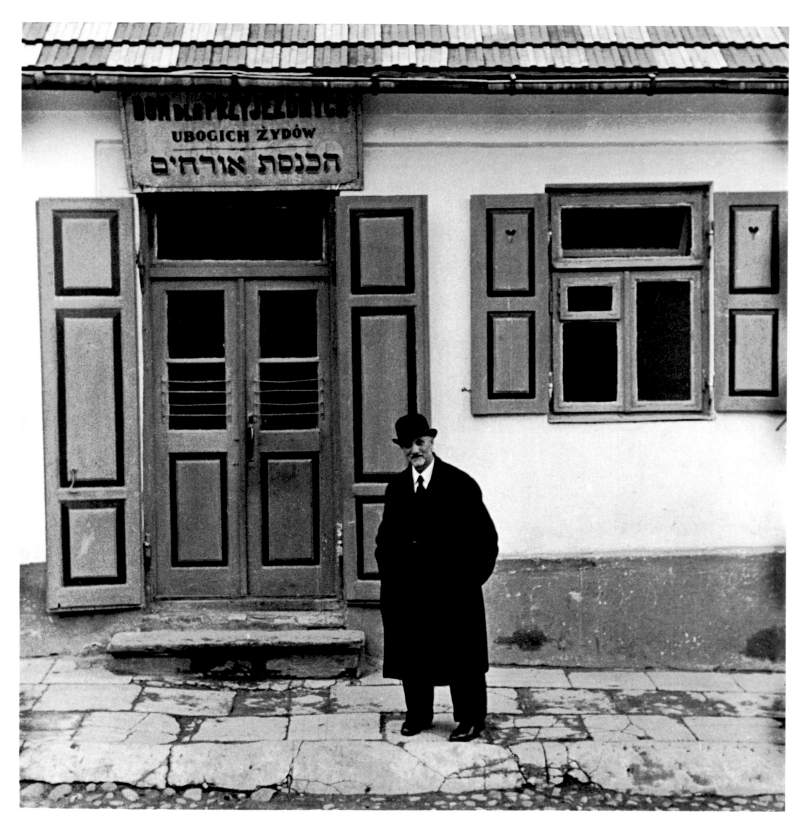

Outside the Jewish guest house.

128

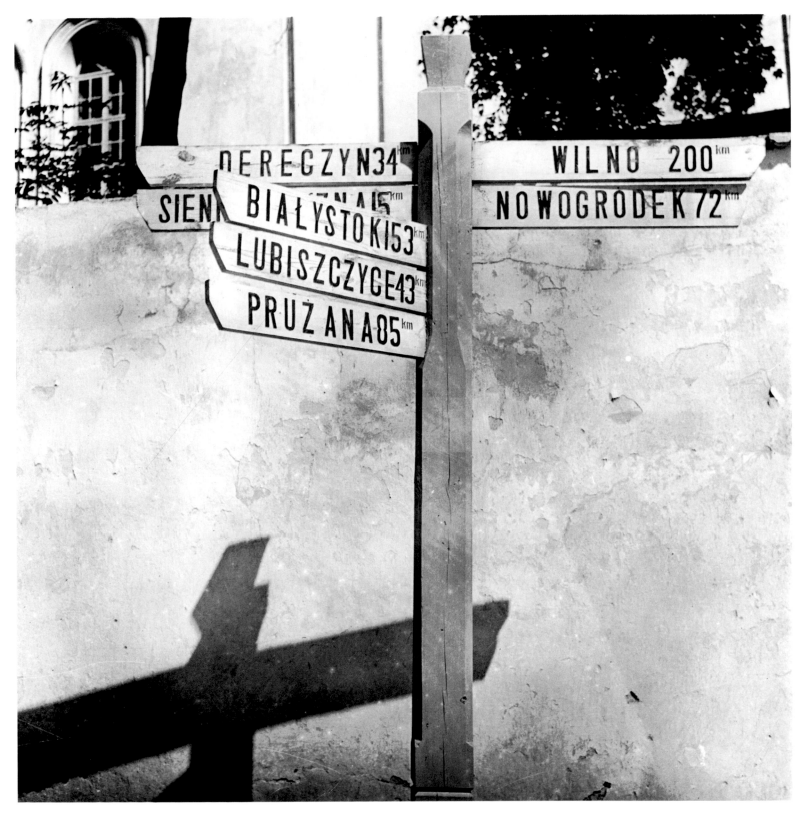

Crossroads.

GALICIA

MOST OF THE REGION in southern Poland known as Galicia was annexed by Austria in 1772, and remained under Austrian rule until the end of World War I. The region was then incorporated into the Polish republic. Today, Western Galicia remains part of Poland, while Eastern Galicia belongs to Ukraine.

Galicia was enormously diverse, its population a lively mix of Poles, Ukrainians, Germans, Jews, and other ethnic groups. Most Galician Jews lived in the towns and cities rather than in the rural villages, and played a crucial role in commerce.

In the 1770s, under the Austrian Empress Maria Theresa, Jews were carefully monitored and heavily taxed. In the next decade, Emperor Joseph II saw in the Jews an opportunity to offset Polish influences. Under his rule, Jews were prepared for their "Germanizing" role through mandated "enlightenment" or secular education. However, an official attempt to close all cheders and yeshivas proved unsuccessful.

In the next century, Hasidism led the struggle of the Jewish populace against such government "reforms." At the same time, it found itself embroiled in a merciless battle with followers of the Jewish Enlightenment, the *maskilim.*

Following the 1848 Revolution, Jews in Austria were emancipated but by 1851 they had lost their newly acquired rights.

Galician Jews suffered bitterly during World War I. In the aftermath of the Russian invasions, there were rampant rape, murder, destruction of Jewish property, and, finally, expulsions.

Between the two wars, Jews enjoyed a time of relative peace and prosperity which came to an end in 1939, when Western Galicia was occupied by the Germans, and Eastern Galicia by the Soviets. By 1941, the Germans had taken Eastern Galicia from the Soviets. During the war, the majority of Galician Jews were murdered in Belzec and other death camps.

CRACOW

The most important city in Western Galicia, and one of the oldest in Poland, Cracow became a major center for Orthodox and Liberal Jewry in the twentieth century. Its synagogue—the first in Poland—was erected in 1356.

Through most of the fourteenth century, Jews held important positions in the city, particularly in banking and commerce. Even the court banker to Casimir the Great was a Jew. But eventually Christians became envious of their Jewish neighbors, and in 1392 the sale of property to Jews was forbidden. Pogroms occurred throughout the fifteenth century, and in 1495 the King expelled the Jews from Cracow. Many moved to neighboring Kazimierz, which in time became a district of Cracow.

During the seventeenth century, as a result of the Thirty Years' War, many German Jews sought refuge in Cracow-Kazimierz; and the Chmielnicki massacres in the Ukraine brought another wave of refugees to the region.

With the final partition of Poland in 1795, Cracow became part of Austria and Jews were restricted to the Kazimierz ghetto. Not until 1867 did a grant of emancipation give Jews the unrestricted right of settlement in Cracow proper.

By 1900, there were more than 25,000 Jews living in the city. With greater freedom came a prospering middle class. Jews were prominent in a variety of businesses and accounted for nearly half of the city's lawyers and a fifth of its doctors.

When Germany invaded Poland in 1939, there were some 65,000 Jews living in Cracow. In December of that year, synagogues were burned, and in 1940 the Germans expelled half the Jewish population.

In early 1941, Cracow's two most prominent rabbis were murdered, and some 20,000 Jews were packed into the ghetto. From the summer of 1942 through the spring of 1943, Jews were either shot or sent to nearby Plaszow labor camp, to Belzec or to Auschwitz.

"The last time I was in Cracow," Roman Vishniac wrote, "was the winter of 1938. I stood in the falling snow, old legends and tales descending upon me. Before coming to Cracow, I had read about the life of the Jews in the Middle Ages. What had changed in half a millennium? . . . I stood in the square. An old scholar passed by slowly, looking like a patriarch in biblical times. He appeared tired. I felt sympathy for him and asked him how long he had walked. 'Since the beginning,' he answered. I did not ask what he meant. . . ."

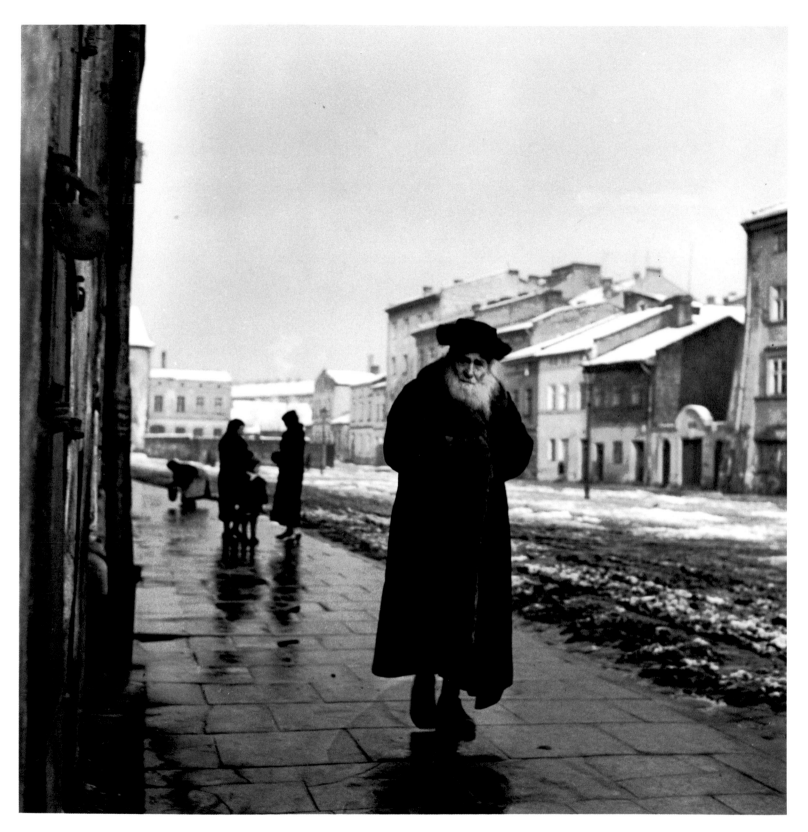

A Talmudic scholar.

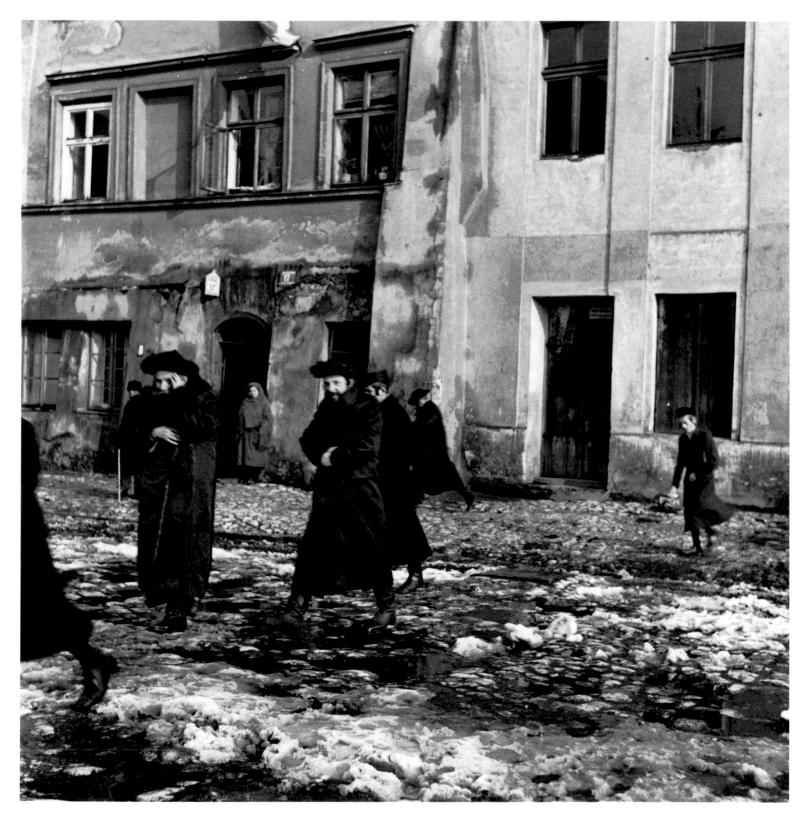

Going to synagogue.

134

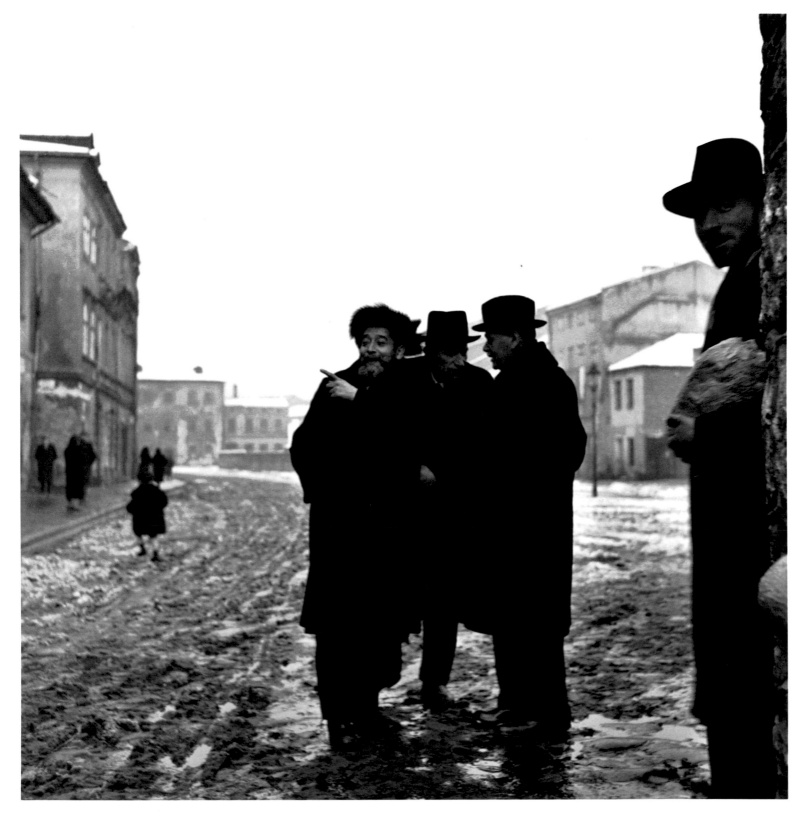

Street scene.

135

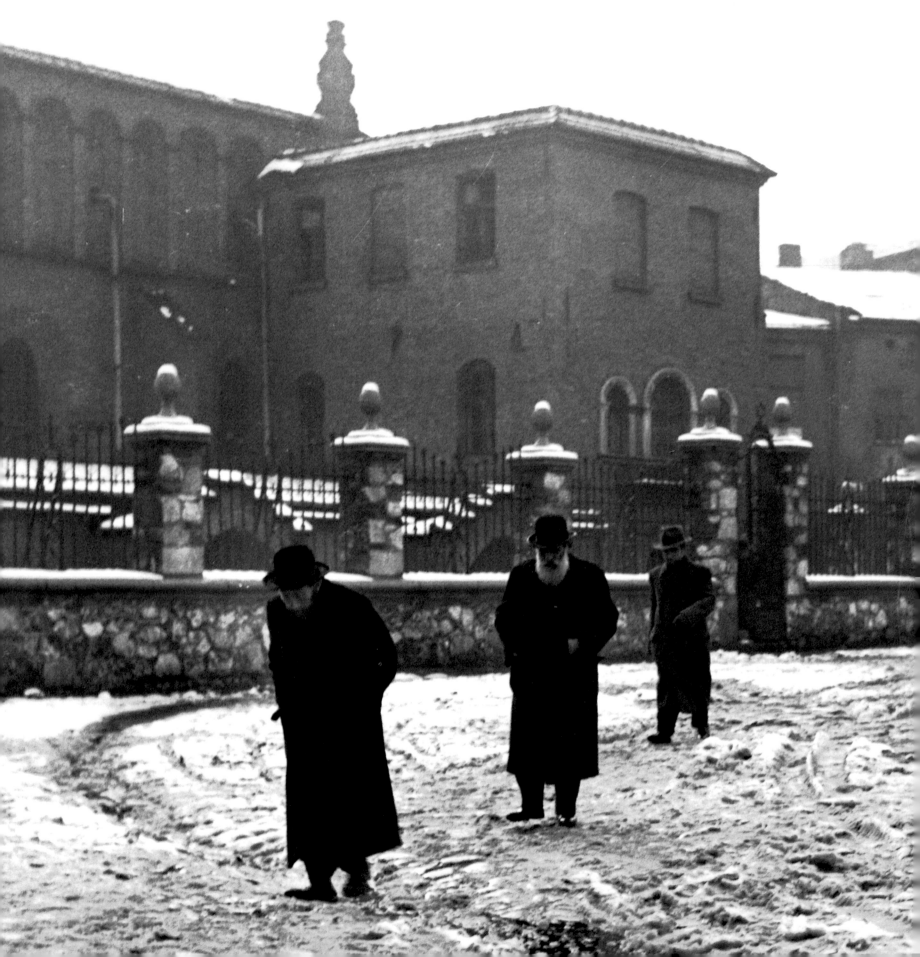

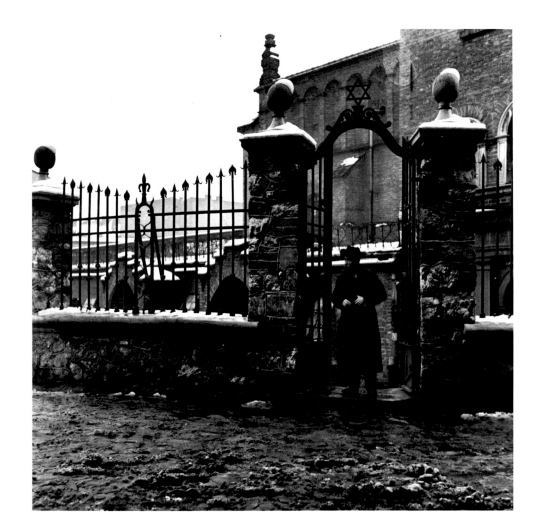

The old synagogue.

OVERLEAF
Waiting in the snow.

137

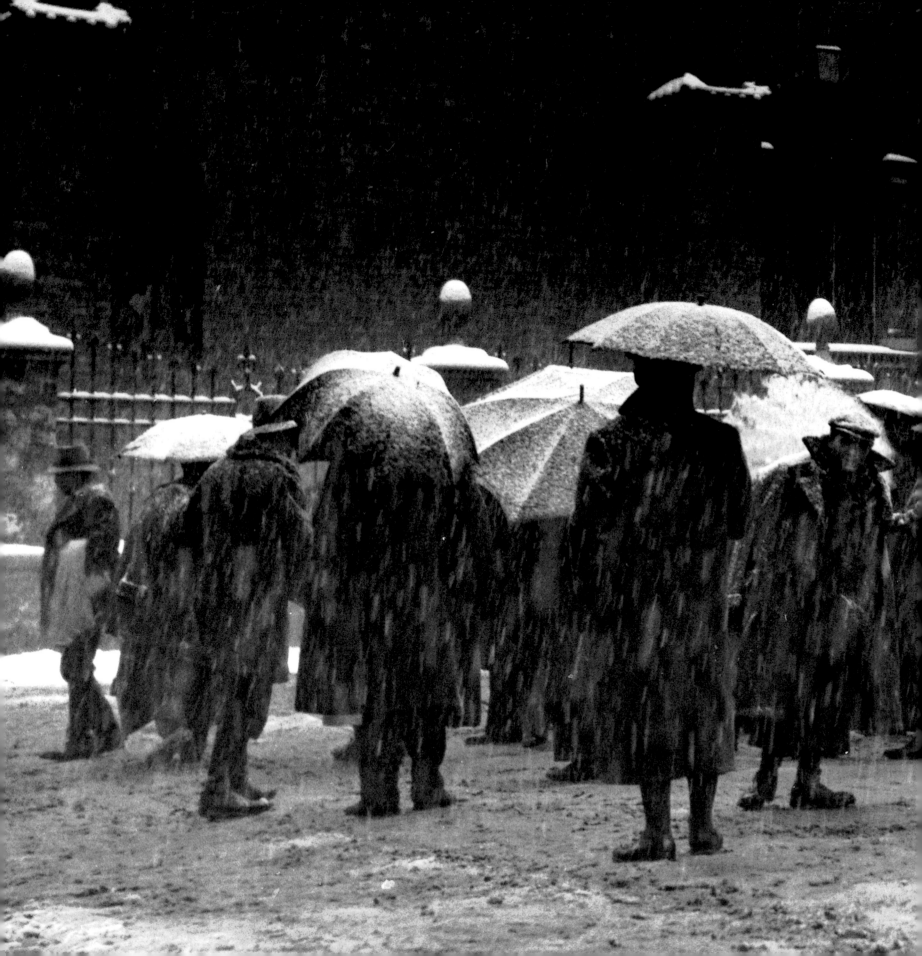

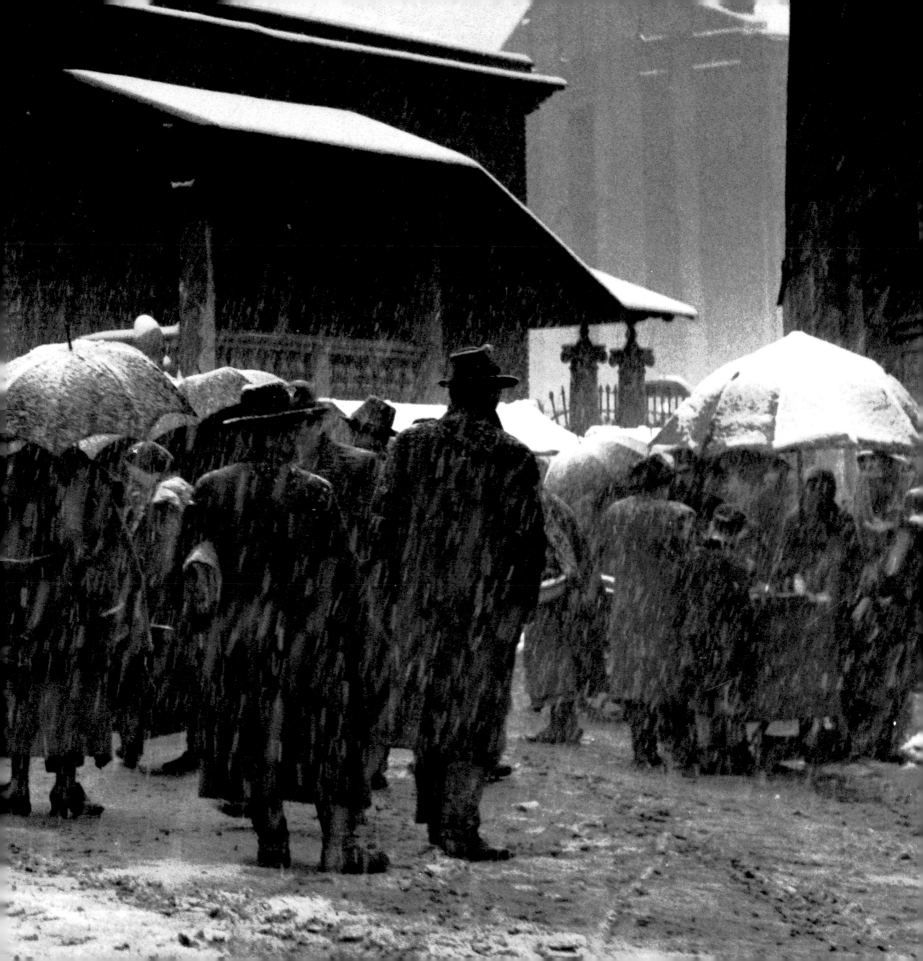

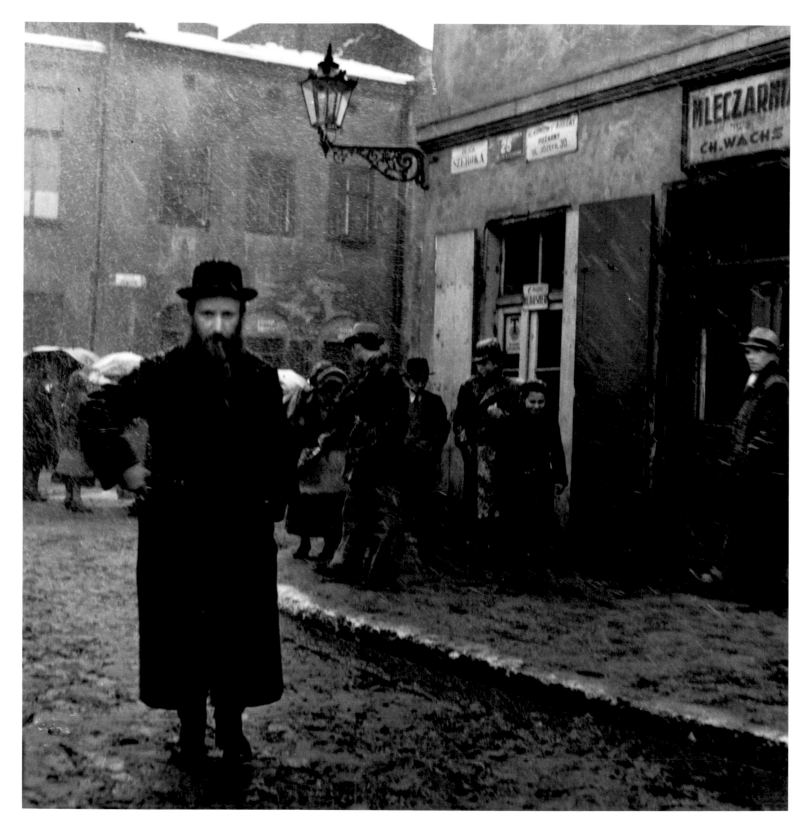

Szeroka Street. (Vishniac referred to it as the "Broadway" of Jewish Cracow.)

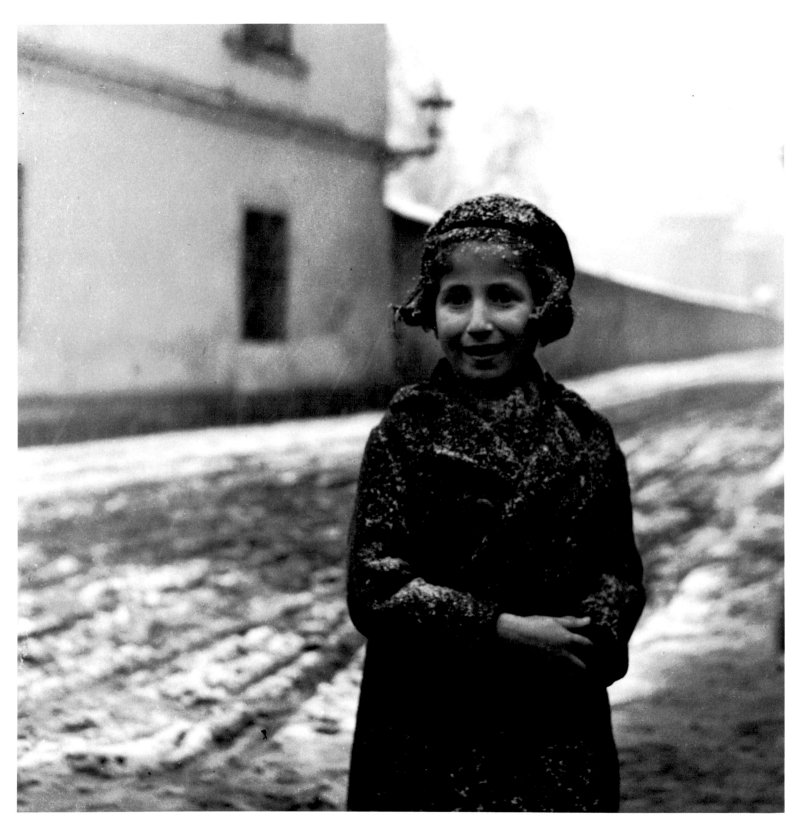

Young girl.

EASTERN GALICIA

Vishniac seemed drawn to the little town of Przeworsk rather than the "emancipated" capital of Lvov. Przeworsk was noted for its distinctive synagogue and for being the home of the *Va'ad*, or Jewish "Parliament."

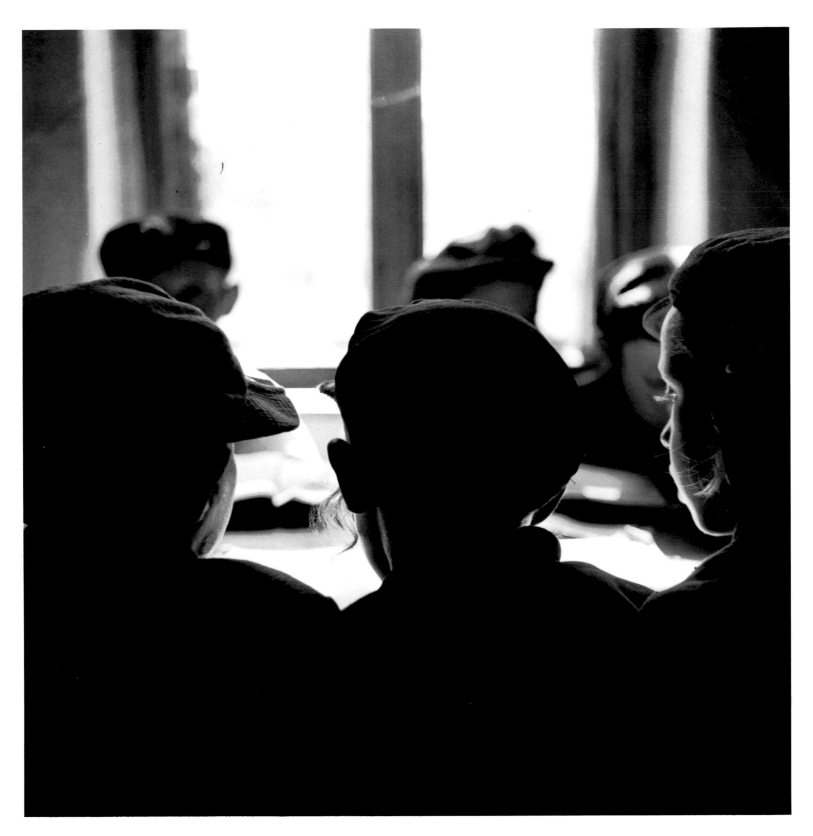

The cheder in Przeworsk.

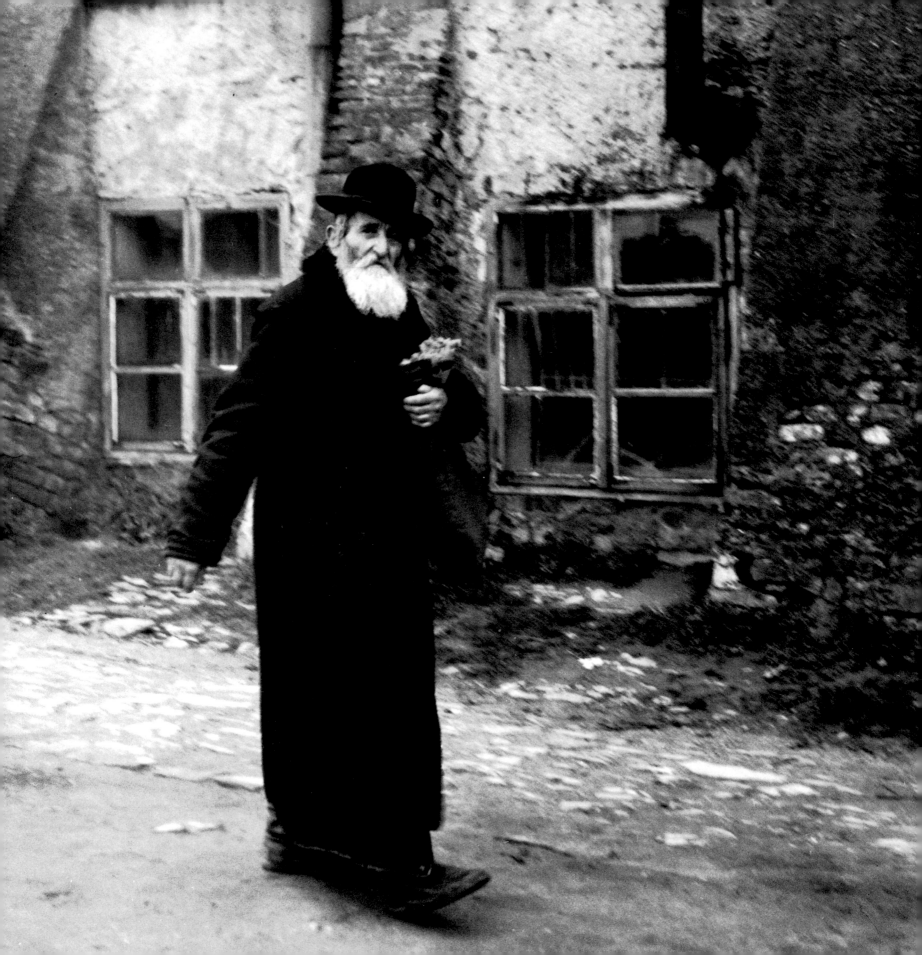

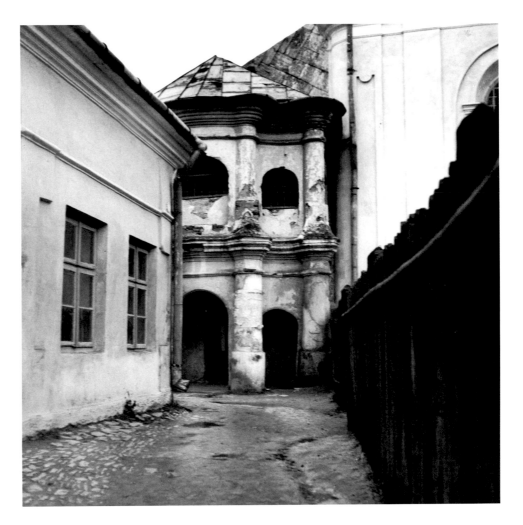

Przeworsk Synagogue.

After services in Przeworsk.

145

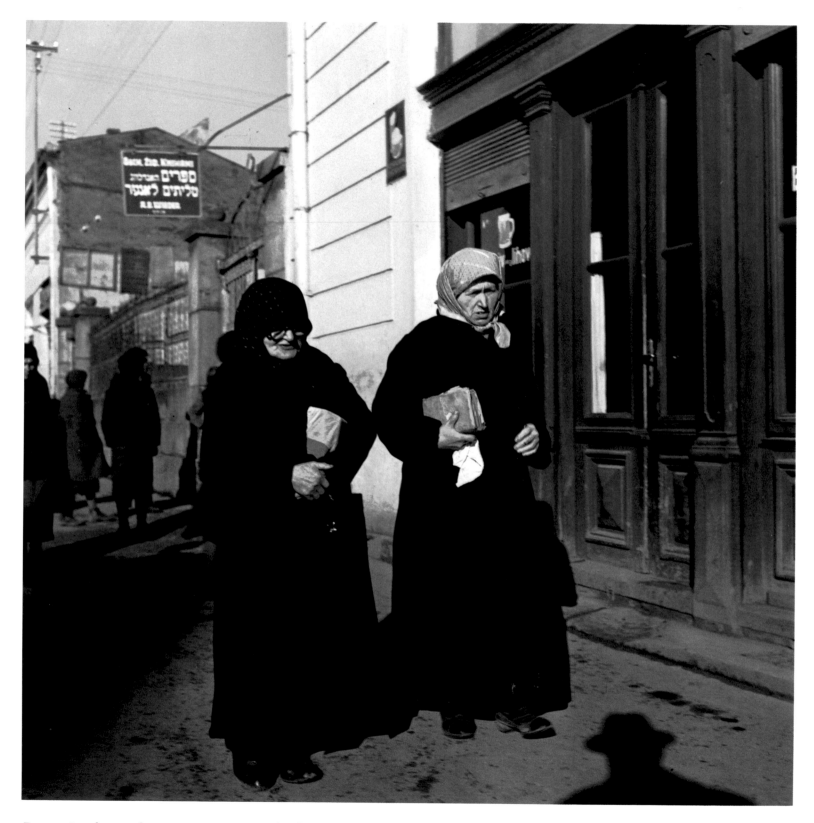

Returning home from synagogue in Chodorov, province of Lvov.
(Vishniac's shadow appears in the lower right-hand corner.)

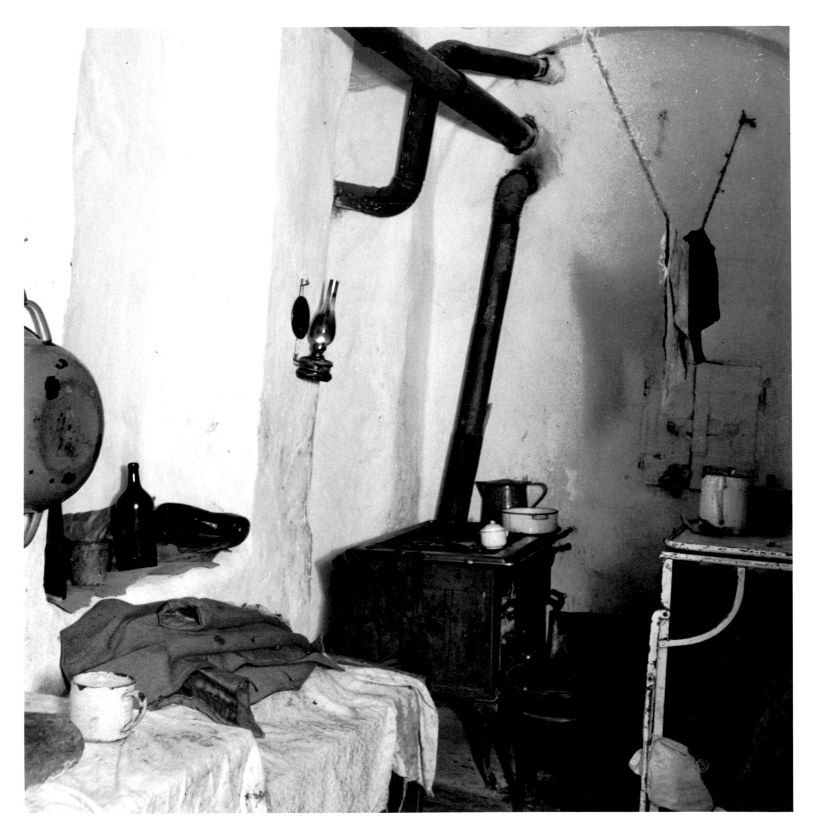

Basement quarters in Przeworsk.

VILNA

JEWS BEGAN SETTLING in Vilna in the fifteenth century, when it was the capital of the Grand Duchy of Lithuania. From 1918 until 1941, the year that Vilna was occupied by the Nazis, the city was ruled by a succession of Lithuanian, Soviet, and Polish regimes.

In spite of the many national upheavals and centuries of persecution, Jewish life flourished in Vilna until World War II. A vital cultural and religious center, it was known in the Jewish world as the "Jerusalem of Lithuania."

In the seventeenth century, more than forty distinguished rabbis lived in the city. In the following century, the celebrated Vilner Gaon (Elijah ben Solomon Zalman) held court there. During the nineteenth century, Vilna became the center of the Haskalah (Jewish Enlightenment).

In 1897, the Bund (Jewish Workers' Union) was formed in Vilna, marking the beginning of the Jewish Labor Movement. Between the two world wars, Vilna—also the birthplace of the YIVO Institute for Jewish Research—became a thriving center of Zionism and Yiddish culture.

There were 80,000 Jews living in the city (nearly one-third of the total population) in 1939. Almost all of them fell victim to the Nazis.

Relatives invited Vishniac to Vilna in the late 1930s. As soon as he arrived he began to take photographs in "the labyrinth of passages and intersections" that had been the ghetto until 1861. In his words: "The center of all Jewish life was the great synagogue with its *shulhoyf* or courtyard. This was the site where the Vilner Gaon held court 200 years ago. . . ."

Vishniac's cousin Max proudly took him to the Strashun Library, which contained "some 40,000 volumes, including incunabula printed in Hebrew twenty years after Gutenberg. . . . In the research hall worked hundreds of young men and women surrounded by stacks of books. We stood behind their chairs, and from time to time Max would place a little note in front of them, asking one or the other to step into the anteroom to discuss his work with us. . . ."

"Some of these works were of philosophical and religious nature in the broadest sense," wrote Vishniac. "Others dealt with such varied subjects as the Bund, Zionism, blood libel, Montefiore, Maimonides, the history of Vilna. . . ."

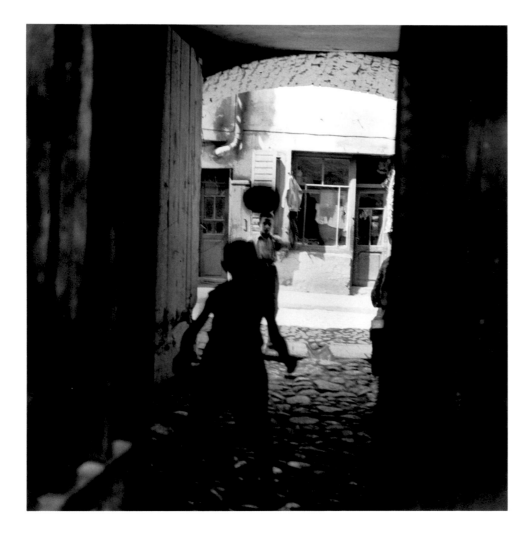

Children of the Jewish quarter.

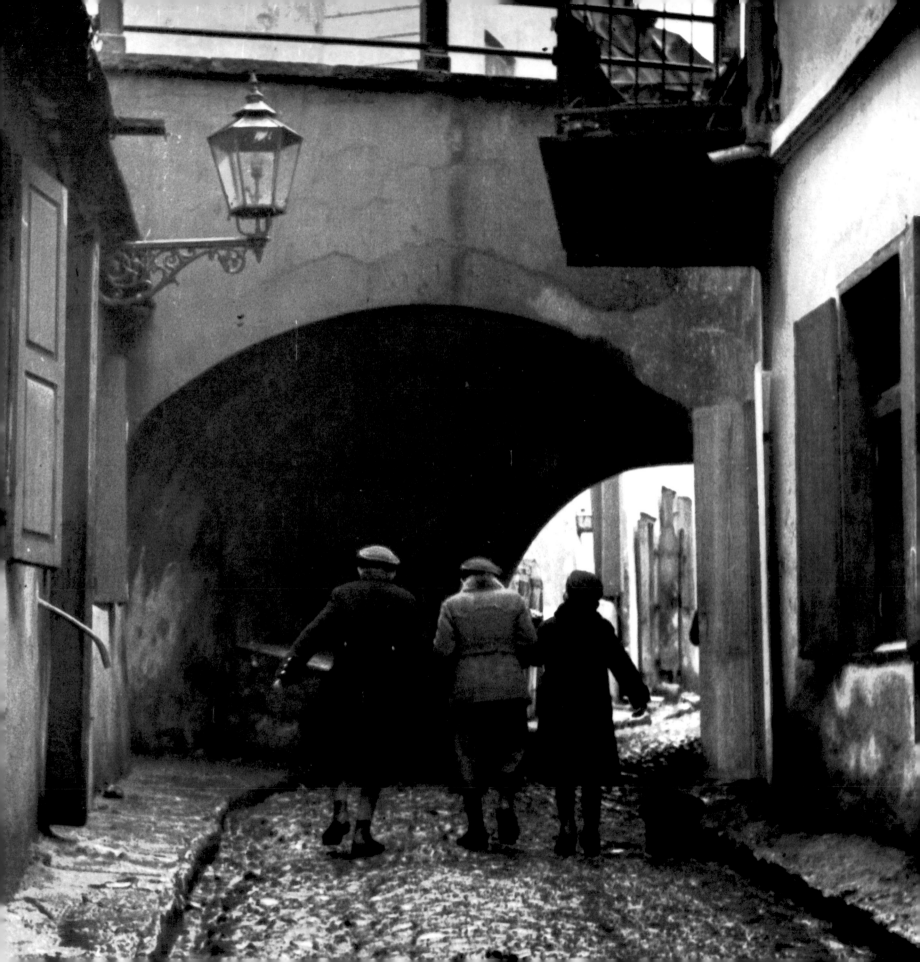

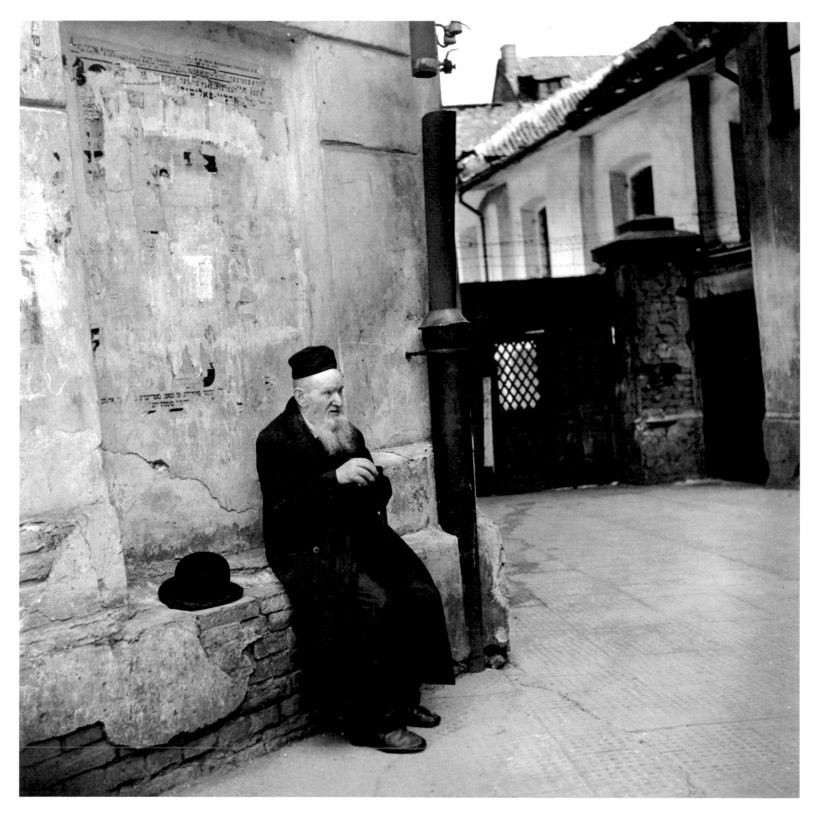

In the synagogue courtyard.

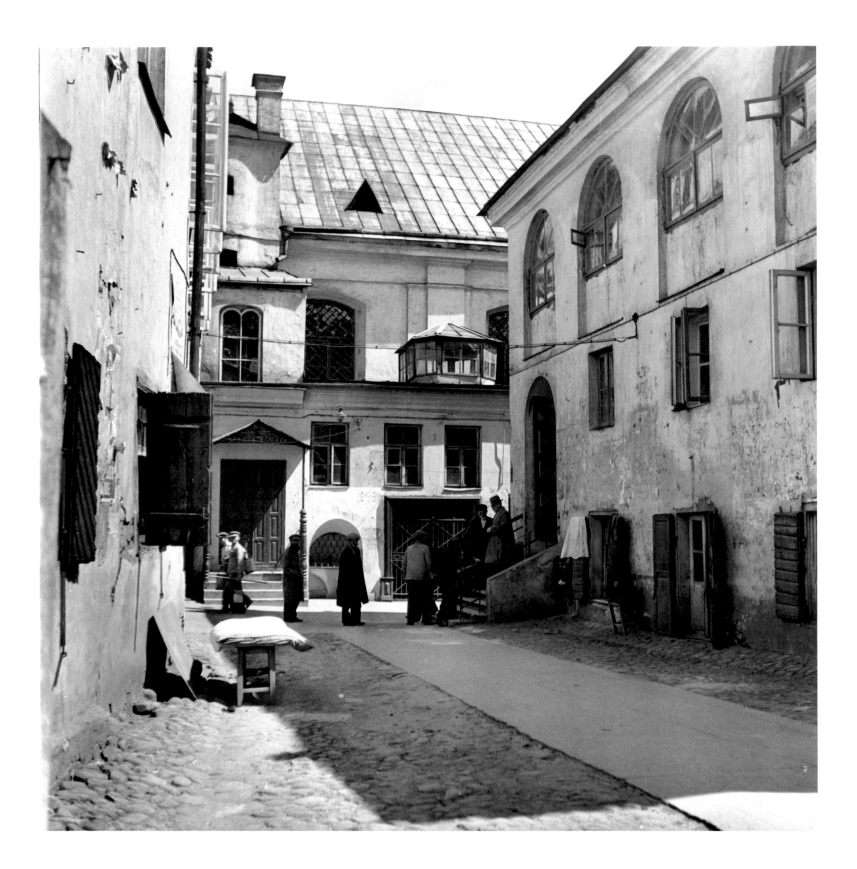

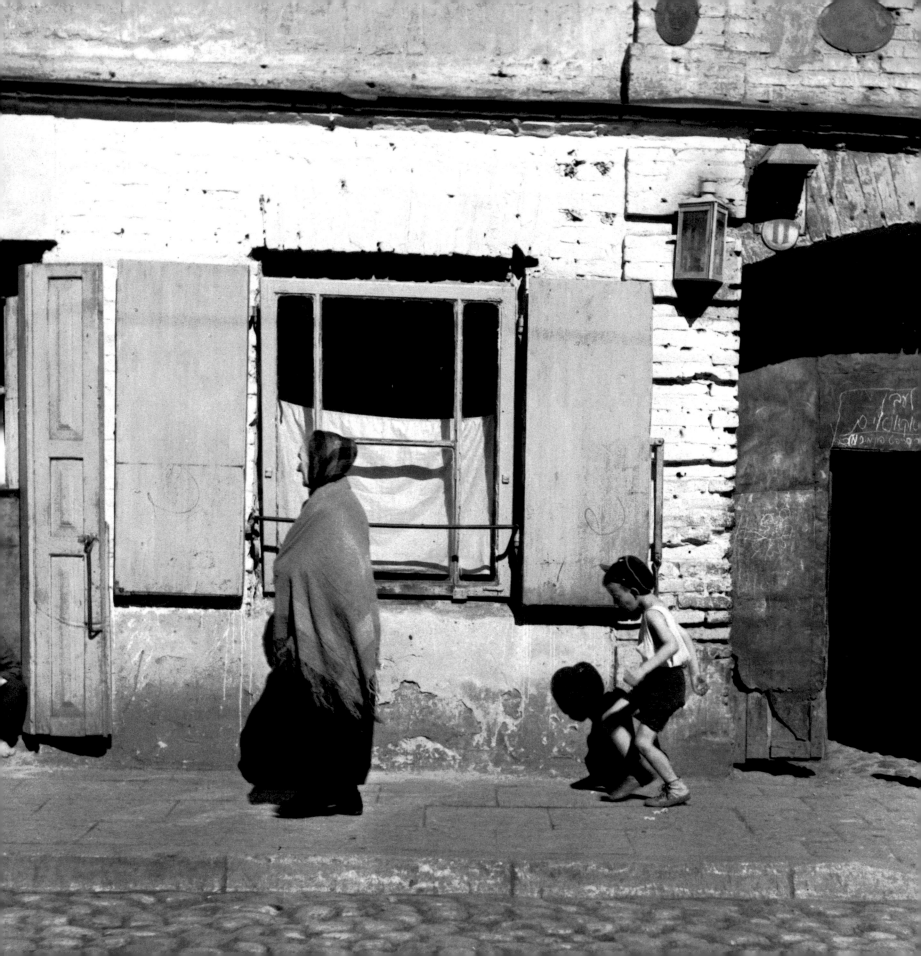

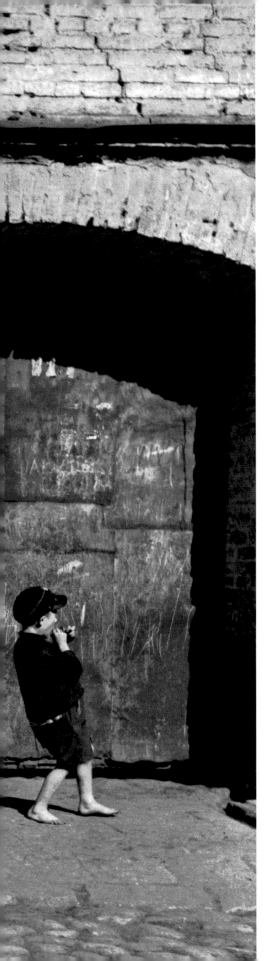

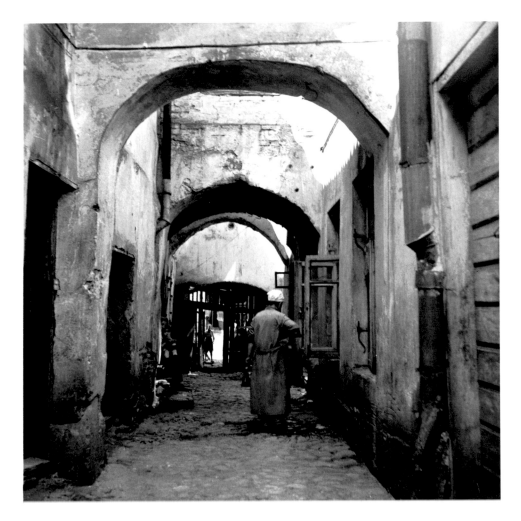

Entrance to the Jewish quarter.

Playing.

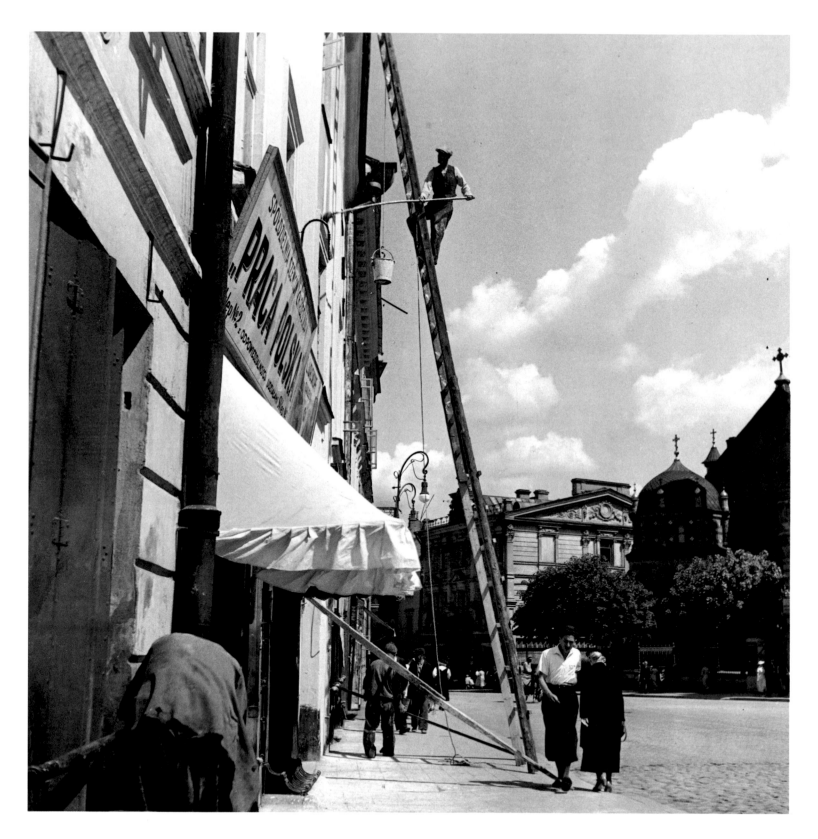

A window washer.

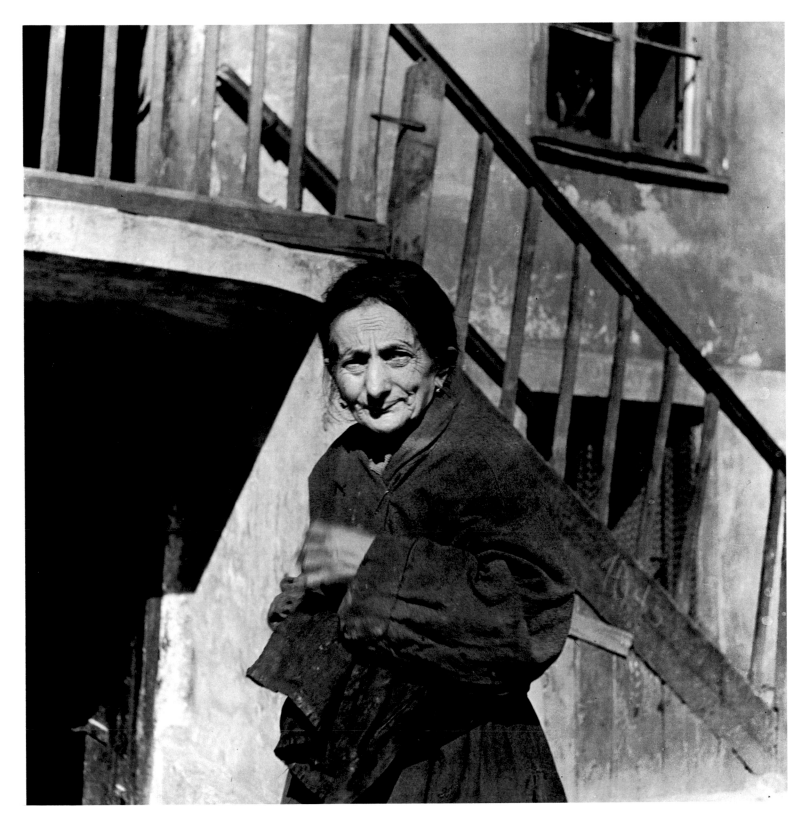

Old woman.

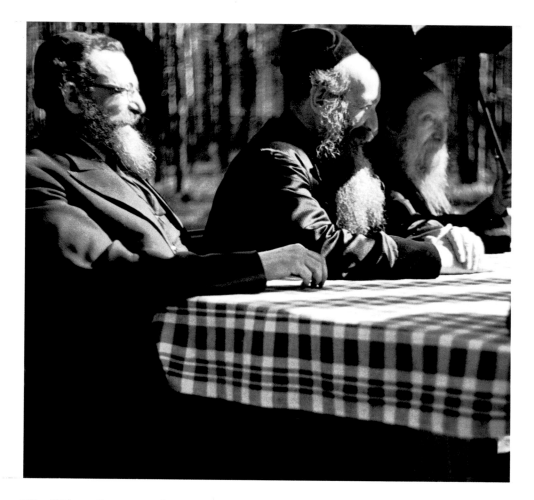

*The Vilner Rov Grodzenski (under umbrella) and disciples
at his summer residence outside Vilna.*

In the woods outside Vilna.

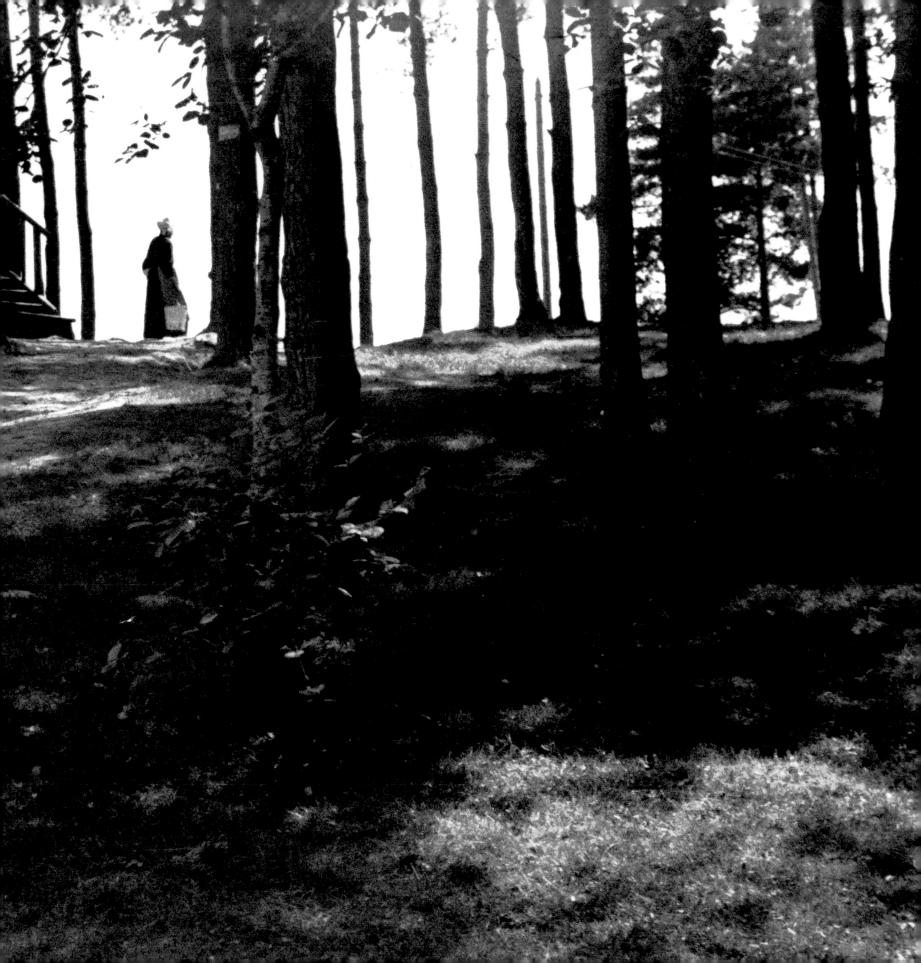

BIOGRAPHICAL NOTE

MY FATHER, ROMAN VISHNIAC, was born in August 1897 near St. Petersburg and raised in Moscow. For a Jewish family to live in the capital was a "privilege" granted only by special permission. Once granted, it became a hereditary right that passed down to several generations. Roman's father, Solomon, was a well-to-do manufacturer of umbrellas and parasols, while his mother's family was in the diamond business. Solomon was one of ten children, so Roman and his sister had many cousins, several of whom were interested in science. Perhaps under their influence Roman too became fascinated by the natural world. When as a young boy he was given a microscope and a camera, he found a way to combine the two and produced his first microphotographs.

After World War I, and the turmoil of the Russian Revolution, many Jewish families decided to search for a quieter, more secure existence in other parts of the world. Berlin, where many members of the Vishniac family had studied, was considered a world center of culture and science. It was there that Roman's parents, Solomon and Manya, settled, and Roman, with his new wife, Luta, soon followed.

In the early 1930s, anti-Semitism in Poland rose beyond its normally high level, and families of modest means, living in traditional communities, were the first to suffer under the ever more restrictive laws and regulations. The Joint Distribution Committee representatives in Berlin asked Roman, who was known for his photographic work, to travel to Eastern Europe, in order to document daily life in the shtetls. These photographs would be used to help raise funds to aid the increasingly destitute communities. Once there, Roman was deeply moved by the hardworking men, women, and children who managed to cling to their traditions despite continuing oppression. For the next four years, 1935 to 1939, Roman repeatedly took his cameras to Poland, the Carpathians, Slovakia, and Hungary. Between trips, he returned to his darkroom in Berlin to develop and print the images that became, in time, the last pictorial evidence of traditional Jewish life before its brutal extinction.

After our family's arrival in New York in 1941 (Roman had been interned in Camp Gurs in France), my father tried desperately to have his documentary photographs exhibited. He believed that pictures of the endangered communities might, even then, focus American attention and prevent further catastrophe. But as we know, it took many years before we were willing to confront the awful truth.

While continuing his efforts on behalf of his documentary work, Roman produced now well-known portraits of Albert Einstein, Marc Chagall, and others; and, as always, he continued his microphotography, which became popular through *Life* and other magazines.

In 1971, Cornell Capa, Director of the International Fund for Concerned Photography (now the International Center of Photography), mounted the first comprehensive exhibit of Roman's work at the Jewish Museum in New York City.

When my father died on January 22, 1990, he knew that his photographs would continue to touch us, to help us remember our people, and to strengthen our concern for the persecuted and the oppressed.

November 1992　　　Mara Vishniac Kohn